The Last Empire

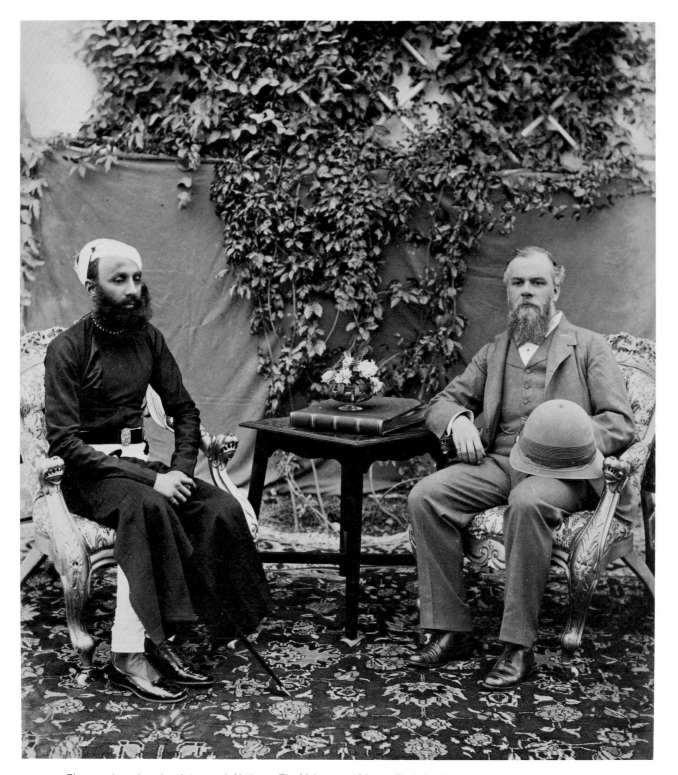

Photograph attributed to Johnston & Hoffman: *The Maharana of Mewar, Fateh Singh, with Lord Elgin, the Viceroy,* 1896.

The Last Empire

PHOTOGRAPHY IN BRITISH INDIA, 1855-1911

Preface by The Earl Mountbatten of Burma

with texts by Clark Worswick and Ainslie Embree

An Aperture Book

A grant from the JDR 3rd Fund enabled Clark Worswick to travel to England to select photographs for the exhibition and the book, and to study the history and records of the British photographers in India.

The publisher wishes to thank R. J. C. Desmond, deputy director of The India Office Library and Records, whose research on photography in nineteenth-century India indicated the range of photographs available and provided the basis for Clark Worswick's notes. Great appreciation is extended to the following individuals and institutions who kindly made their photographic collections available in the preparation of the book: Josef Breitenbach, Weston J. Naef, Howard Ricketts, Samuel Wagstaff, Jr., and Paul Walter; The Boston Public Library, Boston; The British Museum, London; The Carpenter Center for the Visual Arts, Harvard University; The Fogg Art Museum, Harvard University; The Forbes Library, Northampton, Massachusetts; The International Museum of Photography, George Eastman House, Rochester; The India Office Library and Records, London; The National Army Museum, London; The Peabody Museum, Harvard University; The Royal Commonwealth Society, London; The School of Oriental and African Studies, London; The Smithsonian Institution, Washington, D.C.; The Victoria and Albert Museum, London.

Clark Worswick acknowledges with gratitude the help and support of Gail Buckland, Diana Edkins, Bill Jay, Porter McCray, Major Boris Mollo, Pauline Rohatgi, John Rosenfield, Robert Shelton, D.H. Simpson, Raghubir Singh, Allen Wardwell, and Cary Welch.

Library of Congress Catalog Card No. 76-21208
ISBN: Clothbound 0-912334-86-X

Printed in China
Copyright © 1976 by Aperture Foundation, Inc.

Aperture Foundation publishes a periodical, books, and portfolios of fine photography and presents world-class exhibitions to communicate with serious photographers and creative people everywhere. A complete catalog is available upon request. Aperture Customer Service: 20 East 23rd Street, New York, New York 10010. Phone: (212) 598-4205. Fax: (212) 598-4015. Toll-free: (800) 929-2323. E-mail: customerservice@aperture.org. Aperture Foundation, including Book Center and Burden Gallery: 20 East 23rd Street, New York, New York 10010. Phone: (212) 505-5555, ext. 300. Fax: (212) 979-7759. E-mail: info@aperture.org. Visit Aperture's website: www.aperture.org

Aperture Foundation books are distributed internationally through:
CANADA: General/Irwin Publishing Co., Ltd., 325 Humber College Blvd., Etobicoke, Ontario, M9W 7C3. Fax: (416) 213-1917. UNITED KINGDOM, SCANDINAVIA, AND CONTINENTAL EUROPE: Aperture c/o Robert Hale, Ltd., Clerkenwell House, 45-47 Clerkenwell Green, London, United Kingdom, EC1R OHT. Fax: (44) 171-490-4958. NETHERLANDS, BELGIUM, LUXEMBURG: Nilsson & Lamm, BV, Pampuslaan 212-214, P.O. Box 195, 1382 JS Weesp, Netherlands. Fax: (31) 29-441-5054. AUSTRALIA: Tower Books Pty. Ltd., Unit 9/19 Rodborough Road, Frenchs Forest, Sydney, New South Wales, Australia. Fax: (61) 2-9975-5599. NEW ZEALAND: Southern Publishers Group, 22 Burleigh Street, Grafton, Auckland, New Zealand. Fax: (64) 9-309-6170. INDIA: TBI Publishers, 46, Housing Project, South Extension Part-I, New Delhi 110049, India. Fax: (91) 11-461-0576.

Aperture Foundation is registered with the International Photography Council as a charity with the Charity Commissioners for England and Wales.

For international magazine subscription orders to the periodical Aperture, contact Aperture International Subscription Service, P.O. Box 14, Harold Hill, Romford, RM3 8EQ, United Kingdom. One year: $50.00. Price subject to change. Fax: (44) 1-708-372-046.

To subscribe to the periodical Aperture in the U.S.A. write Aperture, P.O. Box 3000, Denville, New Jersey 07834. Toll-free: (800) 783-4903. One year: $40.00. Two years: $66.00.

First Edition
10 9 8 7 6

Table of Contents

India is written across my heart. My father accompanied the Prince of Wales, later Edward VII, on his Indian tour of 1875—76. My elder brother accompanied King George V to the Delhi Durbar on his tour of 1911—12. Both have left accounts, sketches, and photographs which roused my interest in this fabulous country.

I accompanied the Prince of Wales, later Edward VIII, to India in 1921—22 and became engaged to my wife, Edwina, in Delhi, barely a decade after many of these photographs were made. From 1943 to 1946 I had my rear headquarters in Delhi as Supreme Allied Commander in Southeast Asia. In 1947 I went out as the last Viceroy to find a way of transferring power to India. After independence the Indians invited me to stay on as their chosen head of state, the Constitutional Governor-General.

I am delighted to find such a unique collection of early photographs so beautifully presented showing the glory and the poverty of the subcontinent. I hope they will stimulate people into taking a deeper interest in India, not only its past history but its all-important future.

Mountbatten of Burma

Victoria never went there. But no part of her Dominion mirrored so expansively her England and her world. She became absorbed into Indian life, as India became absorbed into hers. "India should belong to *me*," she wrote, after the Mutiny of 1857. Thirty years later, she was studying Hindustani, eating Indian curries, and exclaiming that at last she was in "real contact" with the people of India.

India had once been a wild and faraway place, but in Victoria's reign the steamship and the Suez Canal made it less remote. Yet despite its new accessibility India remained exotic, mysterious, a land of poverty and splendor; a land as much of fantasy as of reality, maintaining one of the oldest continuous civilizations, deeply shaping all Indo-European peoples. Somehow, in the miles that separated India and England, the starvation and suffering became transmuted into money—money that put the shine of polish on British boots and paisley shawls on English shoulders.

India was a dream that invaded English consciousness: the Black Hole and Lucknow; Kipling's tales of Simla and Anglo-Indian life; the Vedas, the Upanishads, and the two colossal epic poems the Mahabharata and the Ramayana. The dreams of India lingered on in bungalows and verandahs, in cool shade and the swinging punkah. In the prototypes of ice cream and air-conditioning. Pyjamas and rattan rather than whalebone and mahogany. And gin and tonic.

The British brought England with them, leaving village cricket greens and ivy-covered church towers in their hill stations and a taste for pig-sticking, badminton, and polo. And the statues of Victoria. And even now when the port goes round in the officers' mess of the Indian or Pakistan army, there are still the British uniforms and the Sam Browne belts.

Long after the Empire, the images and shadows of Victorian India endure—a lasting moment in four thousand years of Indian life.

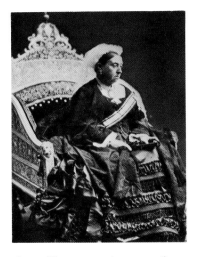

Queen Victoria, seen here upon the ivory throne presented to her by the Maharaja of Travancore.

Photography in British India, 1855–1911

Photography came to India in the 1840's, and photographers adopted the mores and conventions worked out by generations of British artists, who had visited the Indian subcontinent since the late eighteenth century. By the 1850's, the photographer had adopted not only the subjects and clichés of the artist in India, but also the artist's sources of patronage and employment.

It is to the eighteenth century and specifically to the Grand Tour that one owes the photographic conventions of the nineteenth century. Three generations before the invention of photography, men

and women of taste returned to Britain, senses stuffed with the ideal European naturalist landscapes by painters such as Ruysdael, Hobbema and their fellow Britisher, Constable. What these discerning tourists discovered was radical and different ways to appreciate nature—a realization that the artist can fuse nature to observation. Landscape had unique, even magical qualities, and through painting one could understand nature. There was a significance even more elevated: through painting, through art, one could appreciate beauty. The phrase that came to describe this ecstatic condition was "the picturesque."[1]

Between 1782 and 1809, Dr. William Gilpin published a series of small guides relating to the production of "picturesque" scenes. Transported to India, his canons were often applied to photography.

According to the Doctor, nature may have been sublime, but it had to be organized. Every picture must have a background, a middle ground and a foreground. For each individual element, he detailed a particular formula: lakes and mountains were good for backgrounds; middle distance should be filled with convenient valleys and woods, though a river would do equally well; and he was partial to leafy plants, rocks, ruins or waterfalls for the foreground. A background had to have soft mists and clouds. Roughness was important in rocks and mountains. Water should always sparkle. The picturesque production of the artist must always have groups of figures, either animals or people, to establish scale.

In 1786, there arrived in India two professional artists who were to define the way the English viewed both the "picturesque" and the exotic on the subcontinent—through sketching and painting the Indian interior, much of it never before visited by professional European artists.

At Delhi and Agra, Thomas Daniell and his nephew William sketched the tombs, ruins and forts, aided at times by the camera obscura, which helped them with difficult perspective and architectural details.[2] The Daniells spent April of 1789 in the lower Himalaya, and were probably the first Europeans to penetrate Garwhal. In 1792, the artists moved to southern India, and began their second great tour.

The Daniells must be credited with opening India to an English public eager for views of this strange land. Upon their return, they published *Oriental Scenery*, issued serially between 1795 and 1808. A massive work, it contained 144 large aquatints. The curious public demanded more, and in 1810 the Daniells published an additional fifty illustrations entitled *A Picturesque Voyage to India*,

"Disputes about beauty might perhaps be involved in less confusion, if a distinction were established . . . between such objects as are beautiful, and such as are picturesque—between those which please the eye in their natural state; and those which please from some quality capable of being illustrated by painting." — *William Gilpin*, Three Essays on Picturesque Beauty or Picturesque Travel, *1808*

Thomas Daniell and William Daniell (1769–1837): Ruins at Monea: *aquatint, illustration from* Oriental Scenery.

by Way of China. This work was also well received, and for the rest of their lives the two artists continued to mine the rich vein of material they had gathered first as field sketches in India.

While the Daniells were working privately, the East India Company was seeking topographical data to further develop the profitable Indian trade. In 1783, the firm commissioned Colin MacKenzie to survey southern India.[3] A scholar, engineer, surveyor and amateur artist, MacKenzie, together with his meager staff, in the process of map-making, also compiled information related to geography, history, life styles, religion, antiquities, forests, mines, implements and the common and fine arts.

In 1815, MacKenzie was made Surveyor-General of India. His work served to set the tone of the East India Company's involvement in a whole range of government-sponsored projects and eventually the hiring of photographers on a similar basis.

In response to an appeal from the Royal Asiatic Society regarding the dilapidated state of the Ajanta caves, the Madras establishment in 1846 released Captain Robert Gill from active military service to make oil paintings to the scale of the Buddhist frescoes.[4] Gill devoted the rest of his life to this task—working even when ill with fever and dysentery, and surrounded by hostile Bhil aborigines. Living alone at the Buddhist caves with his Indian mistress, Gill began to make sketches for oil paintings of the frescoes, damaged by moisture and vandalism. These paintings were enthusiastically received at the Crystal Palace exhibition of 1851, and all but five of the paintings were destroyed when the glass-and-iron building burned in 1866.

In the 1850's, the Madras Government supplied Gill with a camera, and by the middle of the decade he was an active correspondent with the *Journal of the Photographic Society of Bombay.* After the publication of a book of Gill's stereographic views, the Bombay Government in the late 1860's equipped him with a specially made rectilinear lens made by Dallmeyer of London and an 8 x 10 camera.[5] The wide-angle lens with short focus enabled Gill to take photographs in the confined quarters and narrow entrances of the unique Hindu caves at Ellora. At one point in his correspondence with the Bombay Photographic Society, Major Gill suggested a way to solve his photographic dilemma at Ellora; he would work from a balloon suspended in front of the caves.

The introduction of the daguerreotype, and later of Fox Talbot's calotype process, eroded the position of the professional artist in India. In the late 1840's, the *New Calcutta Directory* listed four professional portrait painters active in Calcutta. By 1849, F. Schranzhofer opened the first recorded

Robert Gill, photographed in front of the Ajanta Caves.

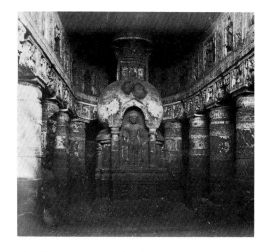

The Ajanta Caves, interior view.

professional photographic studio in India. Individuals such as Fred Fiebig, an artist and lithographer who had produced *A Panorama of Calcutta in Six Parts* in 1847, switched professions and became photographers. In the Georgian mansions of the British nawabs, and in the palaces of Indian princes, photography supplanted miniature painting—both the native and the imported European varieties. By the middle of the nineteenth century, not one commercial portrait painter was listed in the *New Calcutta Directory*.

In 1855, the British East India Company replaced draftsmen with the more efficient photographer. Men like Major Gill at Ajanta had been supplied with cameras, and, before the Mutiny of 1857, the Presidencies of the states of Bombay and Madras had sponsored photographers in the field. Catalogues of the prints available from great commercial photographic firms of the 1870's and 1880's—firms such as Bourne & Shepherd, Johnston & Hoffman, Burke, Saché, T. A. Rust—reflected the growing number of photographers and the diversity of subjects, both government and commercial photographers adopting the mores and patronage of the painters who had preceded them.

The difficulties faced by the Victorian photographer seemed insurmountable. In addition to the problems of dampness, rot, heat, bad chemicals and inadequate supplies of water,[6] the photographer had to cope with one further dilemma: the Pacific and Orient steamship line would not transport collodion to India because the active ingredient of the solution was also the explosive ingredient of smokeless gunpowder! Whether government-sponsored, commercially backed or simply a dedicated amateur, the photographer of the 1850's needed the sensitivity of an artist and the constitution of an ox.

On Tuesday, October 3, 1854, the first Indian photographic society was founded in Bombay. It held its inaugural meeting in the rooms of the Geographical Society at the Town Hall, and Captain Harry Barr, a local photographer, was named president. By 1855, the Photographic Society of Bombay had over 250 members. Not to be outdone, Bengal and Madras established similar societies one year later.

Encouraged by the growing popularity of photography in Bombay, the Photographic Society allowed Messrs. Merwanjee Bomonjee & Co. (photographic importers) to publish in 1856 *The Indian Amateur's Photographic Album* produced by William Johnson, a founding member of the Society, and W. Henderson. After the publication of at least thirteen issues of the album, which

The Wet-Plate Process: *Frederick Scott Archer, who made the first collodion negatives in the autumn of 1848, published his discovery in 1851. The process became so popular that it virtually replaced the daguerreotype and calotype, and was almost exclusively used between 1851 and 1885, when the mass-produced gelatin dry plate caught on. In the wet-plate process, a glass plate replaced paper as the support base for a light-sensitive emulsion. A solution of collodion and potassium iodide was poured onto the glass plate and allowed to flow evenly over the surface. When it became tacky as the ether solution evaporated, the plate was dipped in a solution of silver nitrate. The wet plate was then placed in the camera for exposure of one to sixty seconds, and the resulting still-wet negative developed with pyrogallic acid and fixed with hyposulfite of soda. After the negative was dried, it was coated with a layer of varnish to preserve the fragile plate. The process was both cumbersome and delicate, but it was valued for its structureless film frame, extremely fine grain and clear whites.*

Illustration from nineteenth-century catalogue, view camera of the period.

4

detailed native tribes and types, William Johnson, a member of the Bombay Civil Service, went on to expand this work into a volume published in 1863 containing sixty-one photographs—*The Oriental Race and Tribes: Residents and Visitors of Bombay.*

In its first year of operation, the Photographic Society of Bombay collected a remarkable group of correspondents and local members: Local Members such as J. W. Robertson, A. Robertson, W. Johnson, W. Henderson and Captain Barr; Corresponding Members such as Major Gill of the Madras Army, Dr. Pigou and Captain Briggs of the Bombay Army.

John McCosh, the first war photographer in Asia, appeared on the Indian scene as second assistant Surgeon-General in the Bengal establishment's medical department in 1831. McCosh's second campaign was the Gwalior War of 1843–44. In 1844, his regiment moved to the hill station of Almora in the lesser Himalaya, and it is probable that he took up photography during this posting. In late 1847 or early 1848, Mr. Vans Agnew sat for Dr. McCosh, presumably before his departure from Lahore on March 31. His subsequent murder in April in Multan by the Diwan Mulraj precipitated the Second Sikh War.[7] This portrait of Agnew is the earliest photograph attributed to an individual photographer of the period. In addition, McCosh was the first European war photographer—all of his photographs having been taken during Indian campaigns.

British officers, photographed by John McCosh.

Throughout the 1850's, interest in photography increased. The East India Company began to subsidize photographers: Dr. Pigou and Captain Biggs of the Bombay establishment worked in western India; a Captain Linneaus Tripe was in Madras photographing architectural monuments of south India for the government. In 1853, Dr. J. Murray, principal of the Medical School at Agra, had forty-four of his paper negatives of Allahabad, Benares, Cawnpore and Delhi developed and printed by the School of Industrial Art in Calcutta. In 1858, thirty of Dr. Murray's best prints (17″ x 13″) were issued in book form.

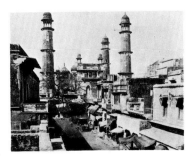

Street scene, Benares, photographed by Dr. J. Murray.

There began a spate of photographically illustrated books when R. B. Oakley photographed *The Pagoda of Hallibeed,* issued in a limited edition of twenty-five copies in 1856. Each of the photographers mentioned, with the exceptions of Dr. McCosh and Captain Barr, produced such illustrated books.

Detail of Hindu sculpture, photographed by Capt. E. D. Lyon.

The East India Company developed a style of photography which was documentary, recording military expeditions as well as topographical surveys, public works projects, famine relief works, archaeological surveys and diplomatic embassy commissions.

The precursors of the archaeological survey were three military men—Captain Linneaus Tripe, Captain T. Biggs and Captain E. D. Lyon. They are curiosities because they survived the violent Sepoy Mutiny of 1857 all the while photographing architecture.

Linneaus Tripe was delegated in 1855 as the "Official Photographer" to the British Mission to the Court of Ava, Burma. He took the first photographs ever made of upper Burma, in spite of ill health and bad weather limiting his photographic activities to only thirty-six days. In 1857, he published his Burmese photographs for the Madras Photographic Society. His double-plate photograph of the city of Prome may be the earliest such photograph ever taken, though its real importance is as a document. Prome, one of the most ancient of Asian cities, predated the Christian era but was destroyed completely by fire in 1862, seven years after Tripe's visit there. Working with his outdated calotype camera, Tripe managed to produce 120 photographs of Burmese monasteries, cityscapes and places of Buddhist worship—all seeming to glow under Tripe's black-flecked, granular skies.

Tripe was unique among the many military photographers active in India in the nineteenth century because of the ten books he published between 1857 and 1858. These books contained over 300 photographs, ranging in size from a stereoscopic format to large 12″ x 15″ plates.

At the same time Tripe was working in Burma, the Bombay Government notified the East India Company that "Captain T. Biggs of the Bombay Artillery, assisted by a small establishment had, subject to the confirmation of the Government of India, been appointed to the special duty of taking copies by the photographic process of the ancient sculptures and inscriptions in Western India."[8] A member of the Bombay Photographic Society, Biggs had been presented in 1854 with a photographic kit capable of making pictures 15″ x 12″ and a set of Ross's single and double lenses. Captain Biggs's assignment was the Muslim architectural monuments at Bijapur and Ahmedabad— work that was interrupted by the Mutiny of 1857. His place was taken by Dr. W. H. Pigou, who died while photographing the sites.

Subsequently, following the Mutiny, Biggs returned. Pigou, and A. C. B. Neill, who succeeded him in Mysore, were published by James Fergusson, the great Indian architectural historian, in a series of massive volumes printed in the 1860's.

In the Sixties, the Viceroy, Lord Canning, became the major patron of photography in India, and his wife, Lady Canning, the patroness of both the Bengal and the Madras photographic societies.[9] Lord Canning sought to create a pictorial record of Indian life and culture. He encouraged army

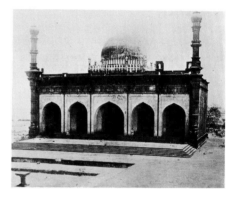

Mosque façade, photographed by Capt. T. Biggs.

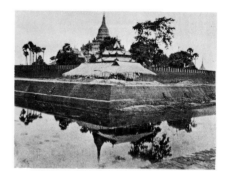

Burmese temple, photographed by Linneaus Tripe.

officers and civilians to assemble collections of photographs depicting life on the subcontinent. The direct result of his rule was that by 1865 the India Office in London had received over 100,000 prints and established a photographic department under J. Forbes Watson. Between 1868 and 1875, Watson and J. K. Kaye brought out eight volumes of *The People of India,* containing the work of over fifteen photographers including Shepherd, Robertson, Waterhouse, W. W. Hooper and Dannenberg. When the publication of *The People of India* was completed, the volumes contained 468 photographs and had the distinction of being one of the first major ethnographic studies produced by the camera.

Lord Canning influenced photography in another important way. Following his appointment of General Alexander Cunningham to head up the centrally directed Archaeological Survey, he urged the Survey to use photography to complement the usual scale drawings made during archaeological field operations. After nearly a decade of frustration in trying to put together a photographic catalogue of the subcontinent's antiquities, the Archaeological Survey finally managed in the early 1870's to persuade the Government of India to accept the employment of professional photographers. By the 1870's, the camera had become the indispensable tool of the archaeologist, and the Survey employed over twenty-eight photographers during its formative periods.

Some of the most significant work of this period was done by Captain E. D. Lyon in Madras during the late 1860's. Formerly of the 68th Foot, Captain Lyon was hired by the Government of Madras to photograph the ancient monuments of the Madras area some ten years after the pioneering work of Tripe. Lyon took over 300 photographs, using the collodion process with Dallmeyer's wide-angle and triplet group lenses. His greatest photographic achievement was lighting south Indian corridors, some of them as long as seven hundred feet, with massed banks of reflectors. Captain Lyon produced these photographs under extremely difficult conditions, and the work when it was exhibited at the Photographic Society of London in 1869 was said to contain great "tenderness and delicacy."

In 1855, the Military Department used the camera to record the building of a barracks; in 1856, the camera explored possible routes and gradients for railway construction; in 1858, the 23rd Company of the Royal Engineers used the camera as an ordinary part of their equipment. Before 1862, Captain Melville Clarke, of the 1st Cavalry, made photographs of his travels to the borders of Tibet through north India, subsequently published in *From Simla through Ladac and Cashmere.*

Lord Canning was Governor-General, and then Viceroy, as the Government of India was transferred from the East India Company to the Crown after the Mutiny of 1857. Both Lord and Lady Canning were fans and patrons of photography at a decisive moment.

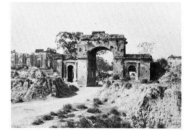

Gateway, photographed by Bourne and Shepherd.

Between the Indian Mutiny in 1857 and the death of Victoria in 1901, the Indian Army fought over twenty wars.[10] Curiously, it was not the hundreds of military photographers active in nineteenth-century India who took memorable photographs of these continuous vicious wars but two commercial photographers: Felice A. Beato and John Burke.

In 1858, Felice A. Beato turned up in India. He photographed the aftermath of the Mutiny — military groups, bullet-scarred walls and blown-out battlements, corpse-littered courtyards and the hangings of mutineers.[11] He operated a commercial establishment in Calcutta, working as A. Beato, as he was listed in the *New Calcutta Directory* in 1859. In the early 1860's, he moved on to China and photographed the last Opium War.

In India during the nineteenth century, John Burke came closer than any other photographer to capturing the pictorial elements that Kipling and later Yeats-Brown in *Lives of a Bengal Lancer* celebrated as the British Presence on the Northwest Frontier. Without the work of Burke, the public, let alone the great writers of the period, might not have been able to visualize the epic British military operations along the frontier from the 1870's to the turn of the century.

From the late 1860's to 1907, John Burke worked in the Punjab, specializing in photographs of military groups and military operations. He provided a view of British cantonment life — the pig-sticking, tiger-shooting, durbars, military reviews, the trades and occupations within the army — as well as glimpses of hostile tribal enclaves along the frontier, portraits of native and English chiefs, and, in the days of crumbling diplomacy, scenes of the "vicious little wars of retribution."

In the late 1860's, Burke made a record of the archaeological sites of Kashmir for the Superintendent of the Archaeological Survey, North-Western Provinces, Lt. H. H. Cole — work that was later published in 1869 in Cole's *Illustrations of Ancient Buildings in Kashmir.* Burke did his most important work from 1878 to 1880, during the Second Afghan War.

Because of the slowness of the plate process in the late 1870's, Burke was not able to photograph actual battles. However, on December 23, 1879, he photographed the preliminaries of what is perhaps one of the greatest forgotten moments in Victorian India. At the British redoubt at Sherpur, inside which Burke worked, General Robert's 5,000-man force repulsed an attack of 100,000 Afghans. The British loss totaled eleven men killed against Afghan losses of over 3,000.[12]

Between 1860 and 1890, commercial photography firms in India took over the tradition of the work

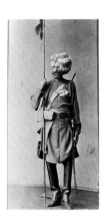

Napoleon had revived the use of the lance for his front-line troops, but no lancers gained as much romantic fame in the nineteenth century as the Bengal Lancers — their costumes a pastiche of European and Indian military styles.

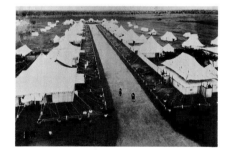

The British Army used the same plans for military encampments that the Romans had brought to Britain, just as today many vestiges of the British Army remain with the Indian Army.

8

done by men like the Daniells, professionals who specialized in views of the picturesque and the exotic. A list of the views available from the commercial photographers in Calcutta and Bombay recapitulates almost exactly the sites visited by the first illustrators to visit the subcontinent a hundred years before.

The number of commercial "view" firms working in just one city in India seems surprising in retrospect. In 1899, there were twenty-four such establishments in Bombay; Madras had another six firms; Calcutta, ten.[13]

By the 1870's, there were commercial photographers in every large city in India. There even developed a specialized photography of ladies in purdah. A Mrs. Garrick opened a zenana studio in Calcutta for purdah photography, a female photographing females who could not be exposed to male company. In 1882, Lala Din Dayal, photographer to H.H. the Nizam, announced "the opening of a zenana studio he has fitted up at Hyderabad. He has placed an English lady of high photographic attainments, and well known there, in charge of it."

The stock-in-trade of firms such as Bourne & Shepherd, Johnston & Hoffman, T. A. Rust and John Burke was not just portraits or wedding photographs. Johnston & Hoffman provided studies of the teak, jute and tea industries, as well as a series of archaeological photographs that the *Encyclopaedia Britannica* still makes use of a hundred years after they were taken; Burke concentrated on photographs of the army and the Northwest Frontier; T. A. Rust, on the people and scenery of the lesser Himalaya; Bourne & Shepherd, on scenic views of Mughal monuments, military groups and native castes, with plates of Kashmir and the higher Himalaya their specialty.

One survivor of the fierce competition among the commercial photographers, and perhaps one of the oldest photographic firms still active in the world today, is an establishment founded in the nineteenth century in India. The firm, Bourne & Shepherd, was formed in 1862 at Agra by Arthur Robertson and Charles Shepherd, and through several permutations eventually acquired its present name. It was in the work of Bourne, however, that the outlook of the firm was shaped, and it became known as the definitive purveyor of nineteenth-century Indian views.

Samuel Bourne arrived in India in 1863. He remained in India only seven years. In that period, during three trips into the higher Himalaya along the Tibetan frontier, he made a legend of his excursions, which he described in a series of long letters to the *British Journal of Photography*.

Bourne's patience was remarkable. It was not unusual for him to wait a day or two by the road to

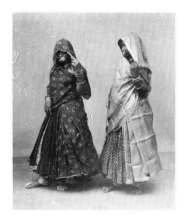

The British outlawed a few customs such as sati — the ritual suicide of the widow on the funeral pyre of her husband — on humanitarian grounds, but in general they interfered very little with social and religious practices. Such customs as purdah — the system of seclusion of women in India — were only gradually affected by Western ideas.

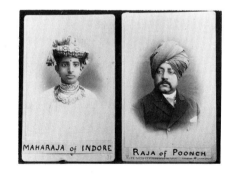

The carte de visite was one of the major artifacts of Victorian life — the stock in trade of the commercial photographer, who supplied them in visiting-card as well as larger sizes to his customers.

obtain a photograph, or an effect he wanted. August of 1863: "On one occasion I waited six days rather than leave two remarkably fine pictures, or take them under unfavorable circumstances." During his trip to the Scind valley above Kashmir, Bourne had waited a full three weeks, camped by himself, for the wind to die. It did not, and Bourne never got the views he wanted.

Portrait photography did not interest Bourne, and he used people only to indicate scale. It was in the construction of his carefully realized landscape photographs that he excelled, and in his letters he seemed obsessed with finding water for his fore- and middlegrounds. His landscape photographs won medals at both the Dublin and Paris international exhibitions, as well as two gold medals offered by the Bengal Photographic Society in 1865. Like many of his contemporaries, Bourne had been an artist before he became a photographer, and his letters demonstrate his continuing concern with color, gradation and, above all, scale.

In his next-to-last communication with the *British Journal of Photography,* Bourne added one final, visionary observation. In it, he accurately predicted the demise of commercially produced large-format views and the death of the tradition that started with the Daniells such a long time before. When the gelatin dry plate was introduced, photographers abandoned the oversize collodion wet and then dry plate cameras. About this, Bourne wrote:

. . . when people are blacking their fingers and spending their cash in photography, why not aim at something that shall be worth looking at when it is finished . . . I take it that *one* good large picture that can be framed and hung up in a room is worth a hundred little bits pasted in a scrap book . . . [14]

Those "scraps" marked the end of an era in Indian photography.

Clark Worswick

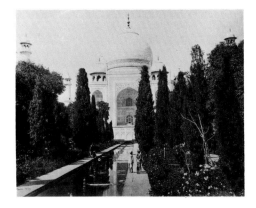

Samuel Bourne: *Taj Mahal,* Agra.

About his equipment, Bourne wrote in the British Journal of Photography in 1864: *"My photographic requisites consisted of a pyramidal tent ten feet high by ten feet square at the base, very simple in construction, having merely a bamboo rod at each of the four corners, and opening and closing like an umbrella . . . My stock of glass consisted of 250 plates 12 x 10, and 400 plates 13 x 8 . I had two boxes of chemicals divided into compartments, each bottle fitting into its own compartment — one box being a duplicate of the other—so that if one should 'come to grief' down some precipitous mountain, I might have the other to fall back upon. One box contained my two mounted glass baths, which were absurdly heavy, camera top, and sundry little loose articles. Another contained four Winchester quart bottles — two for bath solutions, one for spirits of wine, and the other for distilled water. In all, my photographic requisites formed about twenty loads; the remainder consisted of personal baggage, tents, bedding, batterie de cuisine, hermetically-sealed stores, a good supply of Hennessey's brandy, in lieu of 'Bass' and 'Allsopp,' sporting requisites, books, camp furniture, etc., etc. When starting on a ten or twelve months' journey like this it is advisable to take as many portable luxuries as possible (as I afterwards found), seeing that I was sometimes for two months in some solitary and remote district without ever seeing a European, talking nothing and listening to nothing the whole time but barbarous Hindostani, and a hundred local compounds of the same. When everything was packed and ready I found that I should require forty-two coolies! —quite a little army in themselves."*

Photography in British India, 1855–1911

Felice A. Beato: *The Sikh Horse Regiment, Lucknow, During the Indian Mutiny,* March, 1858.

Lt. H. C. Meecham and Assistant Surgeon Anderson are photographed with Sikh cavalrymen, loyal to the British during the Mutiny.

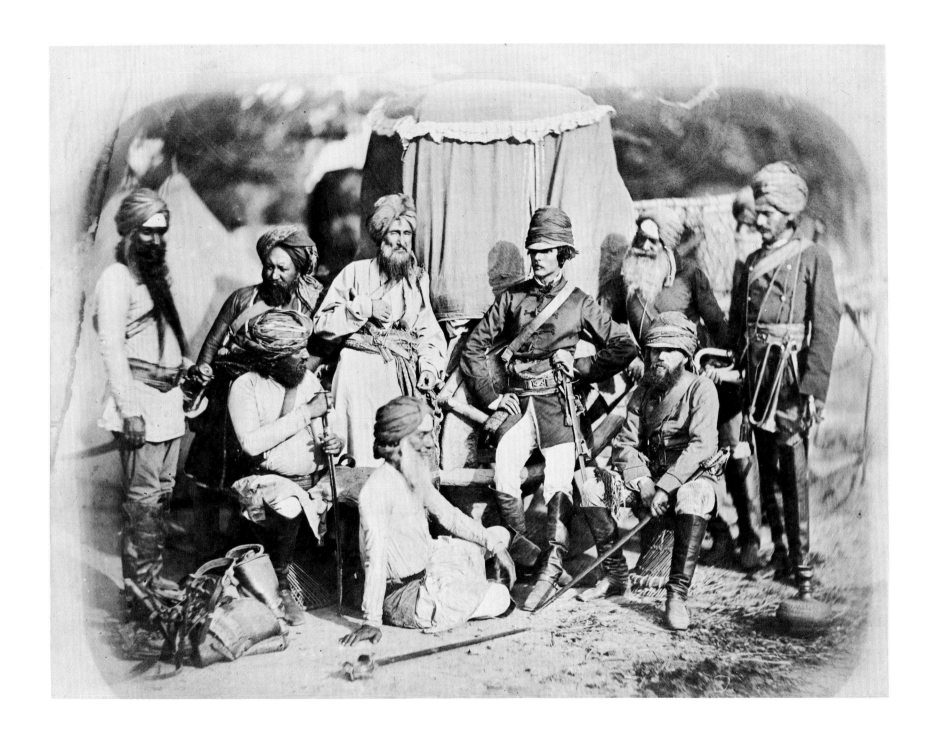

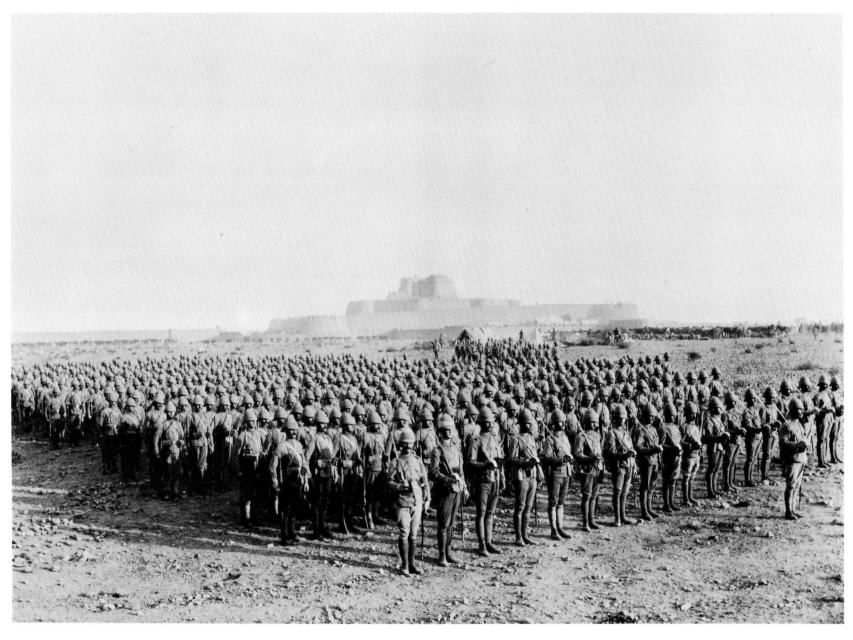

Photographer unknown: *The Tirah Expeditionary Force, Derby-shire Regiment, 1st Brigade,* 1897.

When tribal insurrections broke out in 1897, the Khyber forts overwhelmed and the forts at Chakdara and Malakand attacked, the British put 60,000 men in the field—eventually pacifying the frontier.

John Burke: *"Guides" Officers,* Kabul, 1879.

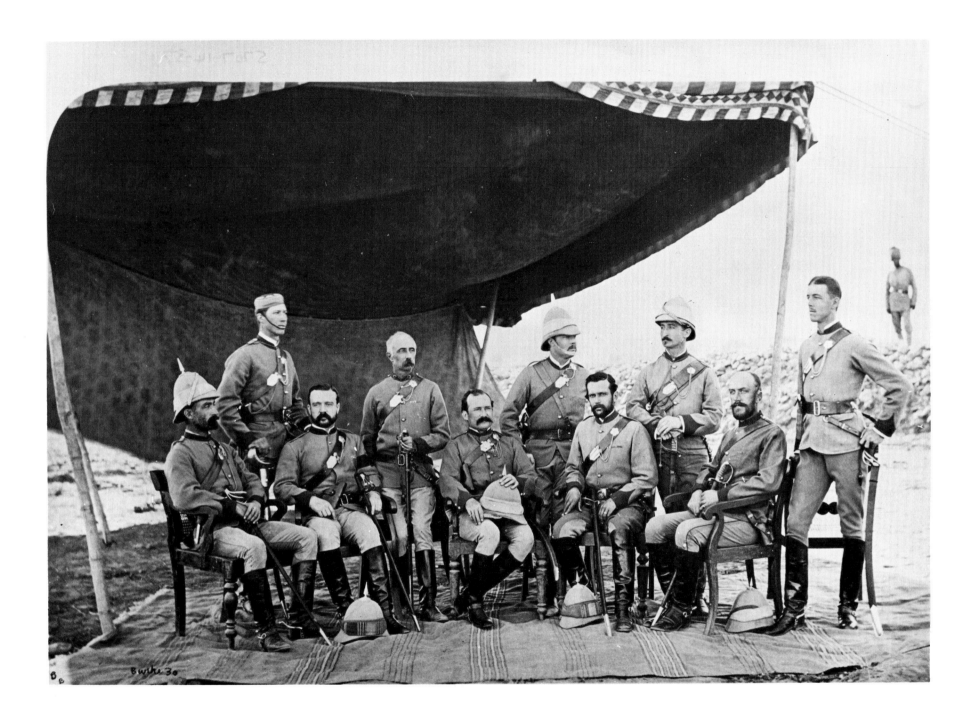

15

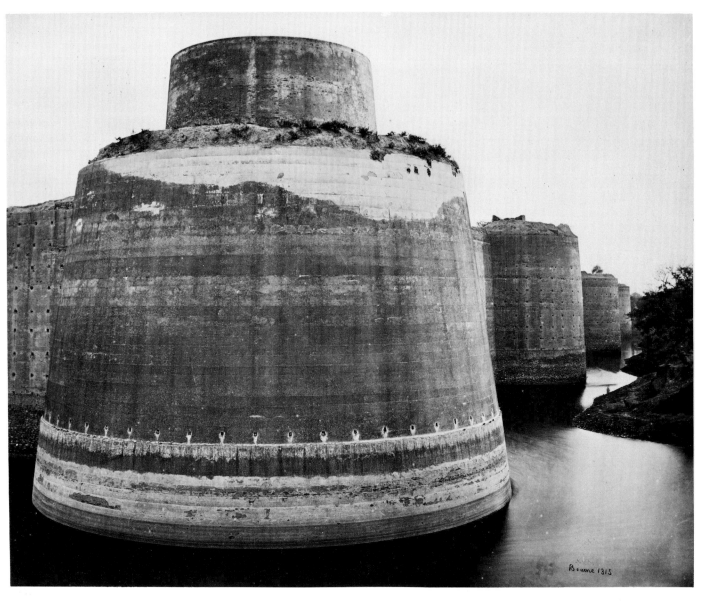

Samuel Bourne: *Deig Fort, from the Northwest*, 1865, Item 1315 in the Bourne & Shepherd catalogue.

Photographer unknown: *The Red Fort, Agra: The Great Court Piled with Cannon and Shot*, 1862–65.
Here, in 1609, the first British Ambassador to the Mughal Court came to petition the Emperor Jehangir for permission to build an English factory on the western coast of India. After the Mutiny of 1857, the British used the courtyard of the audience hall as an artillery park.

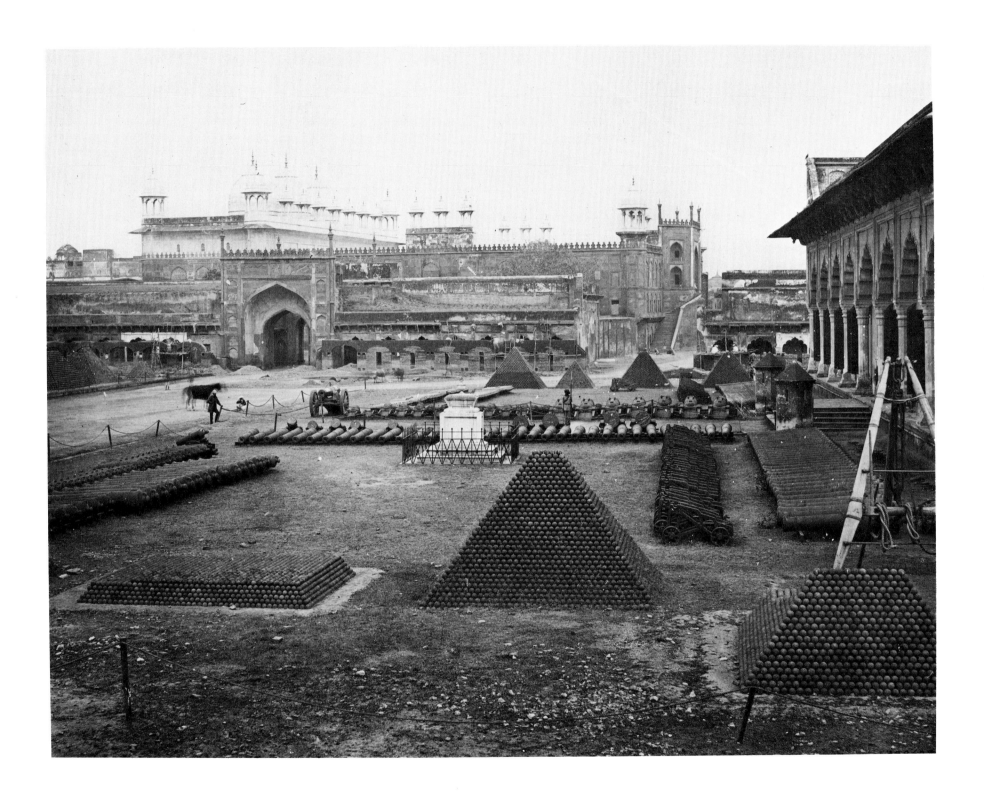

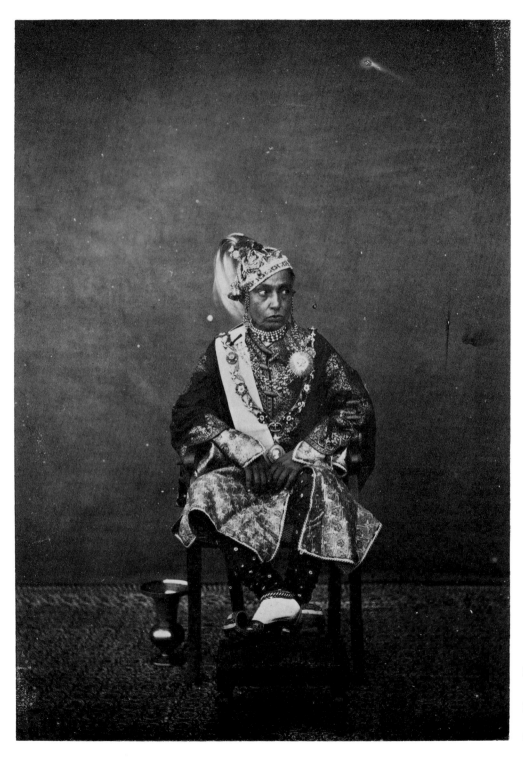

Photographer unknown: *H.H. the Begum of Bhopal,* 1860's.
 The Begum was one of the few ruling women in India.

Photographer unknown: *9th Lancers,* June, 1860.
 Left to right: Lt. Bell-Martin, Lt. Thursby, Capt. Marshall,
Capt. Fawcett and Lt. Pretor.

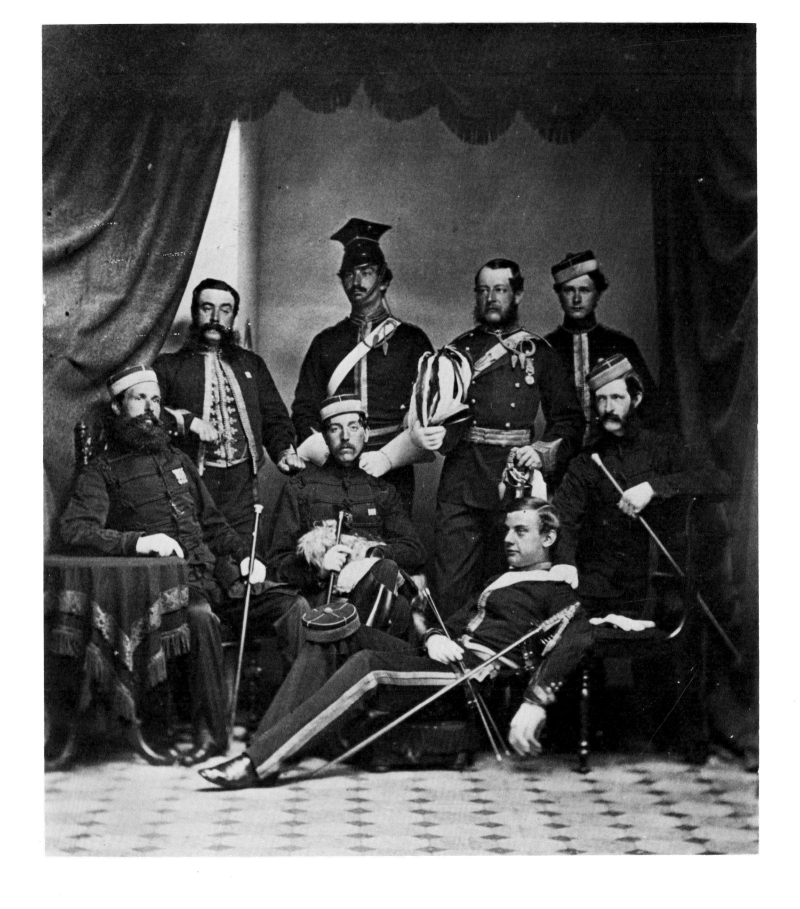

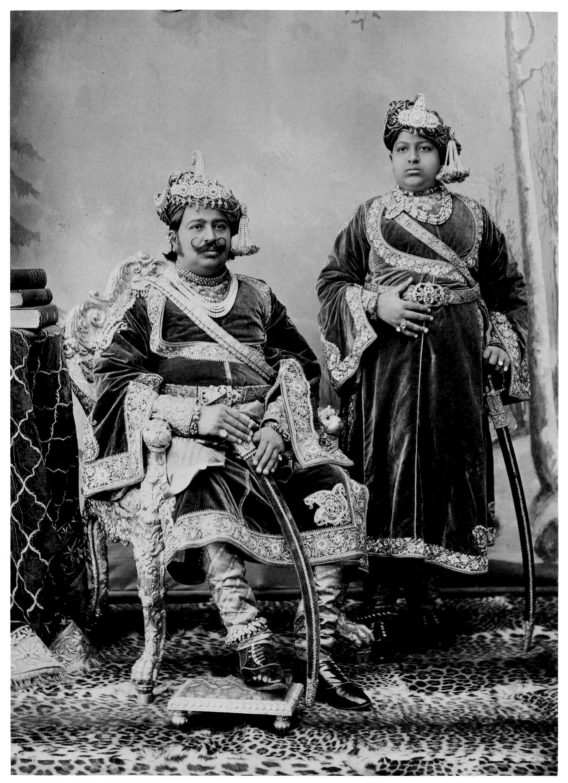

Photographer unknown: *The Raja of Bansda and the Heir Apparent,* 1880's.

The Raja had 35,000 subjects and ruled a state 348 square miles in area.

Photographer unknown: *Imperial Cadets,* 1905.

The corps, with their white and sky-blue uniforms faced with gold, was formed of the sons of Indian nobility to act as an honorary bodyguard for functions such as the coronation durbars of both Edward VII and George V in Delhi.

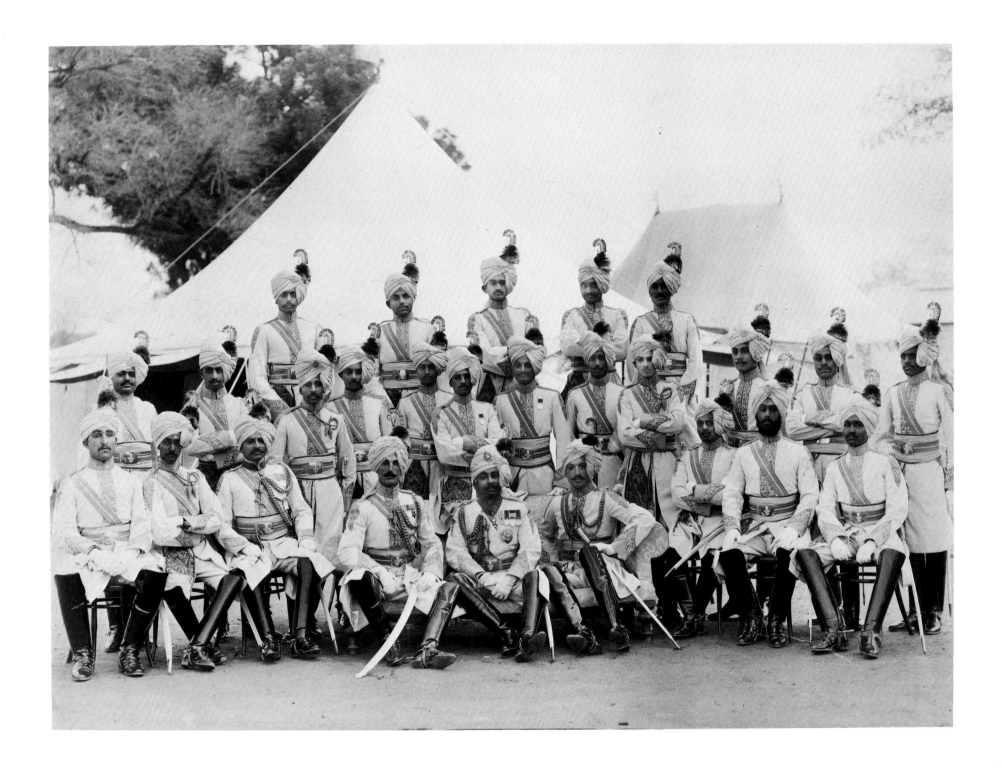

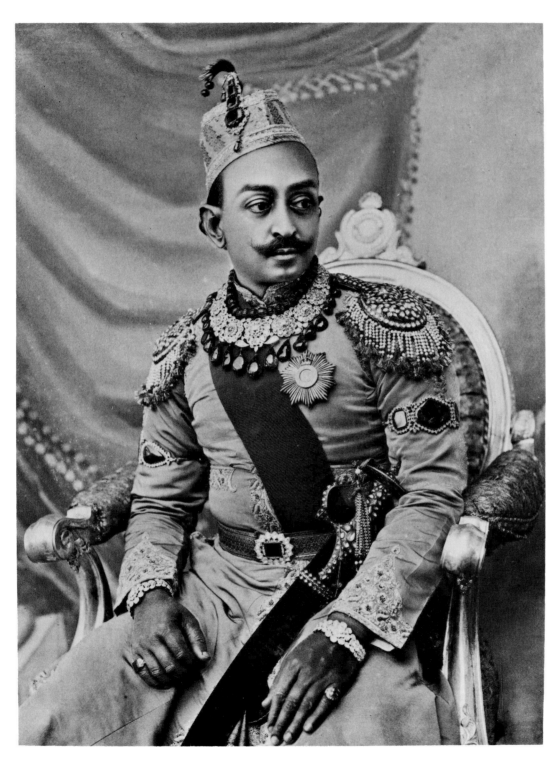

Photographer unknown: *Maharaja of Benares.*

John Burke: *Native Officers, "The Guides,"* 1890's.
 The "Guides" were the elite of the Indian Army. Founded by Harry Lumsden in the 1840's, and including all the wild and warlike tribes of upper India, the "Guides" were the first regiment in the world to adopt the khaki uniform.

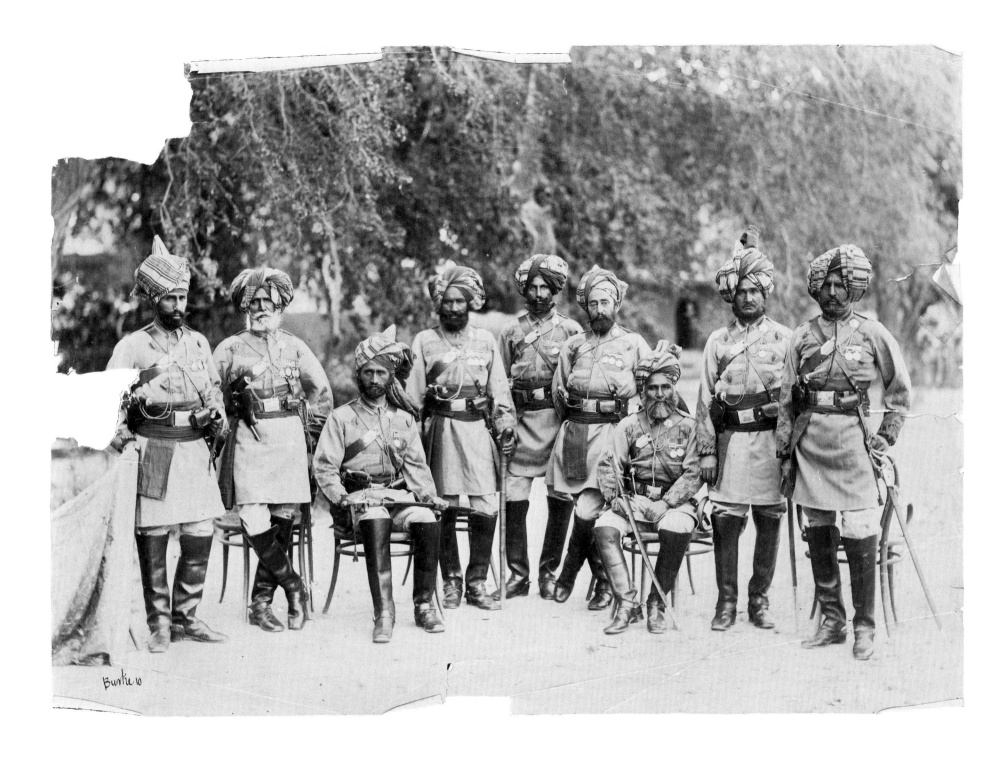

Burke 10

23

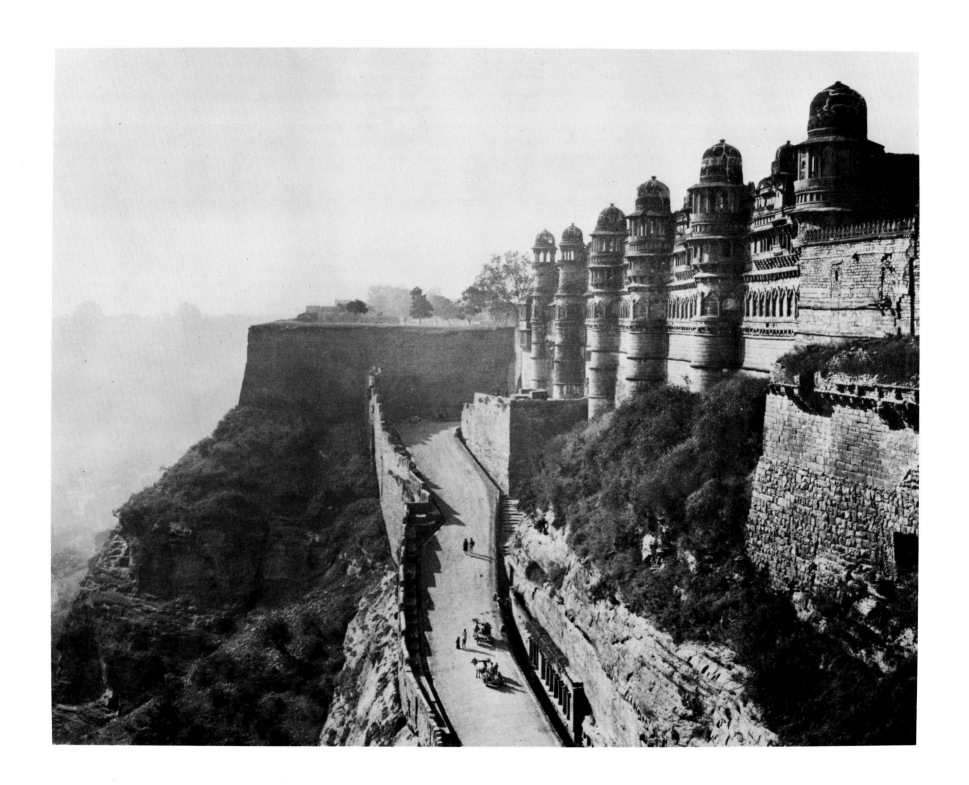

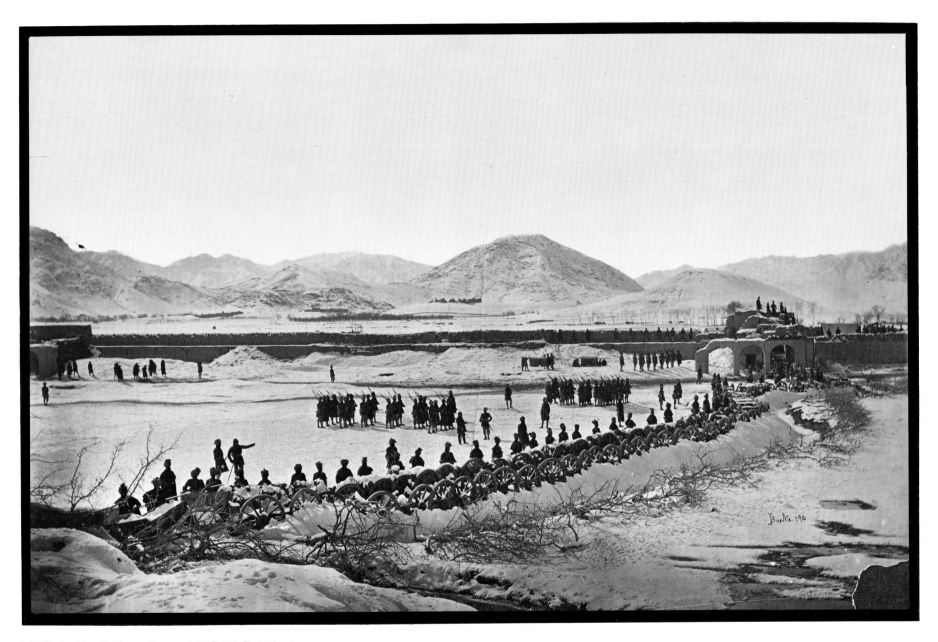

John Burke: *The Northwest Corner of the British Redoubt at Sherpur,* December 20, 1879.

The day after Burke took this photograph, 100,000 Afghans attacked the 5,000-man British force at Sherpur. Commanded by Gen. F. S. Roberts J.C., the Afghans were driven off with a British loss of only eleven men.

Photographer unknown: *The Principal Entrance of Gwalior.*

During the Mughal period, the fortress at Gwalior was used as a royal prison.

John Burke: *Regimental Group,* Kabul, 1879.

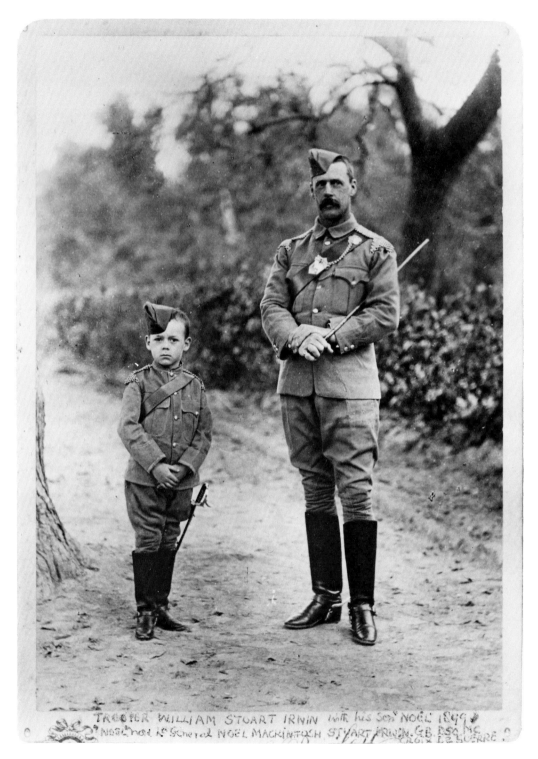

Photographer unknown: *Trooper Irwin with His Son Noel,* 1899.
 The inscription on this photograph reads: "now Lt. General
Noel McIntosh Stuart Irwin, M.C., D.S.O., C.B., Croix de
Guerre."

Photographer unknown: *The Residency,* Shillong, 1891.

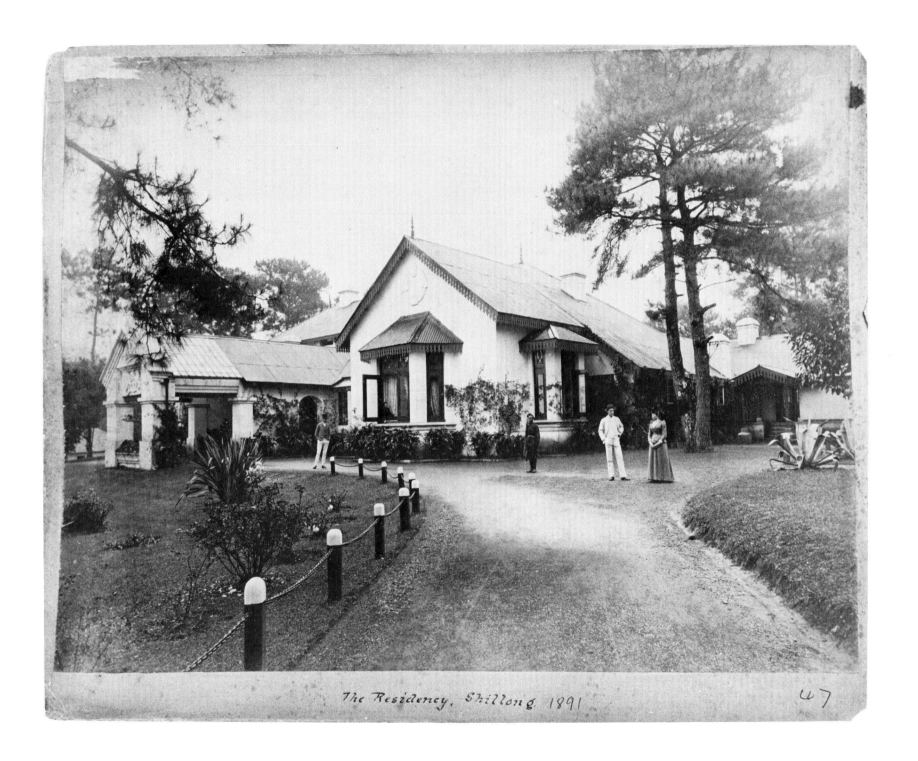

The Residency, Shillong 1891

47

29

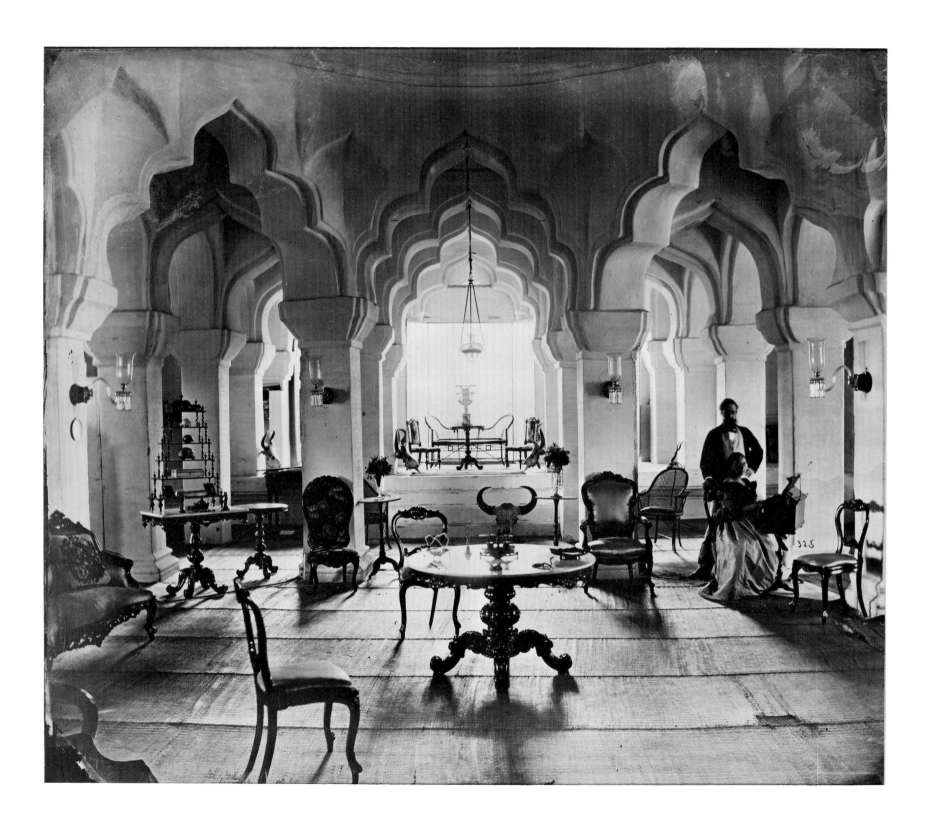

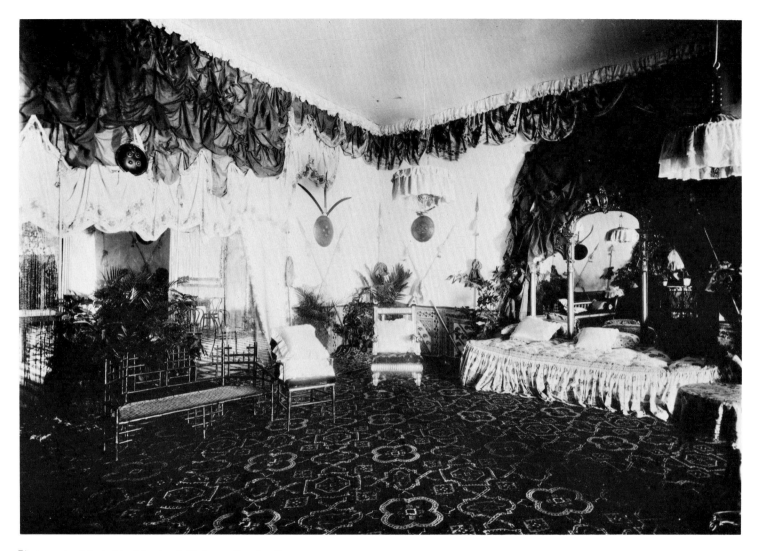

Photograph attributed to Johnston & Hoffman: *Drawing Room in the Tent for the Viceroy's Staff,* Gwalior, Autumn, 1895.

 This tent, put up on the occasion of Lord Elgin's state visit to Gwalior, was part of the elaborate pageantry surrounding the Viceregal office. The height of such ceremonies was reached in 1911 at the coronation durbar of King-Emperor George V in Delhi, where 40,000 tents were erected to accommodate 300,000 guests.

Capt. E. D. Lyon, *Interior of a Home at Madura,* Madras, mid-1860's.

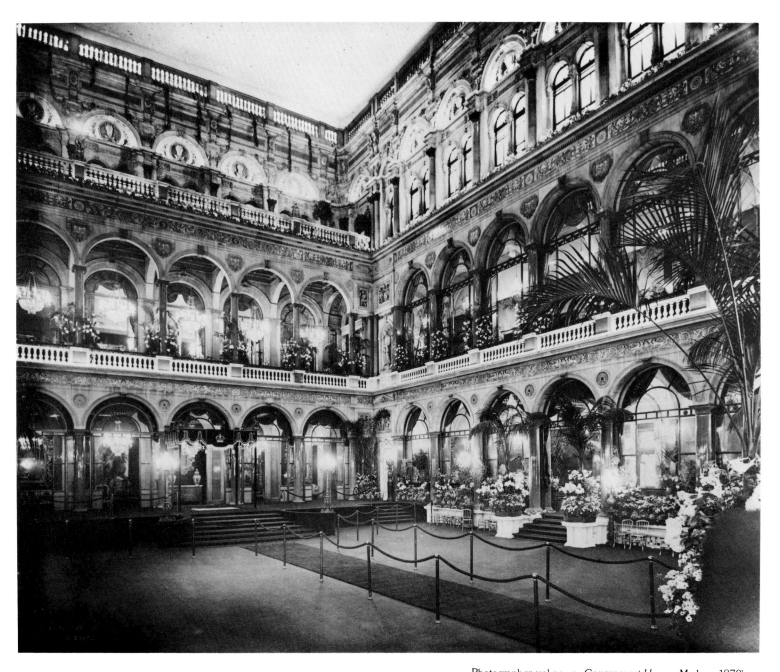

Photographer unknown: *Government House*, Madras, 1870's.

John Burke: *The Viceroy, the Marquis of Dufferin and the General Staff of the Indian Army at the Rawalpindi Durbar*, 1885.
 The Viceroy poses with his staff—having reviewed 17,000 Indian troops with the Amir of Afghanistan. Lord Dufferin sought to impress the Amir because of increasing British and Russian tension over Afghanistan.

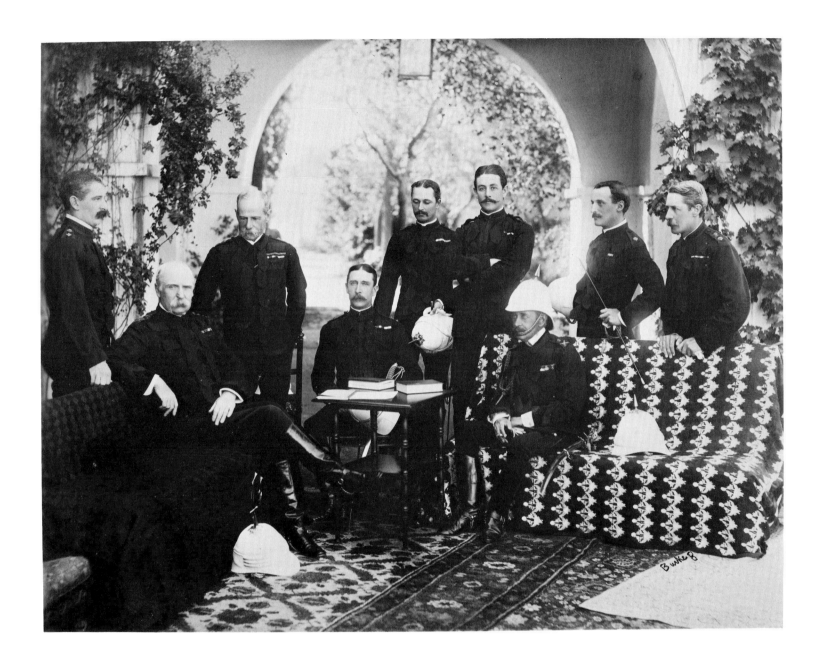

33

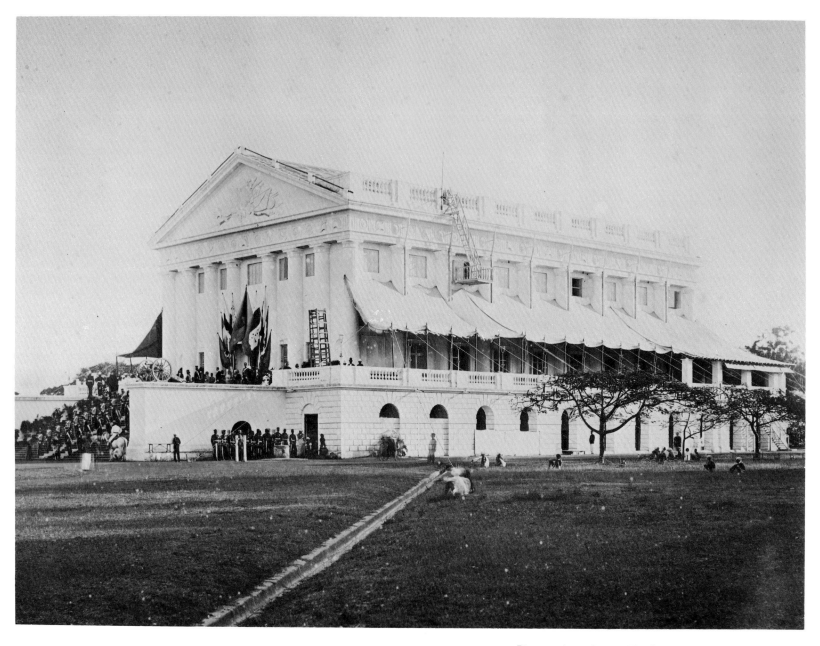

Photographer unknown: *The Banqueting Hall,* Madras, c. 1878.

Photograph attributed to Howard: *Creepers,* Broach (western India), early 1860's.

It is remarkable that out of the wildness of an exotic and faraway place, the British photographer could find a scene so evocative of Victorian England.

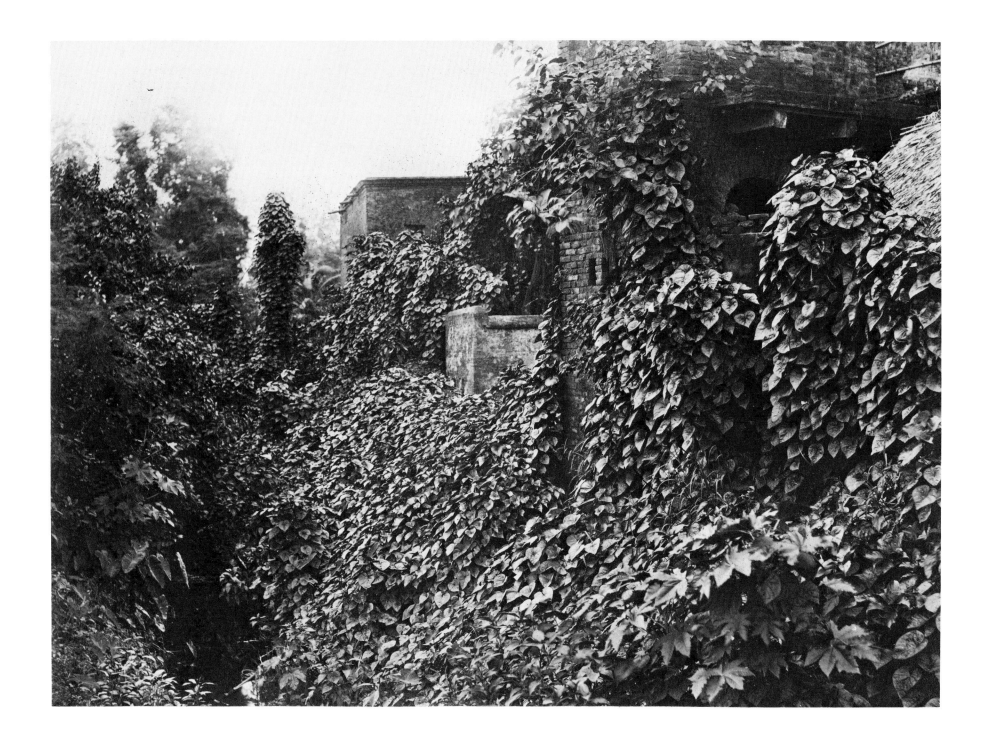

35

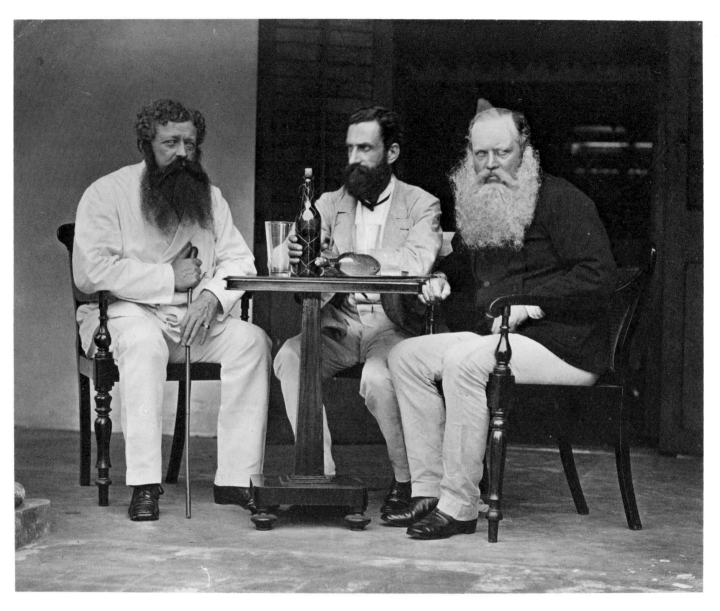

Photographer unknown: *Three Planters at Drink*, 1870's.

Photographer unknown: *George V and Chandra Sham Sher, the Prime Minister of Nepal, with Trophy*, 1911.
 Arriving in India for his coronation durbar, the King-Emperor was invited by the King of Nepal to attend a traditional shoot in the Nepalese Terai.

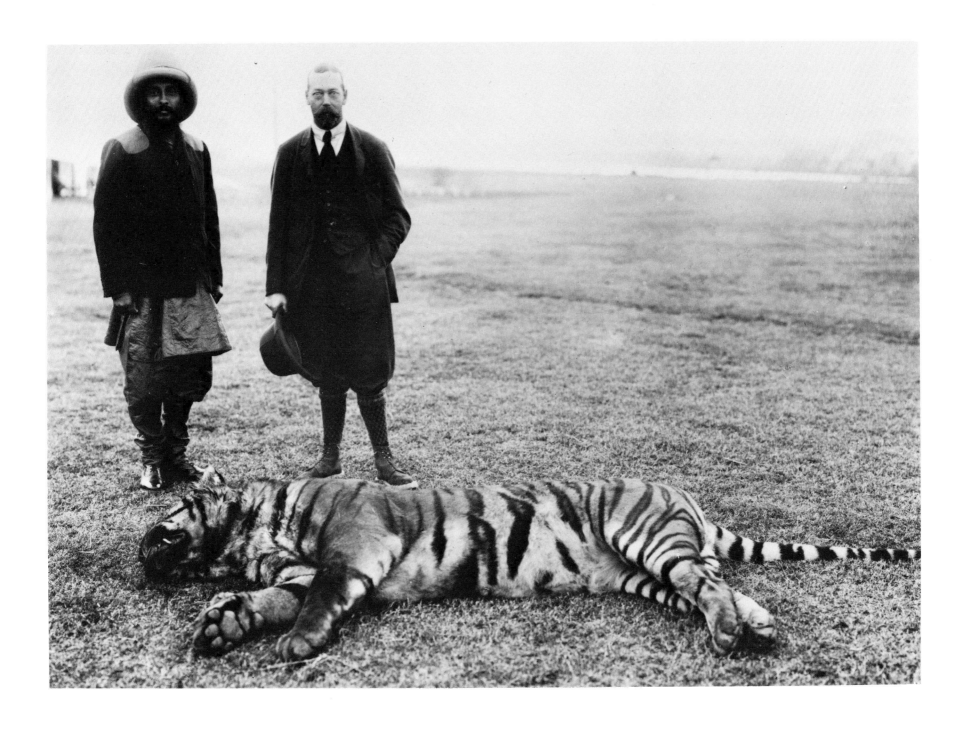

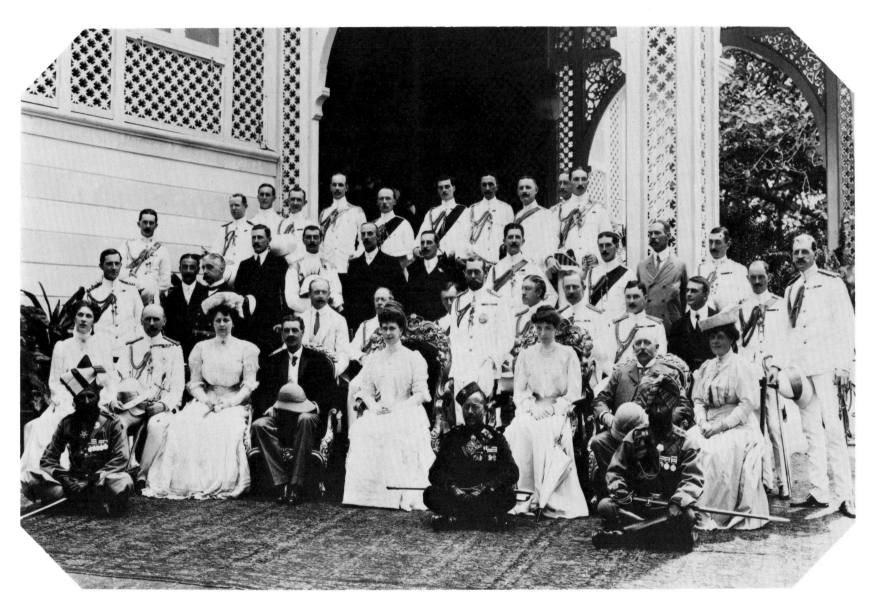

Photographer unknown: *The Royal Party, George V and Queen Mary*, Bombay, 1911.

Photograph attributed to Howard: *Tolley's Nullah*, Parel, Bombay, 1862.
 Parel is now one of the most densely populated sections of Bombay.

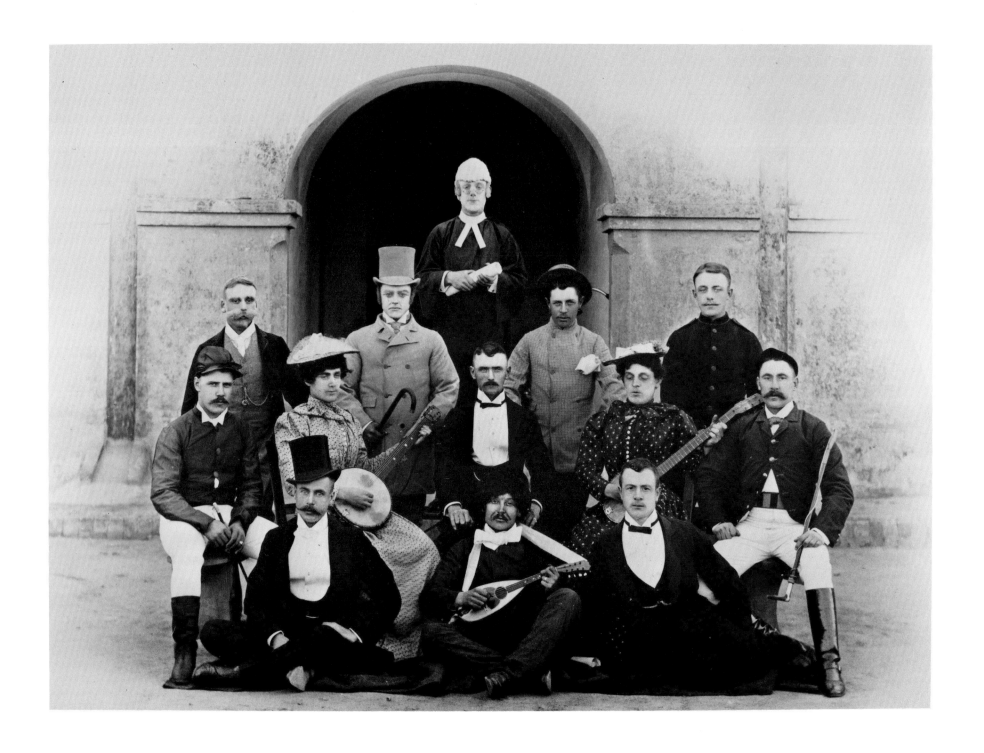

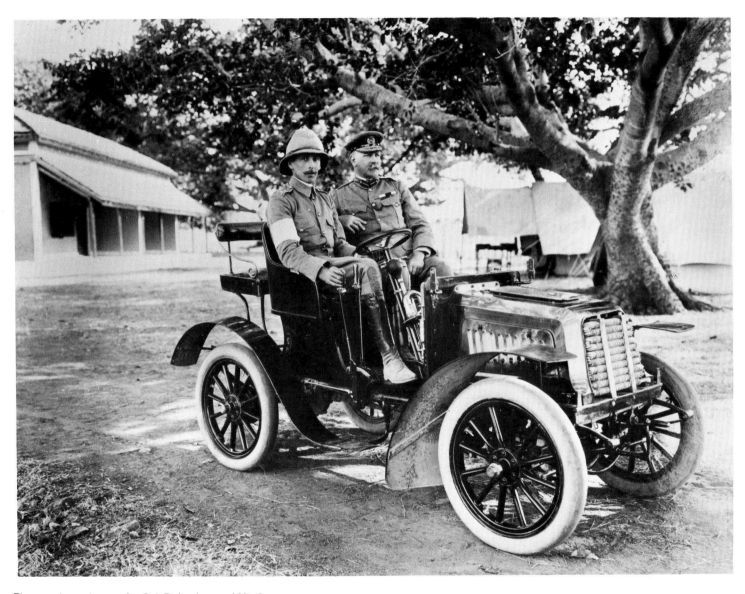

Photographer unknown: *Lt. Col. Richardson and His Car,*
Poona, 1904.

Photographer unknown: *Theater Group.*

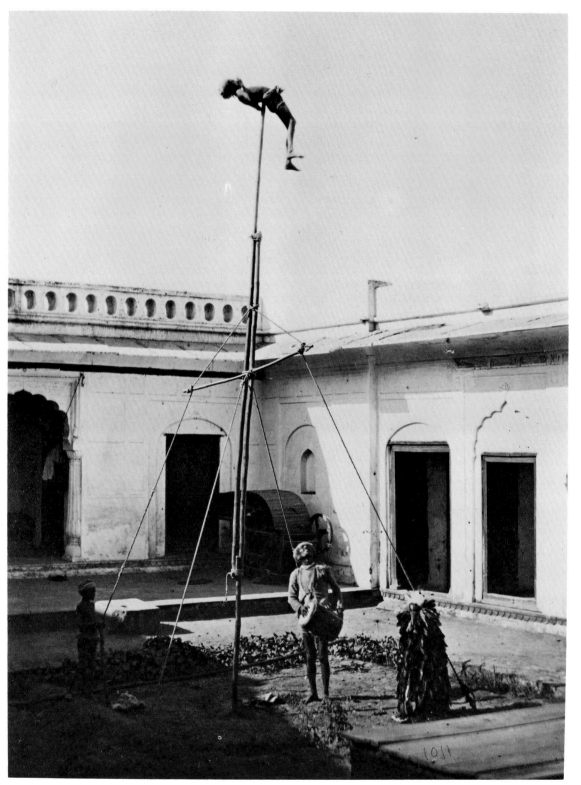

Photographer unknown: *Acrobat Balancing on Pole,* Delhi.

Myers Brothers: *Royal Reception,* December, 1911.

George V, the first reigning monarch to visit India, and Queen Mary are under the Gateway of India, built to commemorate the event in the style of sixteenth-century western Indian architecture. In 1947, the last British troops passed under the gateway—ending an association that lasted 349 years.

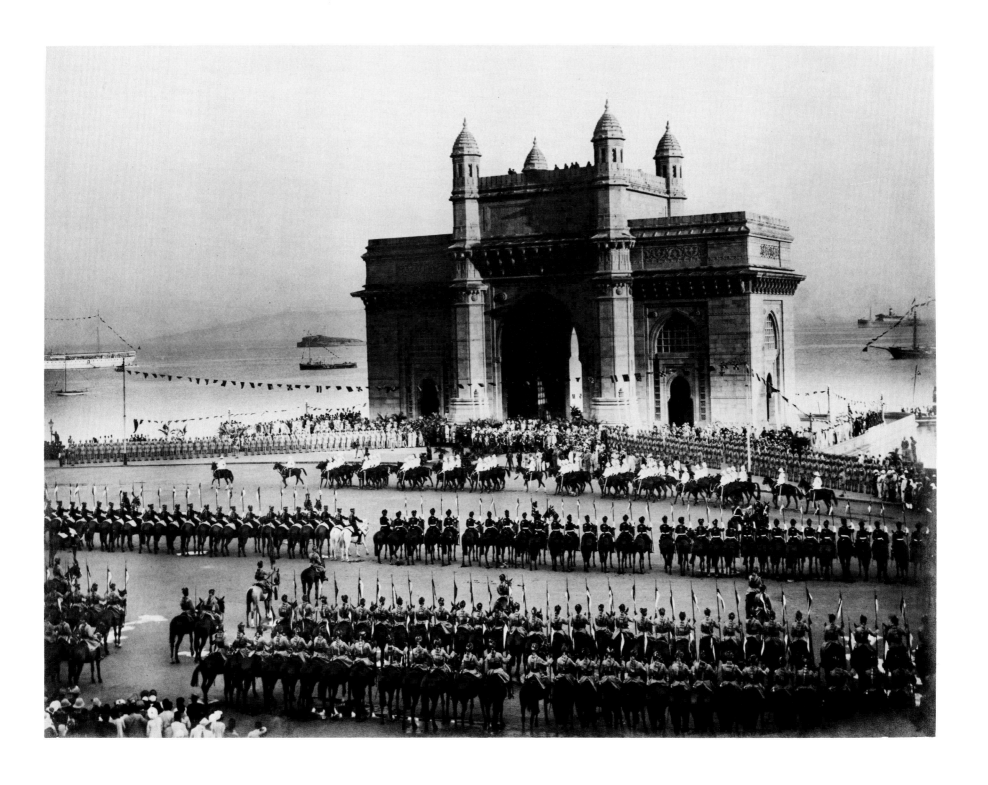

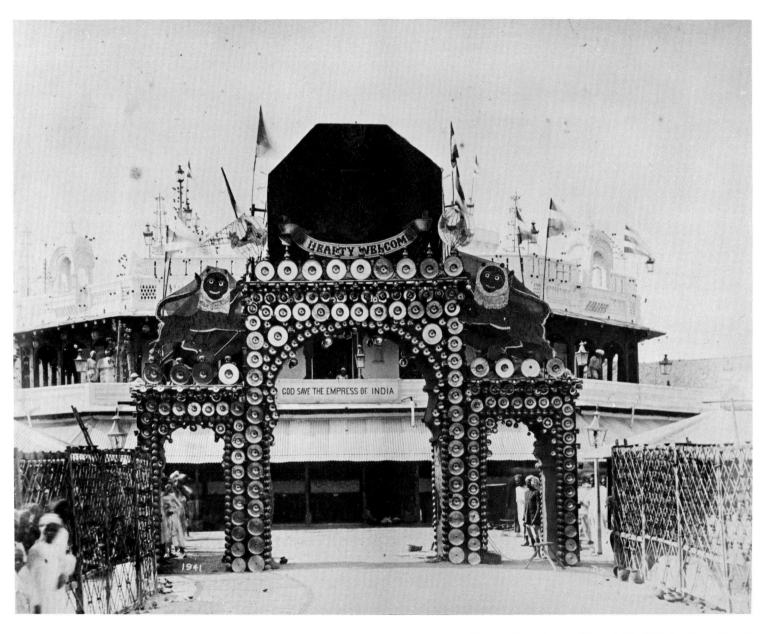

Photographer unknown: *Triumphal Arch Made of Brass Utensils,*
"In Honor of the Agent to the Governor-General's Visit,"
Rutlam, 1890's.
 A similar arch erected in Bombay at the time of the Prince of
Wales' visit in 1875 read: "Tell Mama We're Happy."

Lala Din Dayal: *Drawing Room, Falukituma Palace,* Hyderabad,
1880's.

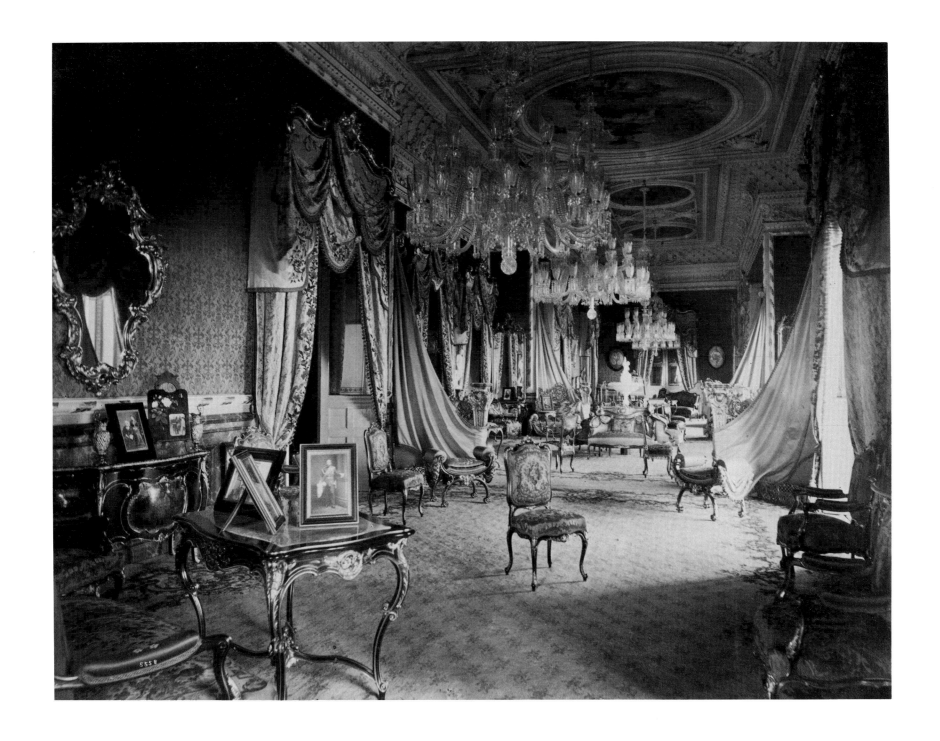

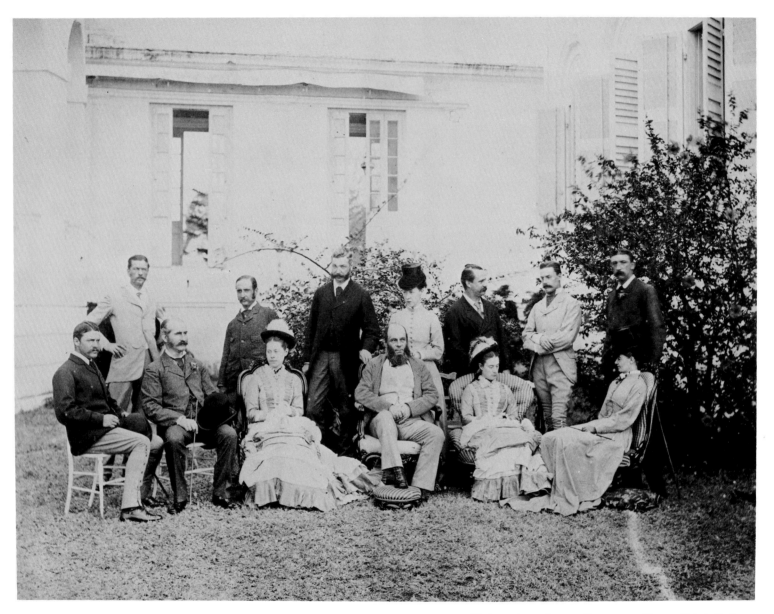

Photographer unknown: *Government House,* Guindy Park,
1878.
 The Governor of Madras is flanked by Lady M. Grenville and
Lady C. Grenville, and friends.

Photographer unknown: *Camp of His Grace the Governor of
Madras, Delhi,* 1877.
 The Governor of Madras and party visiting a local ruling
prince.

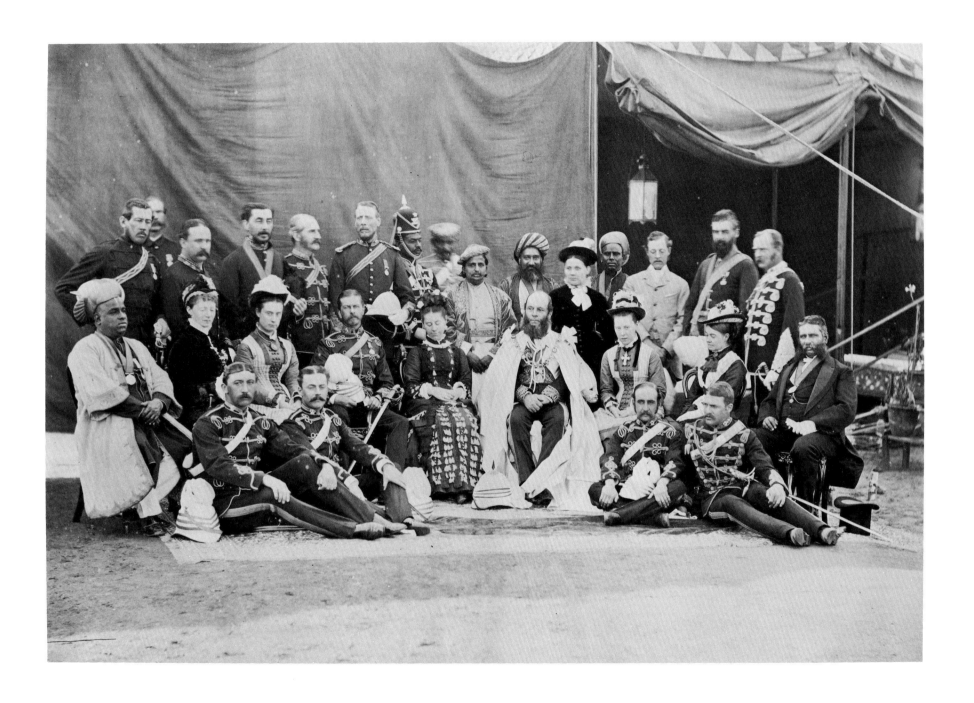

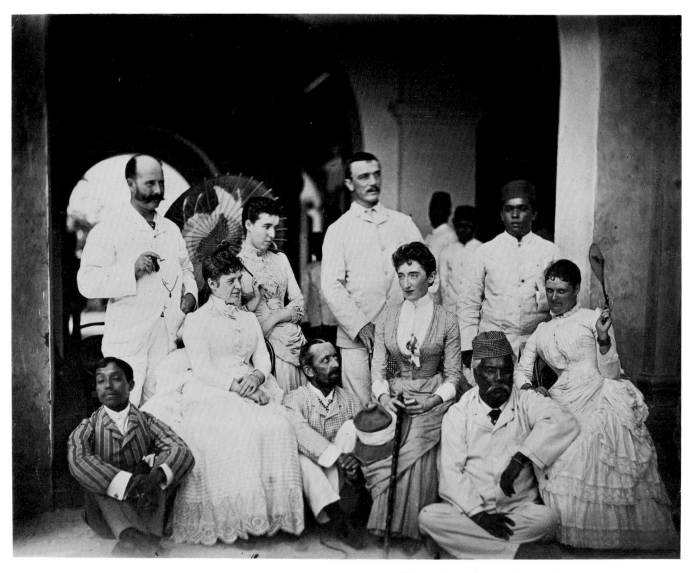

Photographer unknown: *Costume Group,* 1860's.

Photographer unknown: *Badminton Party of 21st B.N.I.,* Rawalpindi, 1890's.

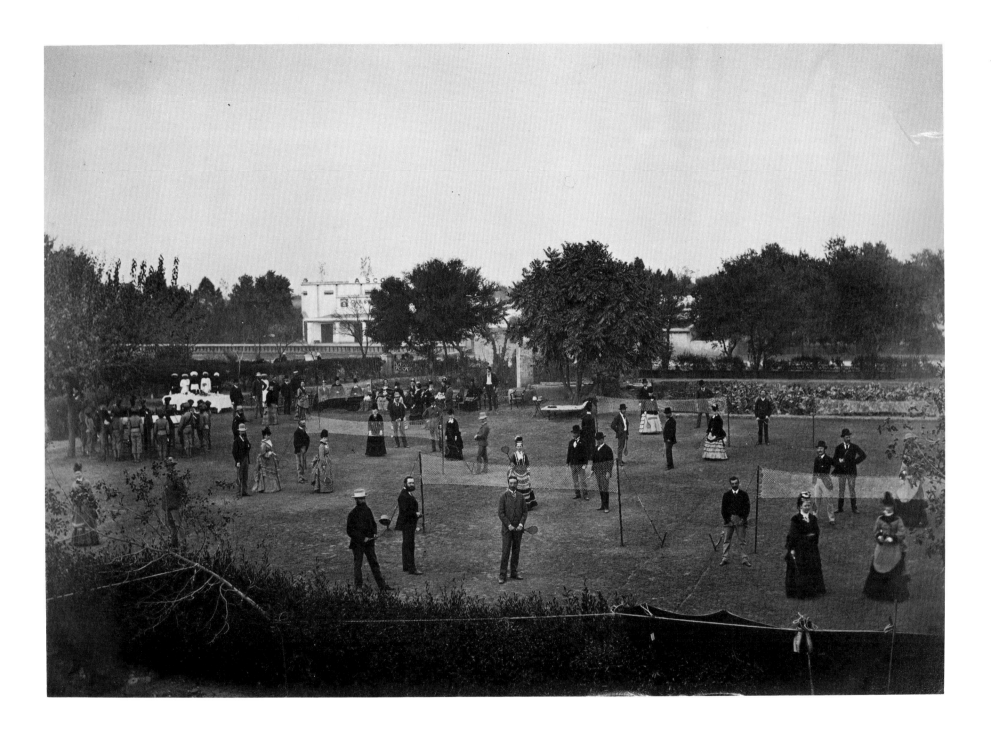

49

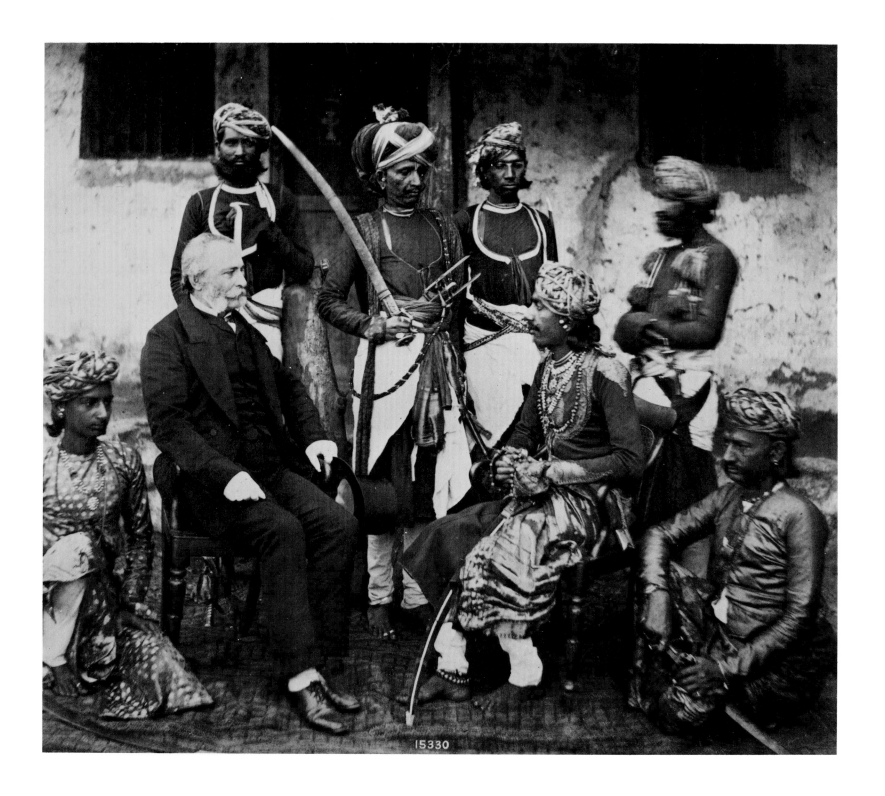

15330

50

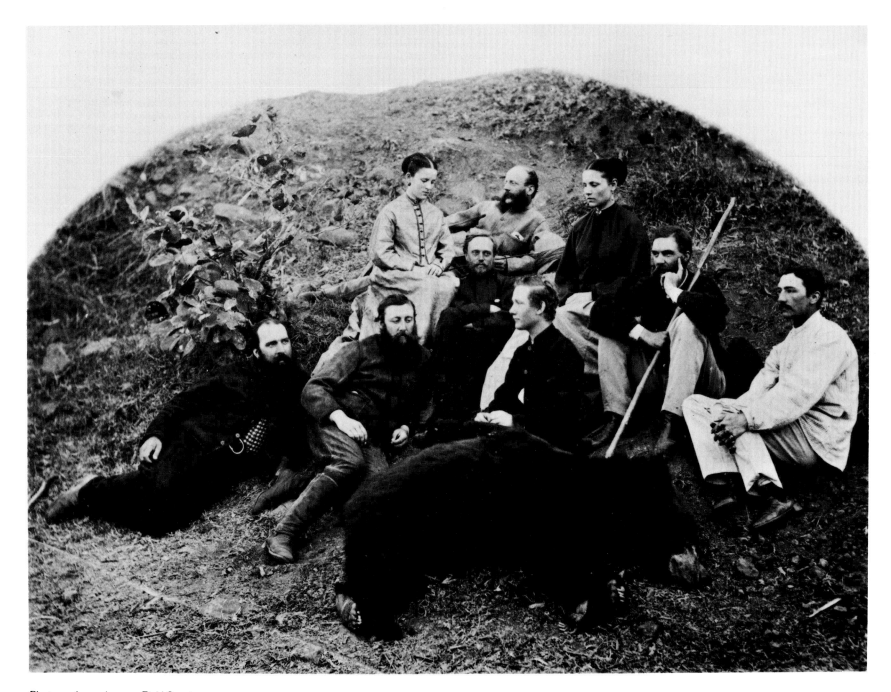

Photographer unknown: *Field Sports.*
This photograph is from an album entitled *Hyderabad Assigned Districts and Berar,* collected by Col. James Allardyce (1864 to 1870).

Lt. Churchill: *Englishman with Ruling Prince and Suite,* 1860's. Part of the Frith series of Indian views published during the nineteenth century.

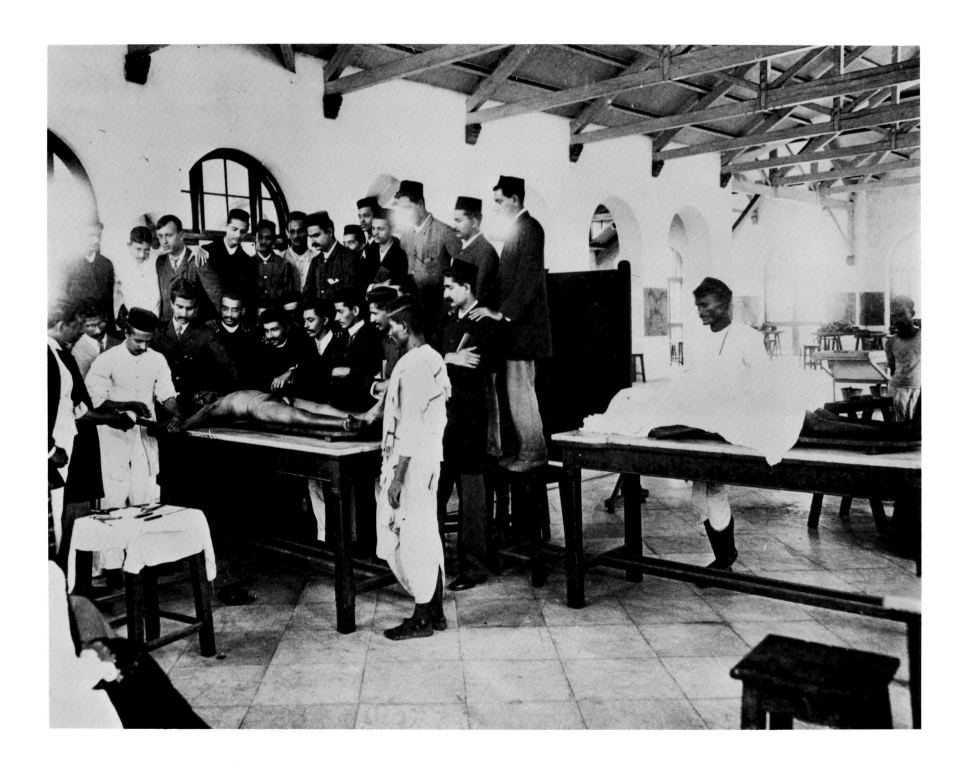

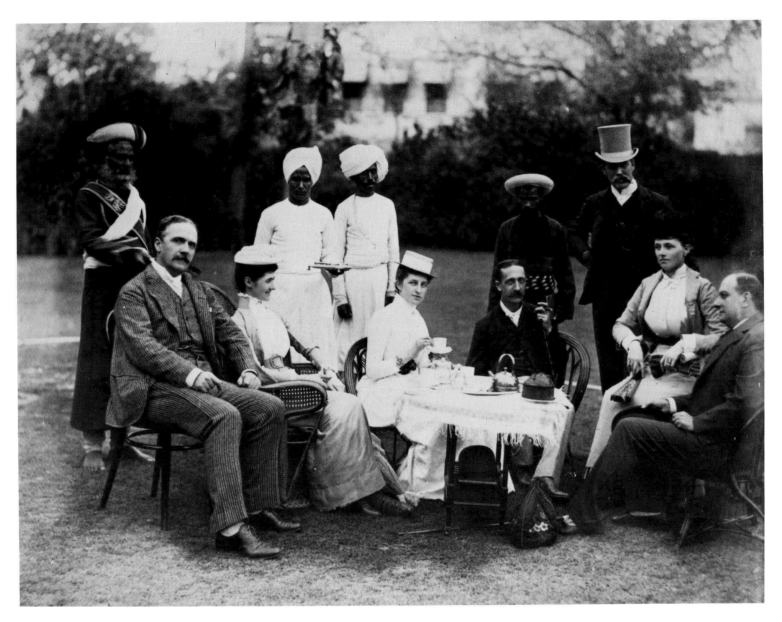

Photographer unknown: *Afternoon Tea.*

Photographer unknown: *Dissection, Grant Medical College,*
Bombay, 1910.

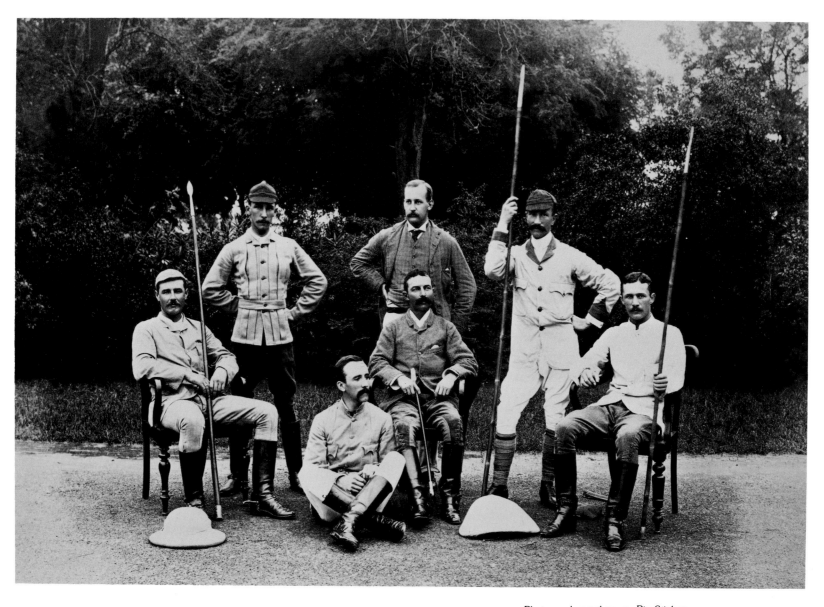

Photographer unknown: *Pig-Stickers*.

Samuel Bourne: *Hamilton and Co. Show Rooms,* Simla, 1868,
Item 1814 in the Bourne & Shepherd catalogue.
 Simla, to the north of Delhi, was the summer capital of the
British Government and provided the setting for many of
Kipling's most famous stories.

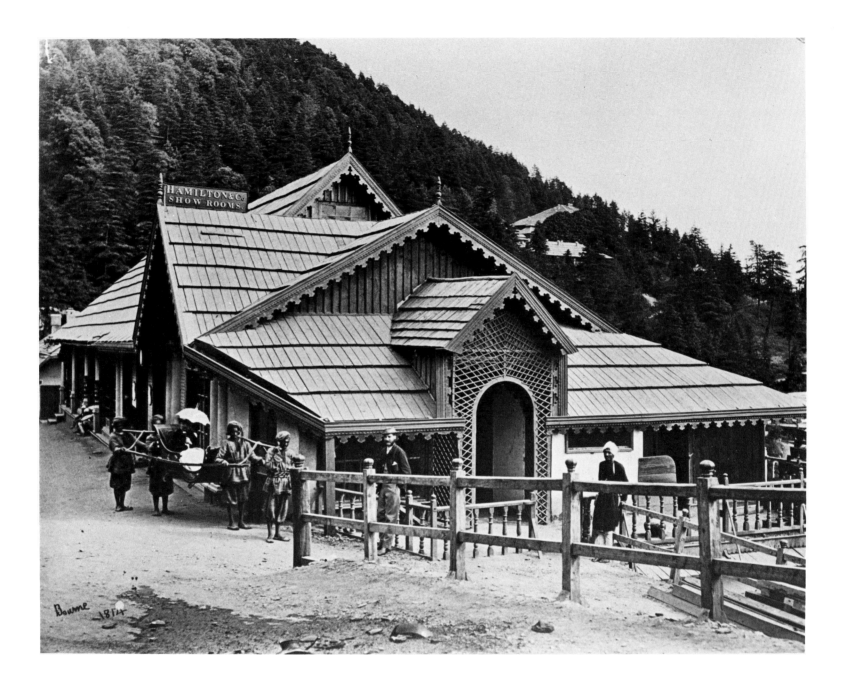

55

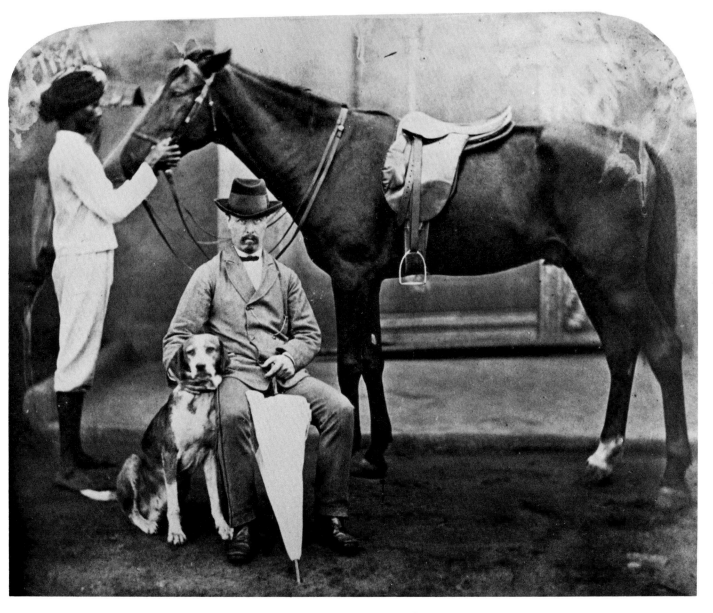

Photographer unknown: *Englishman with His Dog and Horse.*

Capt. W. W. Hooper: *Englishman Being Served Coffee in Bed,*
1870.

 This photograph is from an album of Indian scenes by V. S. G.
Western and Capt. W. W. Hooper.

56

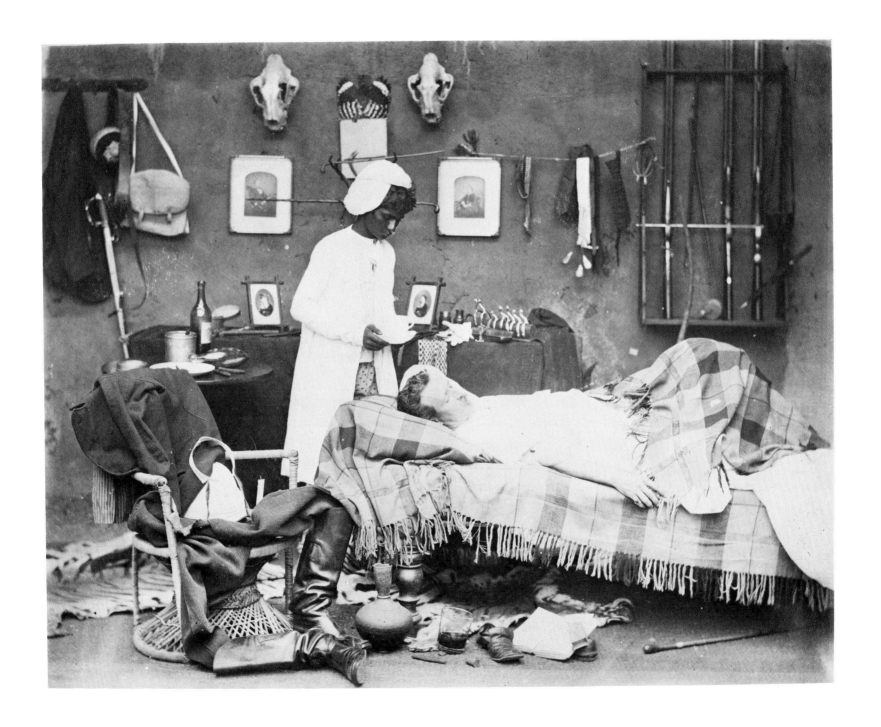

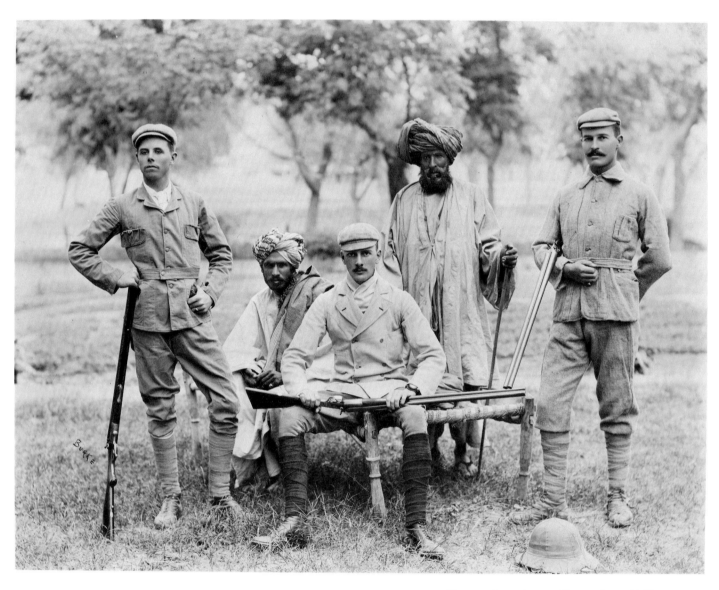

Photographer unknown: *Hunting Party,* 1860's.

Photographer unknown: *"My Stud,"* 1903.
 This photograph was part of an album assembled in the Punjab by an Indian Army officer.

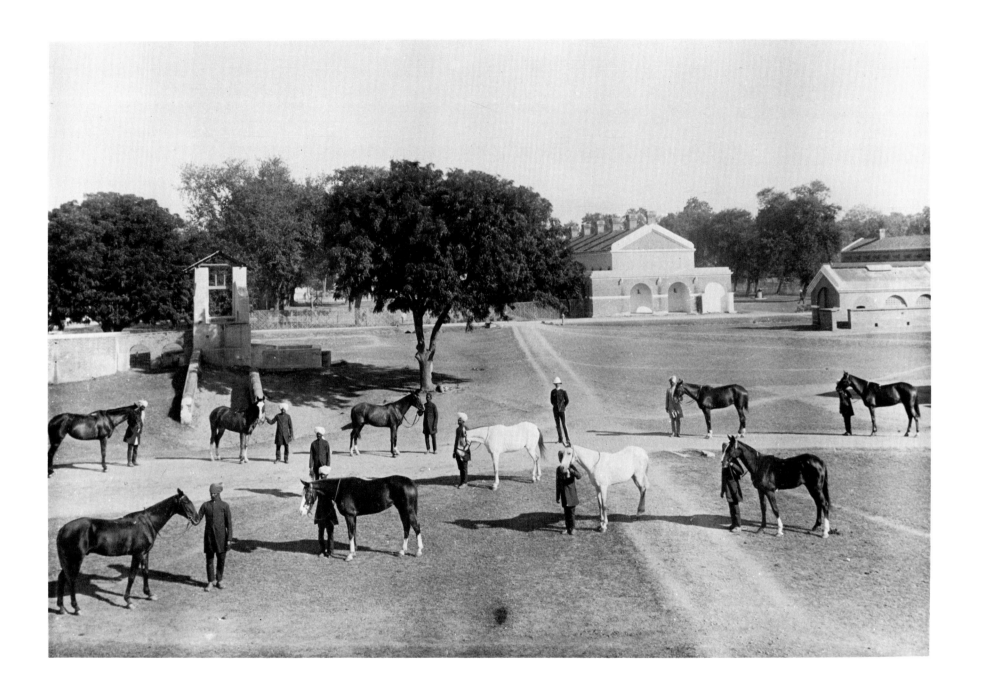

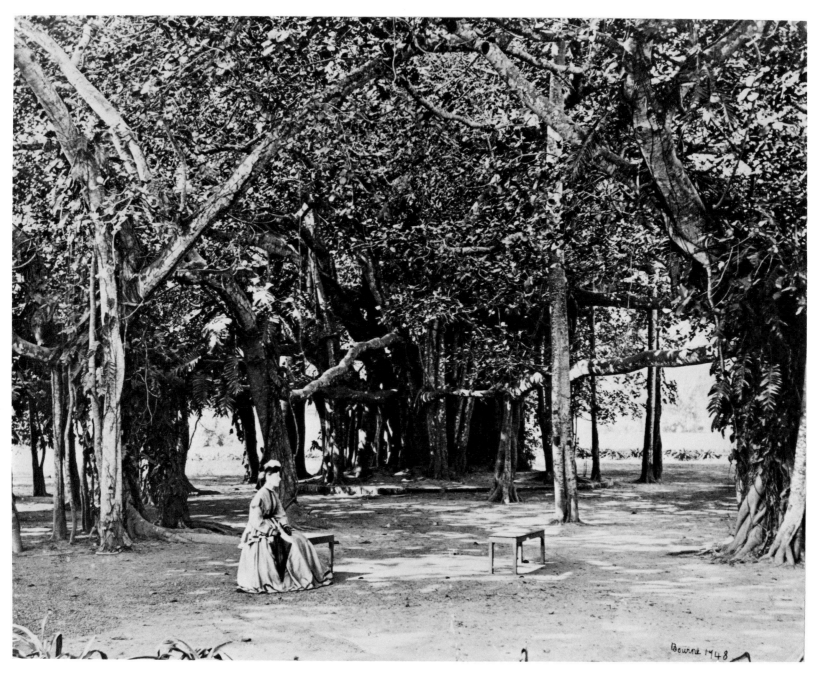

Samuel Bourne: *Giant Banyan Tree,* Barrackpore Park, Calcutta, 1867, Item 1748 in the Bourne & Shepherd catalogue.

Barrackpore was the country residence of the Viceroy, fourteen miles outside Calcutta. Posed in the banyan grove is Mrs. Samuel Bourne.

Samuel Bourne: *Cane Bridge over the Runjeet River near Darjeeling,* 1869, Item 1879 in the Bourne & Shepherd catalogue.

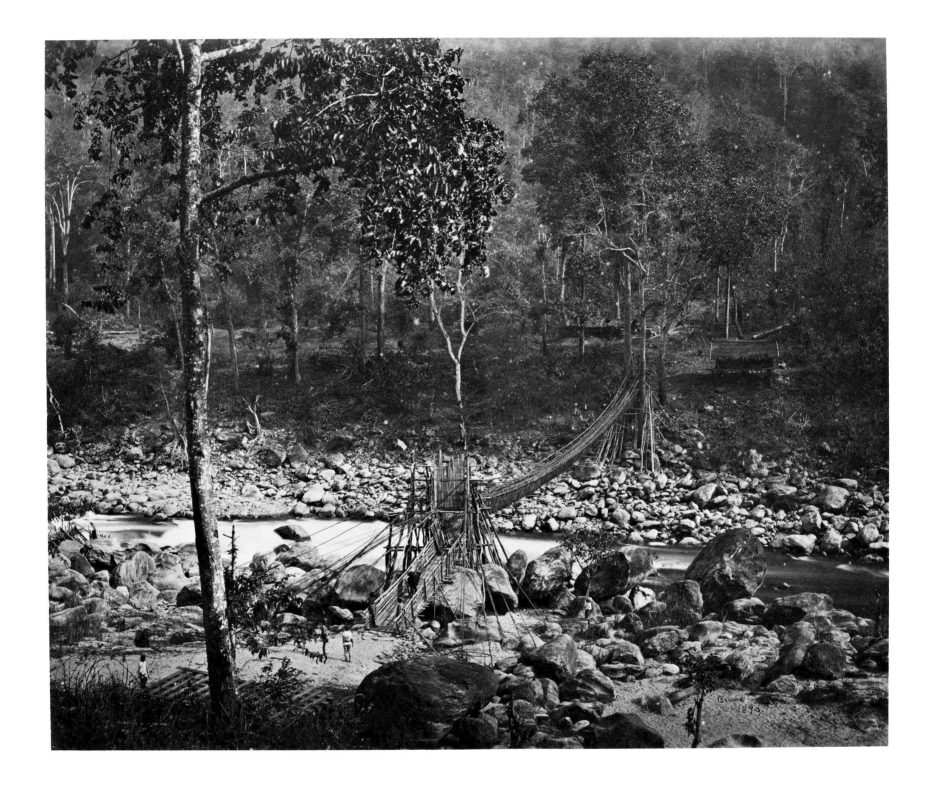

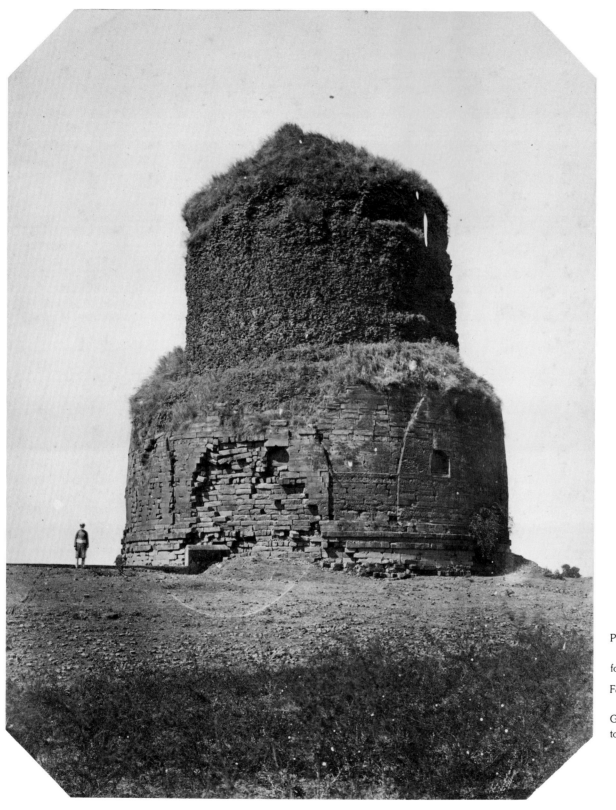

Photographer unknown: *Sarnath Stupa,* near Benares.

The sixth-century stupa at Sarnath is where the Buddha set forth his teachings in the "Sermon in the Deer Park."

Felice A. Beato: *The Royal Boat of Oude,* Lucknow, 1858.

Beyond the Royal Boat is a bridge of boats spanning the Gumpti River—with the Chutter Munzil, the palace of the Queen, to the left and the British Residency in the distance.

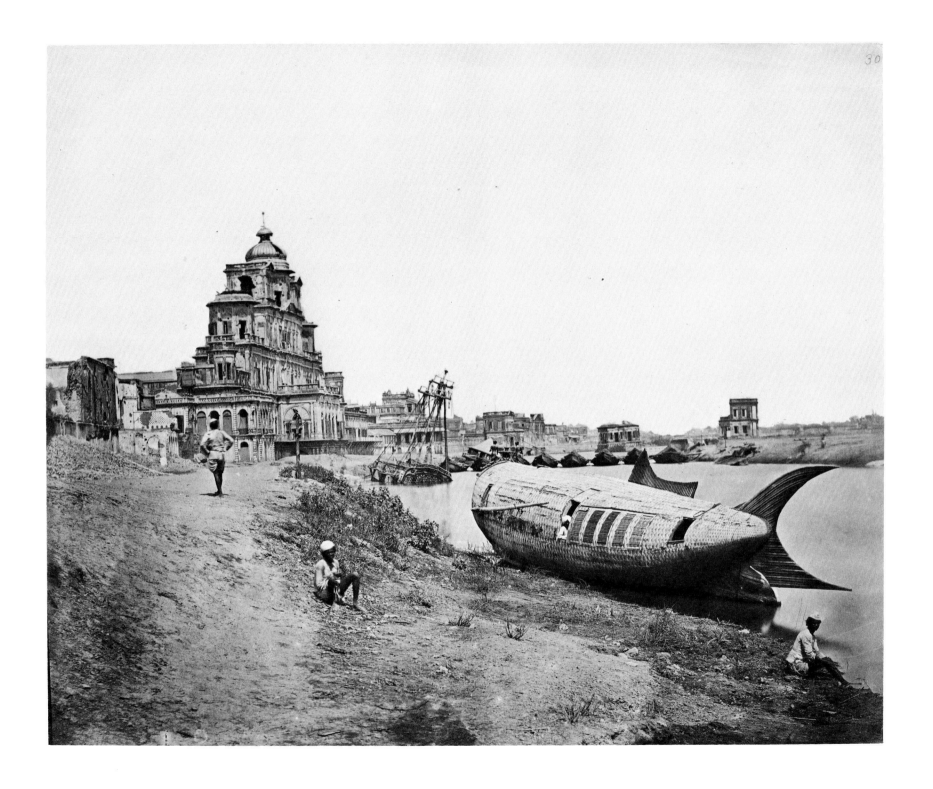

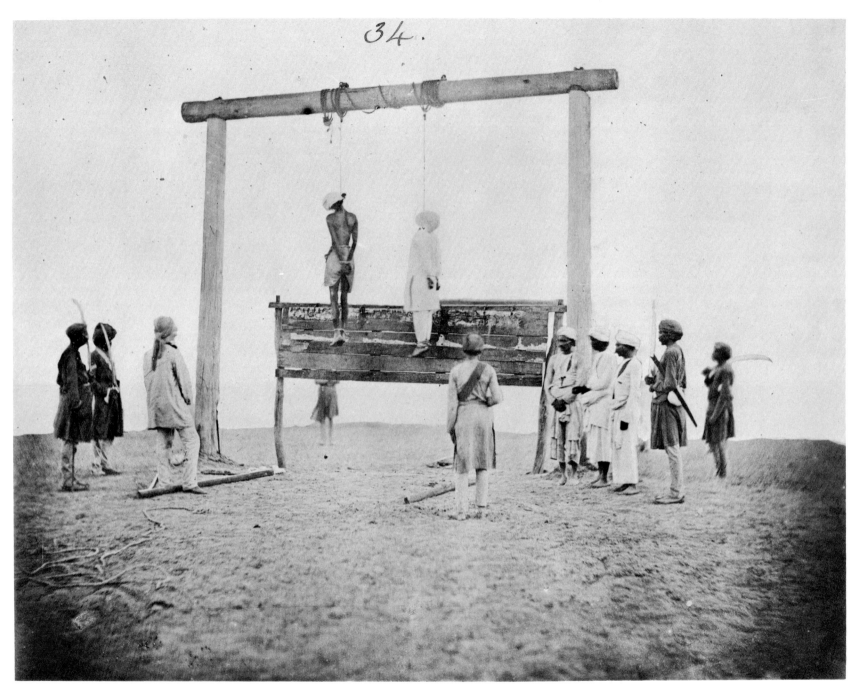

Felice A. Beato: *The Hanging of Two Rebels*, the Indian Mutiny, 1858.

Felice A. Beato: *Damage Caused by a Mine in the Chutter Munzil*, Lucknow, 1858.
Formerly a palace for the royal queens, the Chutter Munzil was part of the fortifications used by the British in their defense of the Residency at Lucknow.

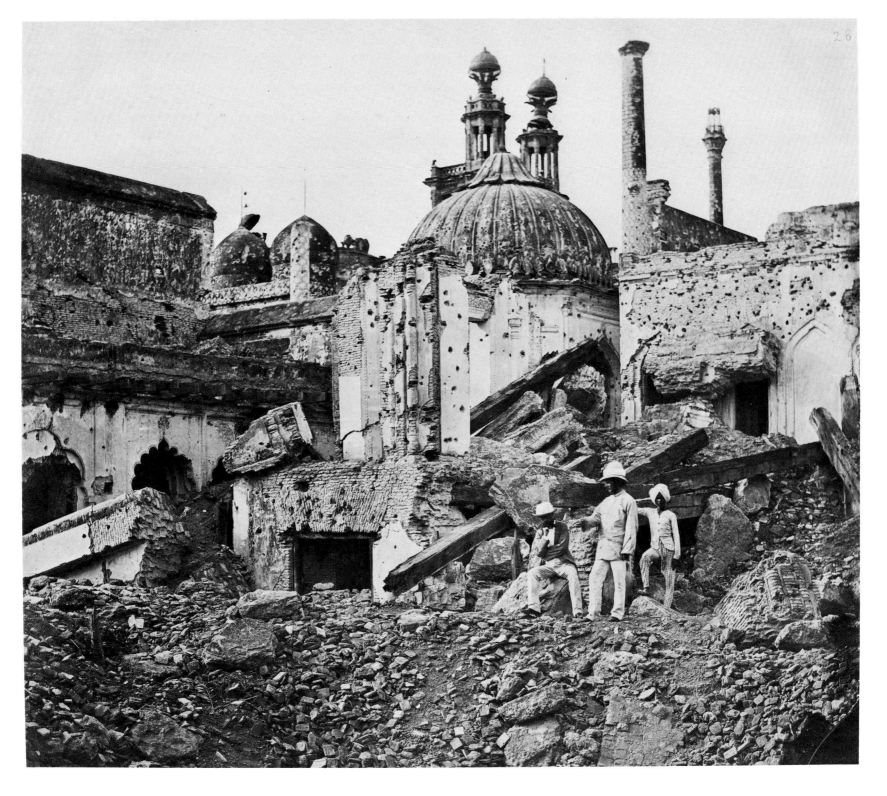

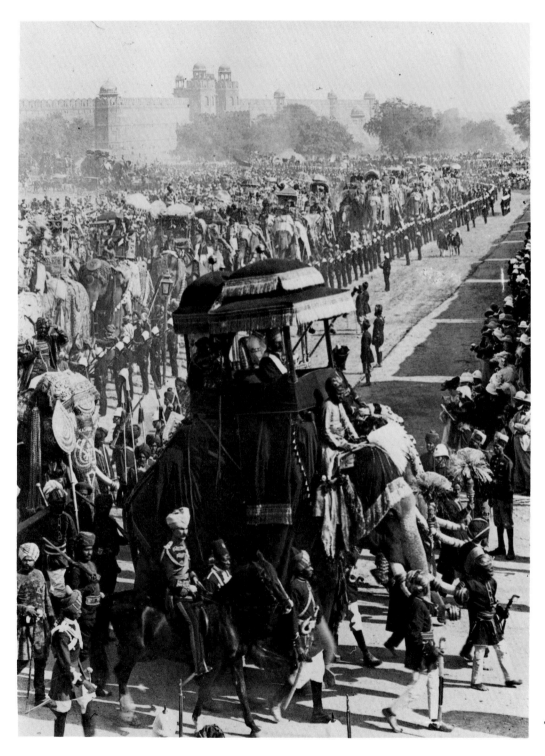

Photographer unknown: *Great Durbar,* Delhi, 1903.

Johnston & Hoffman: *Bathing in the Hooghly River,* Calcutta, 1890's.

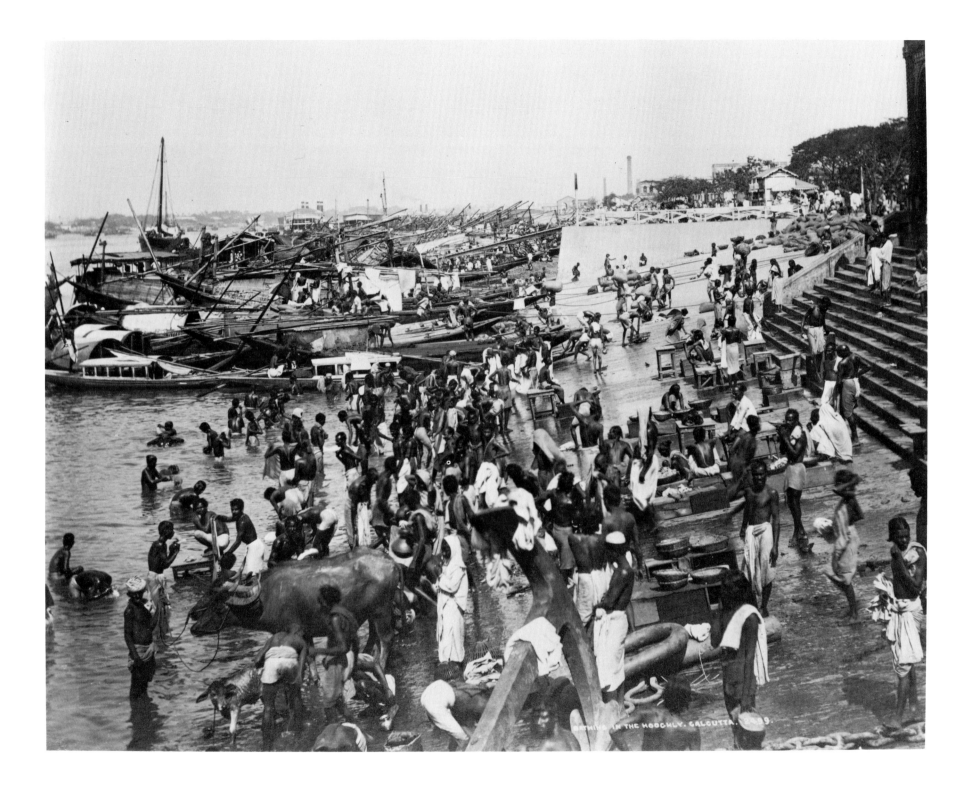

BATHING IN THE HOOGHLY, CALCUTTA.

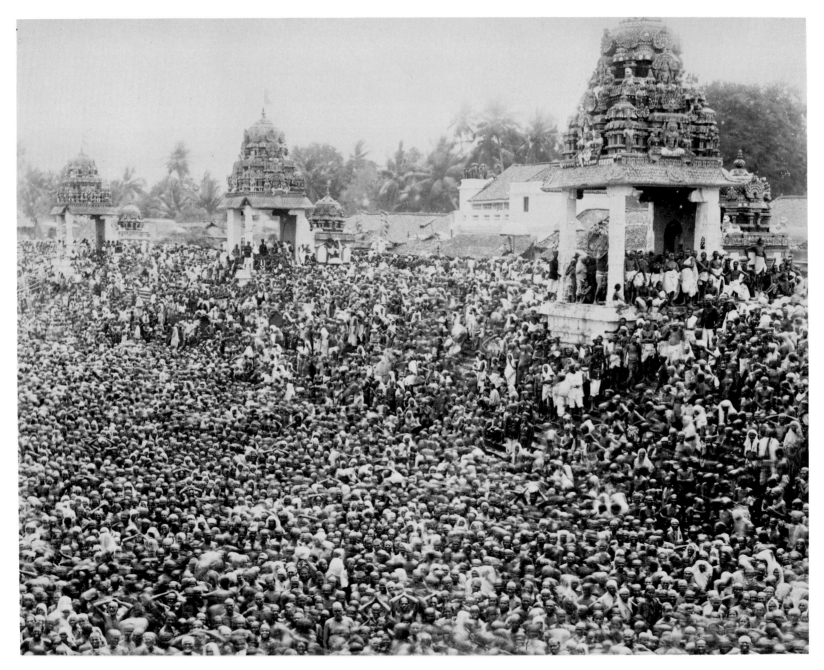

Photographer unknown: *Hindu Festival,* South India, 1880's.

Samuel Bourne: *"Vishnu Pud" and Other Temples near the Burning Ghat,* Banaras, 1865, Item 1170 in the Bourne & Shepherd catalogue.

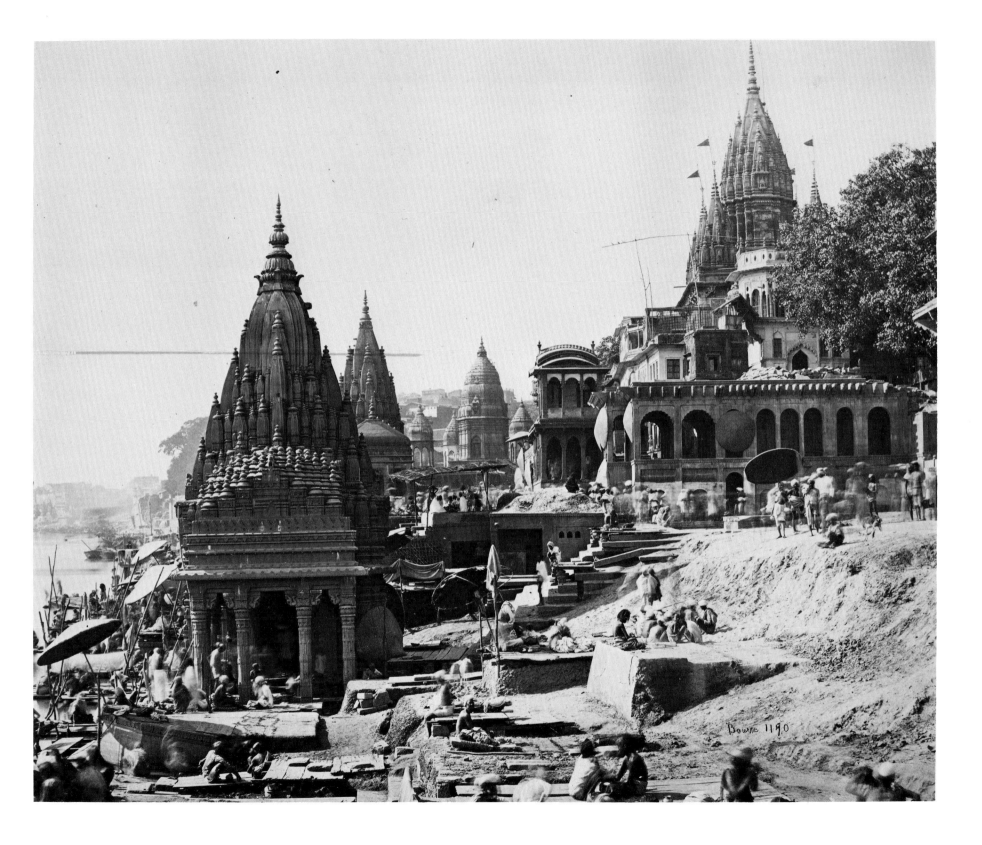

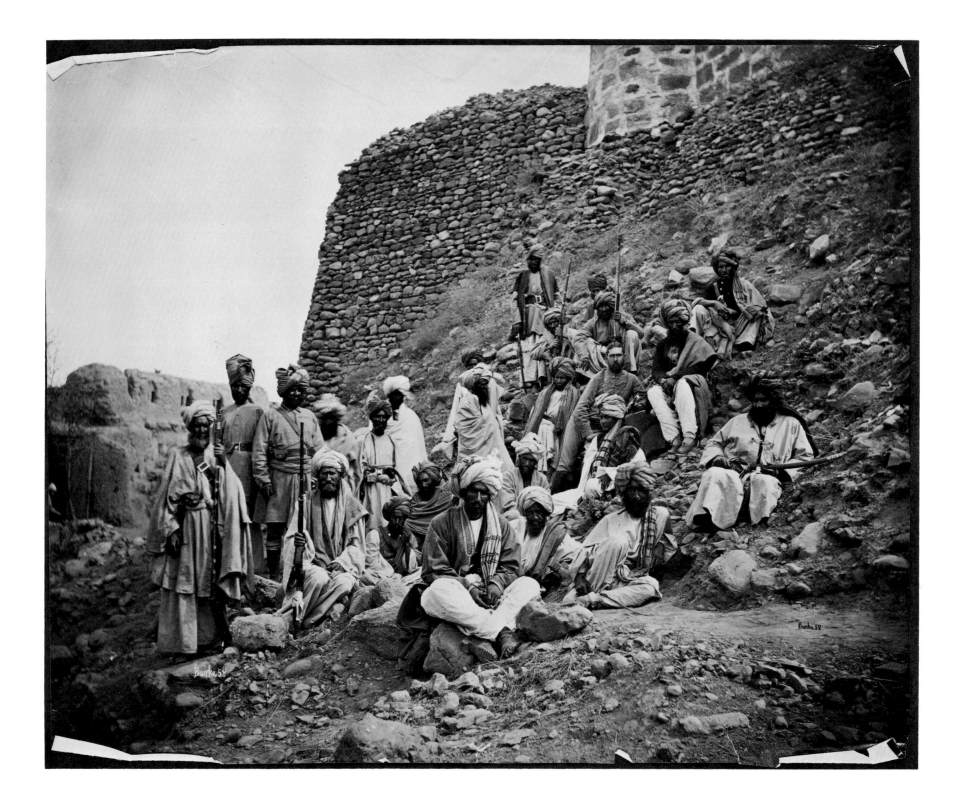

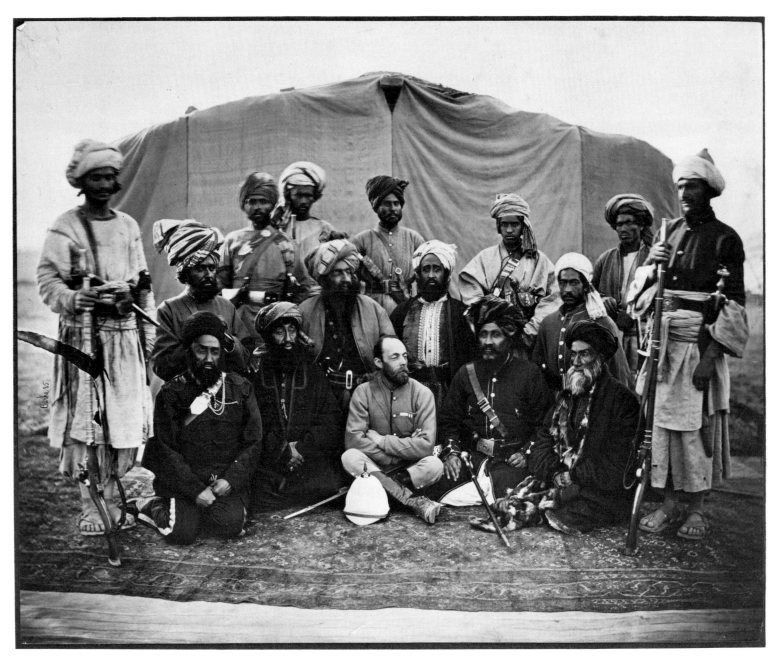

John Burke: *Maj. Cavagnari with the Sirdars of Kabul and Kunae Synd,* 1879.

 Three months after this photograph was taken, Sir Pierre Louis Napoleon Cavagnari, the British Resident at Kabul, was killed with all his staff by Afghan insurgents on September 3, 1879.

John Burke: *Khyber Chiefs and Khans,* 1878–79.

 During the nineteenth and well into the twentieth century, the British fought the tough, warlike tribes that almost constantly ringed the Northwest Frontier.

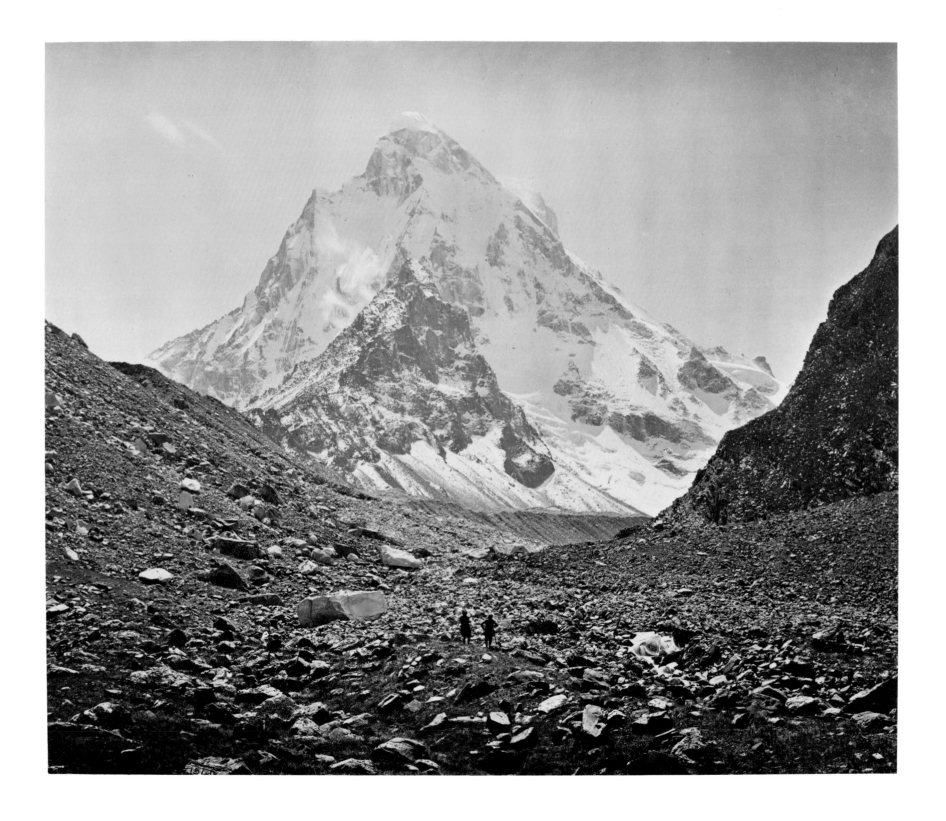

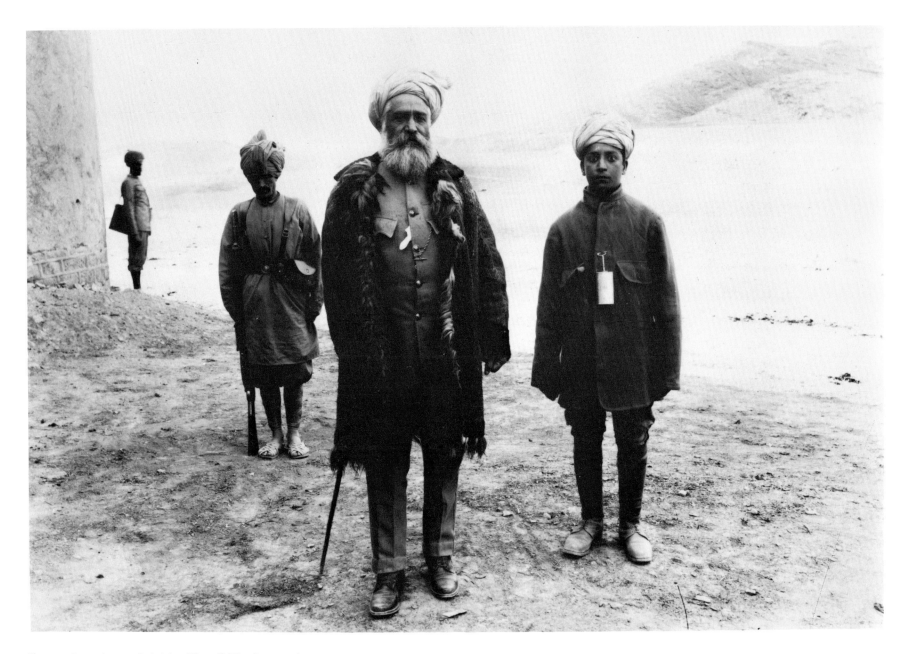

Photographer unknown: *Col. Aslam Khan, C.I.E. —Commandant of the Khyber Rifles, with His Son,* Tirah Campaign, 1897.

Aslam Khan was the son of the Usman Khan, the ex-Prime Minister of Afghanistan. The family settled in Peshawar, where their political acumen established them in the affairs of the Northwest Frontier.

Samuel Bourne: *Shiv Ling Peak, South of the Gangootri Glacier,* elevation 21,466 feet, 1866, Item 1544 in the Bourne & Shepherd catalogue.

The source of the Ganges River, the Gangootri Glacier is one of the holiest Hindu pilgrimage sites in India.

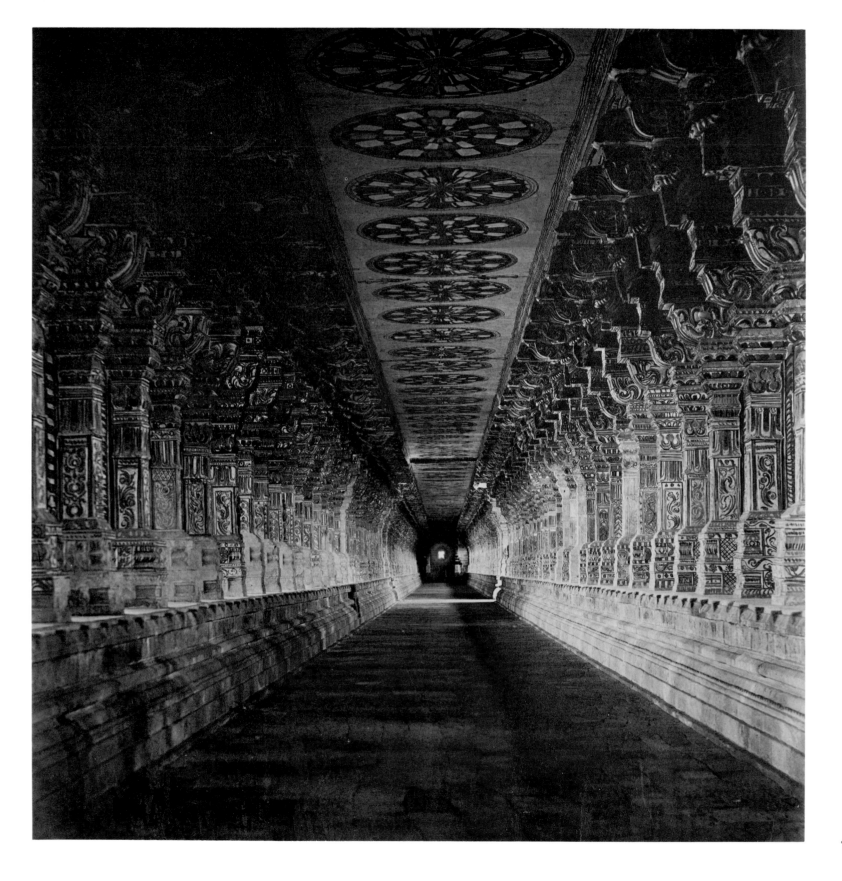

74

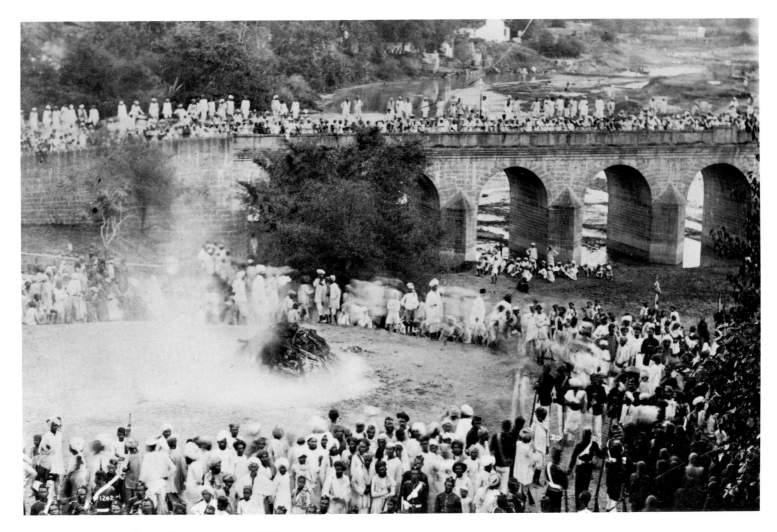

Photographer unknown: *Funeral Pyre of Maharaja,* 1890's.

Capt. E. D. Lyon: *Rameswaram Temple Corridor,* 1860's, part
of a series done by Capt. Lyon for the Archaeological Survey.
 The 700-foot-long corridor was illuminated by native helpers
holding reflectors.

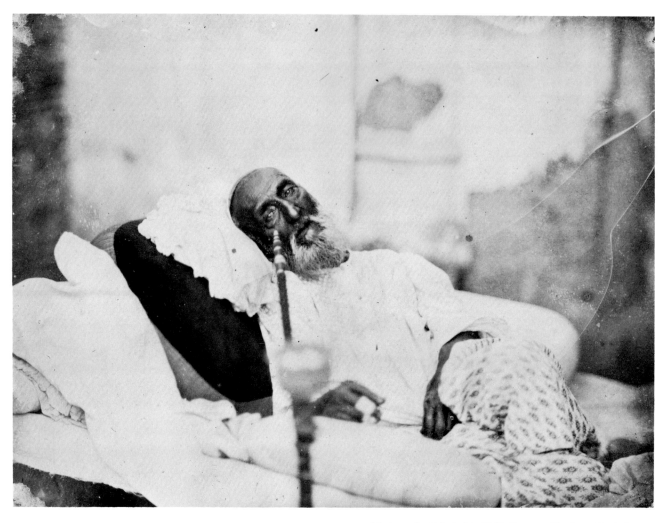

Photograph attributed to P. H. Egerton: *The Last Mughal, Bahadur Shah II, in Exile*, 1858.

Bahadur Shah was exiled to Rangoon for his part in the uprising of 1857, in which he sided with the mutineers. A poet of distinction, his life in exile was a popular subject of curiosity for British tourists to post-Mutiny Delhi.

P. A. Johnston, for Johnston & Hoffman: *The Moti Masjid—"The Pearl Mosque,"* Agra, 1895.

The Moti Masjid, one of the greatest monuments of the Mughal period, was built by the Mughal Emperor Shah Jehan between 1646 and 1653.

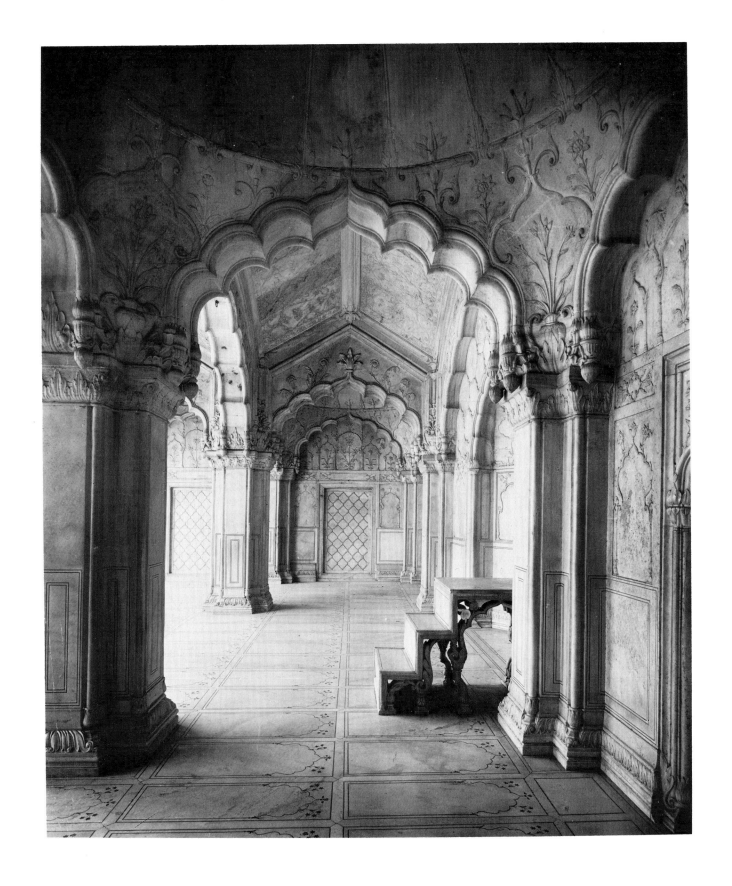

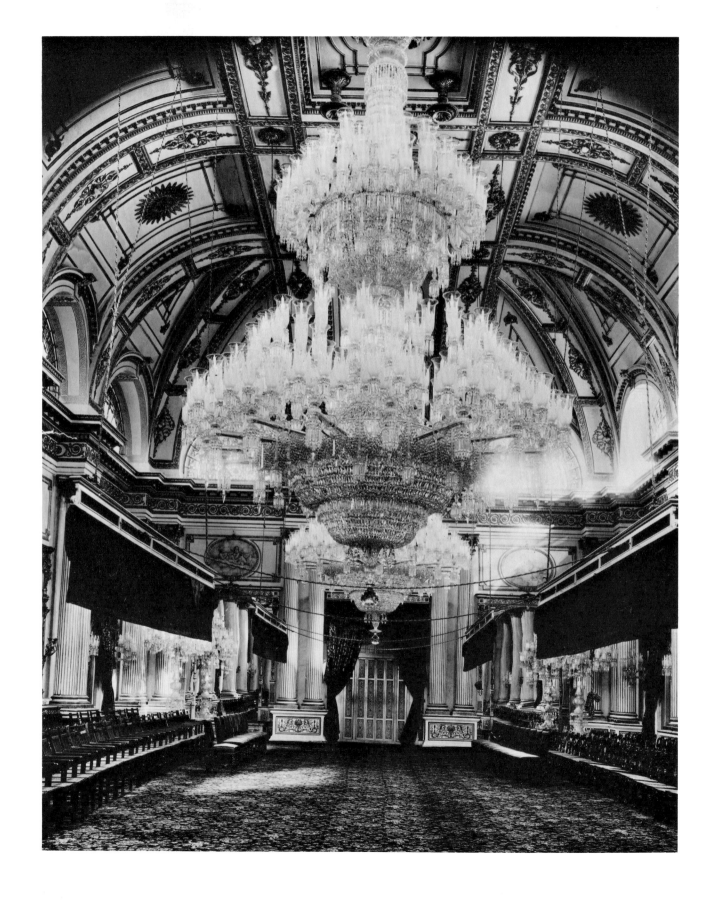

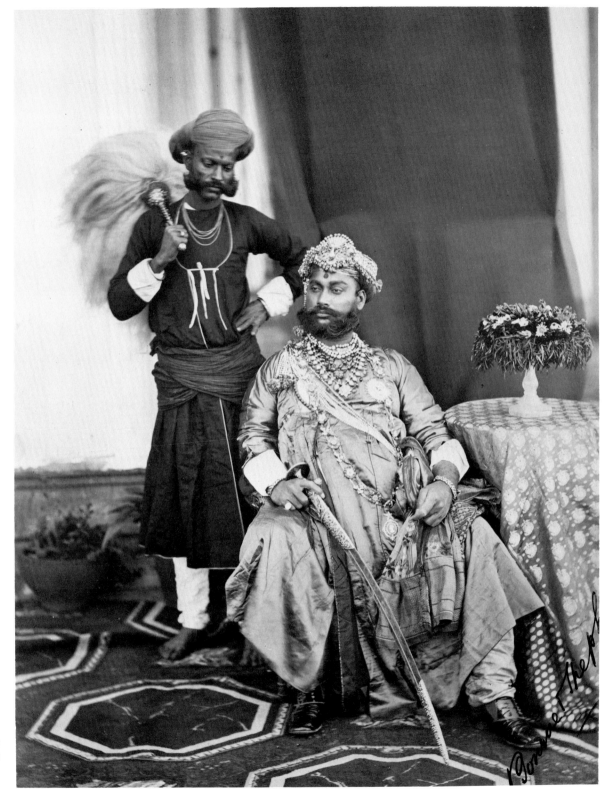

Bourne & Shepherd: *Maharaja Tukoji Rao of Indore and Attendant,* 1877.

Holkar of Indore ruled a population of 1,100,000.

Johnston & Hoffman: *The Great Chandelier,* Gwalior, 1895.

When the Maharaja of Gwalior decided to decorate his palace with a chandelier greater than any in Buckingham Palace, he was told the ceiling would not support the weight. He hoisted his largest elephant to prove the roof would hold.

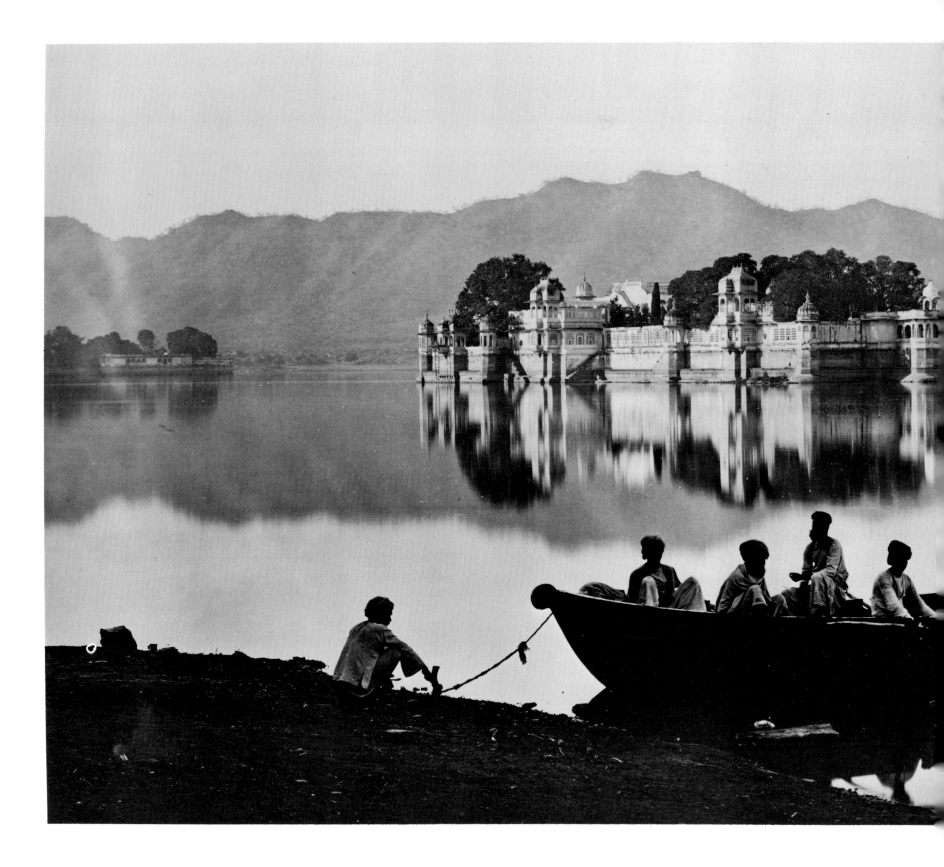

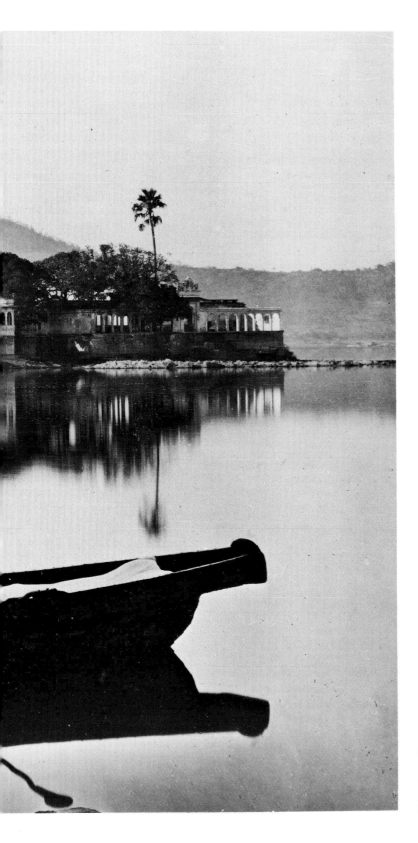

Colin Murray: *The Water Palace,* Udaipur, 1873.
When Samuel Bourne returned to England in 1871, Murray apparently inherited his camera and used it for the 13″ x 8″ plates that were included in *Photographs of Architecture and Scenery in Gujerat and Rajputana,* published in 1874.

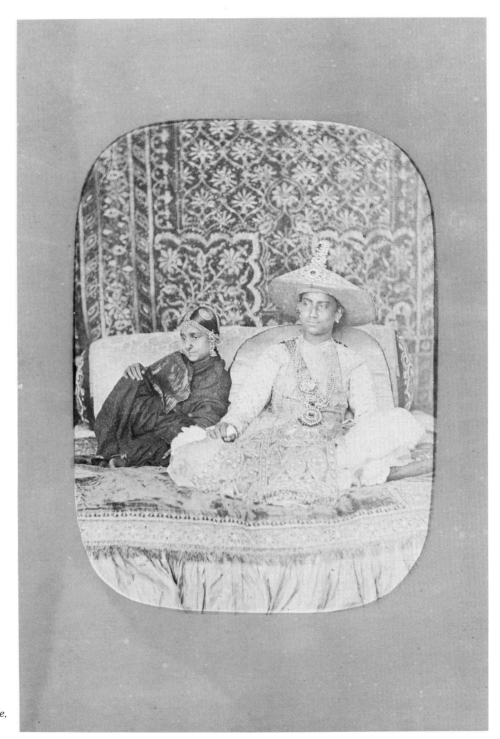

Photographer unknown: *The Royal Bath*, Delhi, 1890's.

Photographer unknown: *South India Raja and Child Bride,*
1870's.

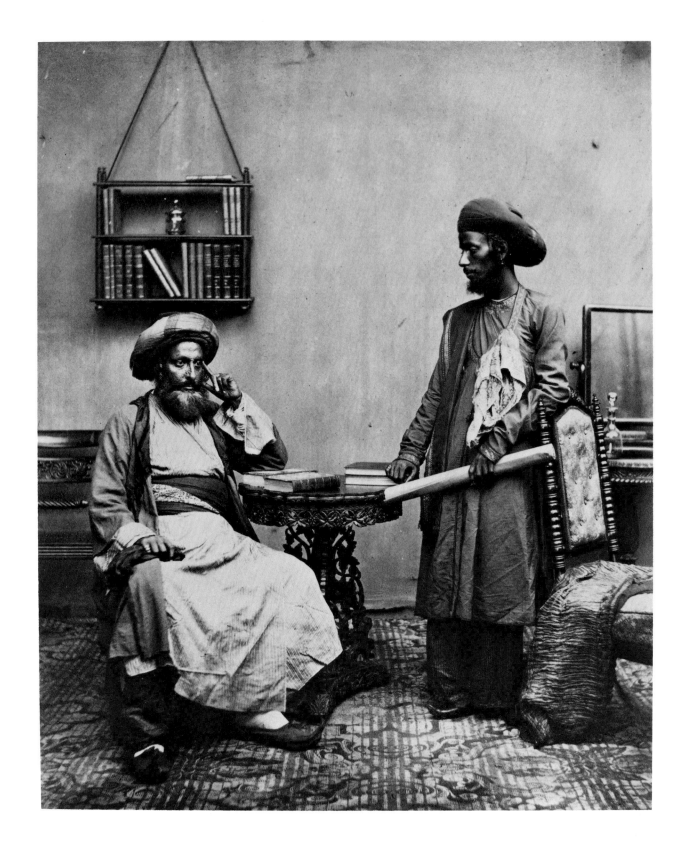

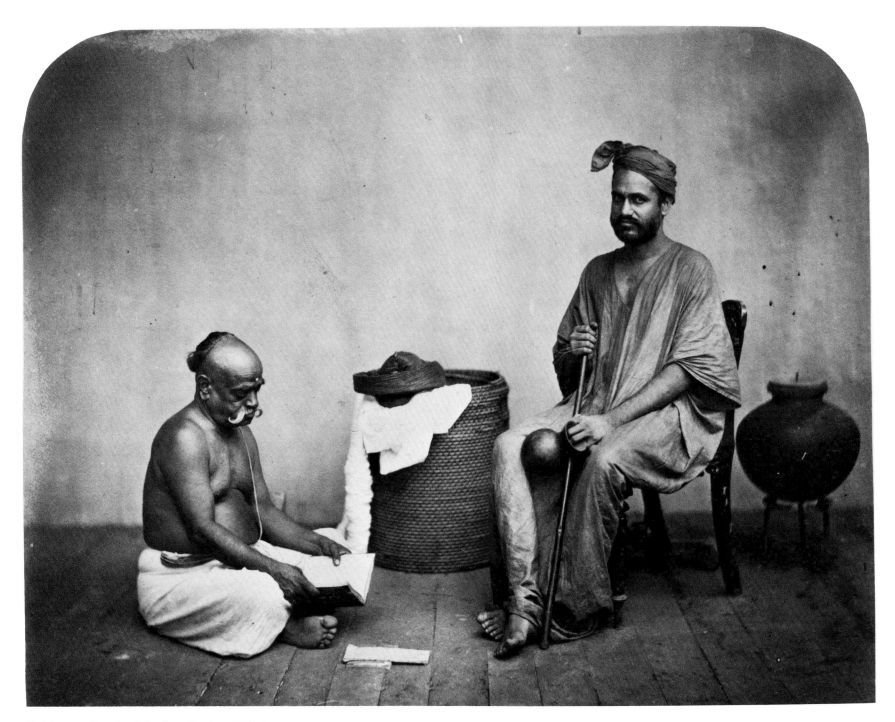

W. Johnstone: *Beni-Israel Teachers*, Bombay, 1856, from
Indian Amateur's Photographic Album.

The Beni-Israel are a sect of Jews who first settled in India
during the early years of the Christian era.

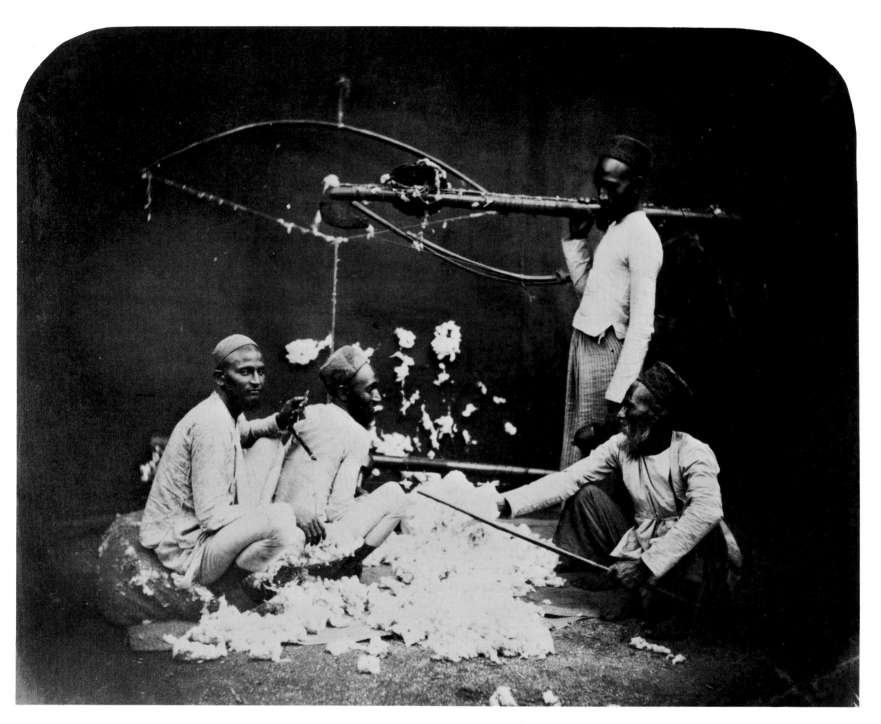

W. Johnstone: from *Indian Amateur's Photographic Album* (1856).

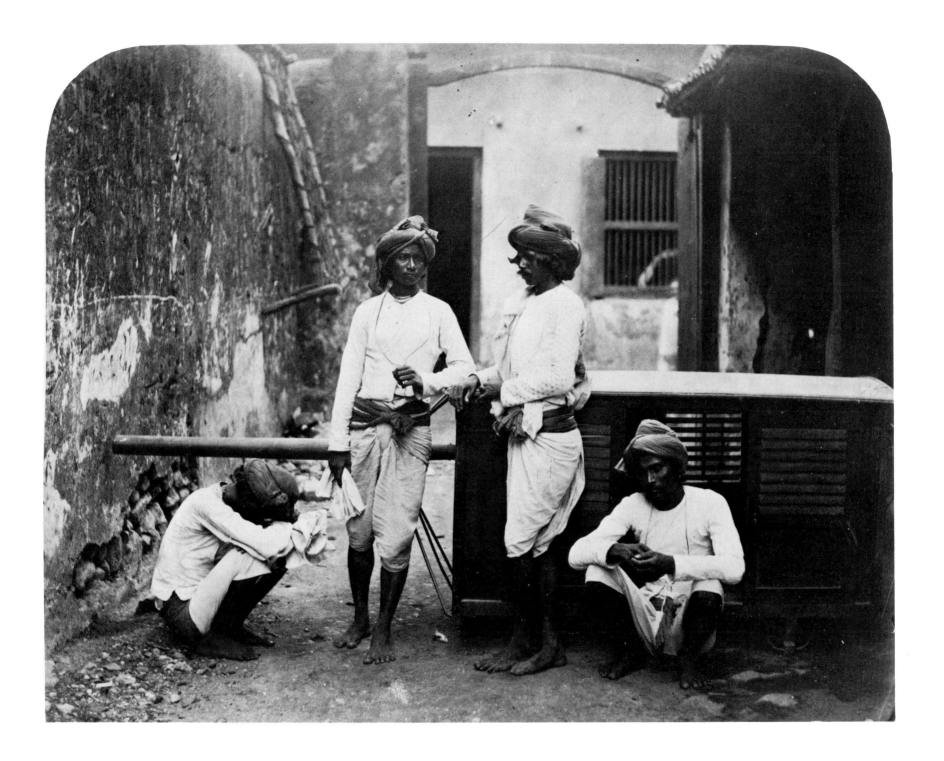

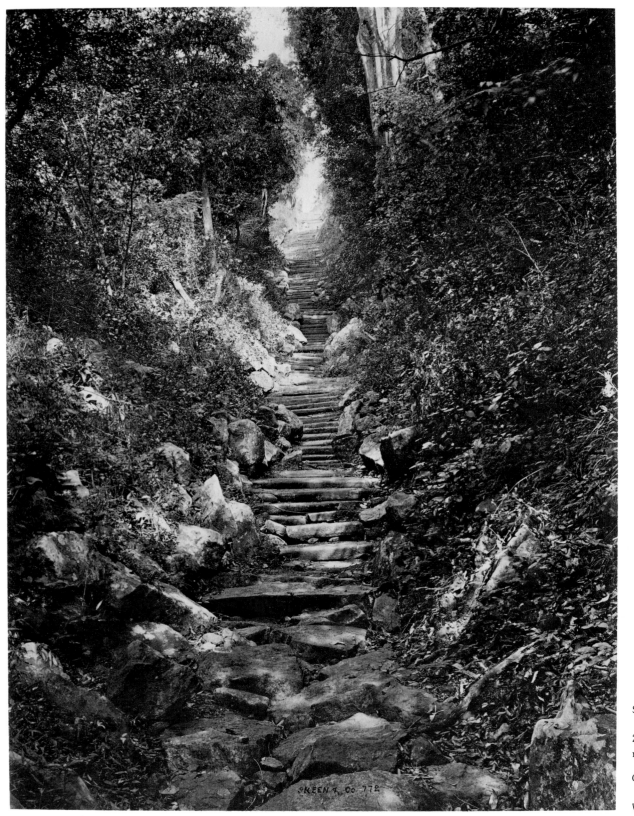

SKEEN 7 Co 772

Skeen: *Steps, Anuradhapura,* Ceylon, 1885.
 Anuradhapura, "the buried city of Ceylon," encompassing 256 square miles, was founded in 437 B.C. and abandoned as a royal residence in the ninth century A.D.

Capt. W. W. Hooper: *View in Goty,* 1870.
 This photograph is from an album of Indian scenes by V. S. G. Western and Capt. W. W. Hooper.

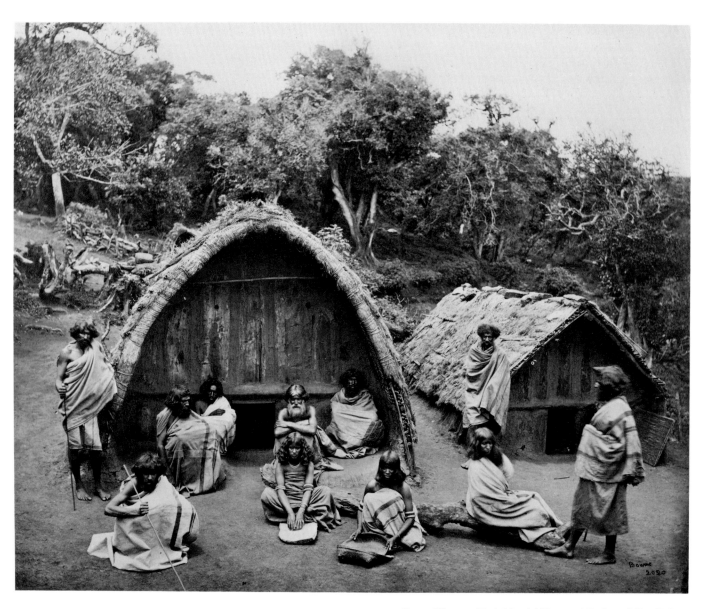

Samuel Bourne: *Toda Mund, Village and Todas*, 1868–69, Item 2020 in the Bourne & Shepherd catalogue.

Samuel Bourne: *Mussocks Crossing the Bea River below Bajoura,* 1866.

The *mussock* men used their inflated buffalo skins to float goods and passengers across swift-moving mountain streams. Bourne's dark-tent is visible under the trees. The dark-tent, like those of the other Victorian photographers in India, was made of the same bright-yellow material used to make the robes of Buddhist priests.

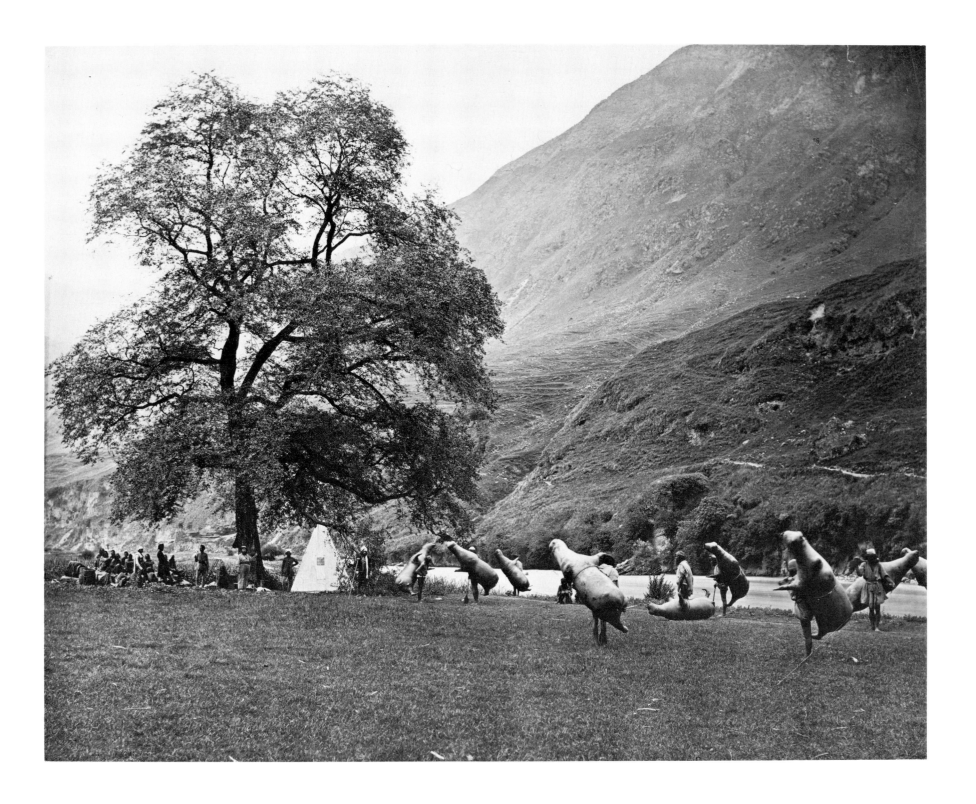

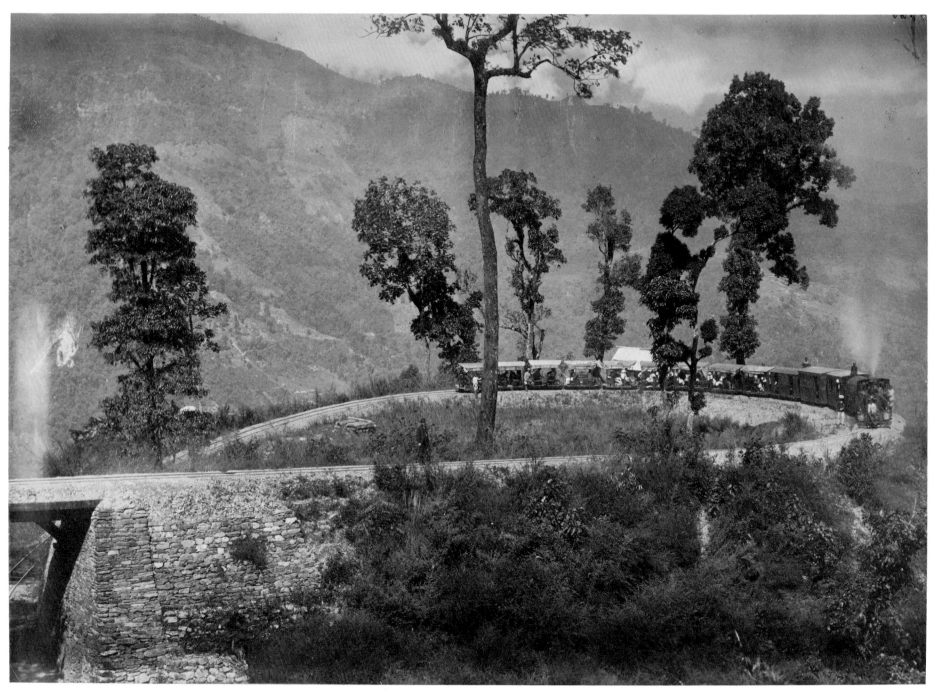

Photograph attributed to Johnston & Hoffman: *The Darjeeling-Himalayan Railway, the Loop below Tindharia,* 1885.

Constructed in 1879–81 with a two-foot gauge, the railway ran fifty-one miles from Siliguri to Darjeeling and took five and three-quarters hours to travel.

Scoween: *Giant Bamboos,* Peradeniya Gardens, Ceylon, 1880's.

This species of bamboo grew to a height of one hundred feet.

94

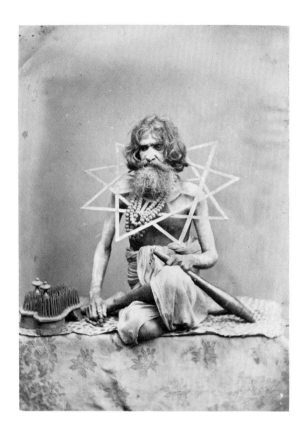
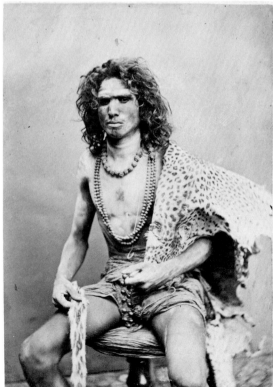
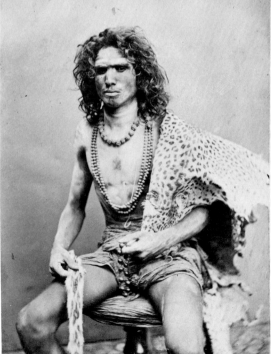

Photographer unknown: *Four Photographs from an Album Assembled by Capt. J. E. Parish,* 1871.

The photographs are: A. Juggler doing the sword trick. B. Fakir, Madras. C. Dumb fakir. D. Paimdaurum fakir.

Shepherd & Robertson: *Udasees (Fakirs),* Delhi, 1862.

This photograph was listed in the Bourne & Shepherd catalogue throughout the nineteenth century under the heading ''Groups of Native Character.''

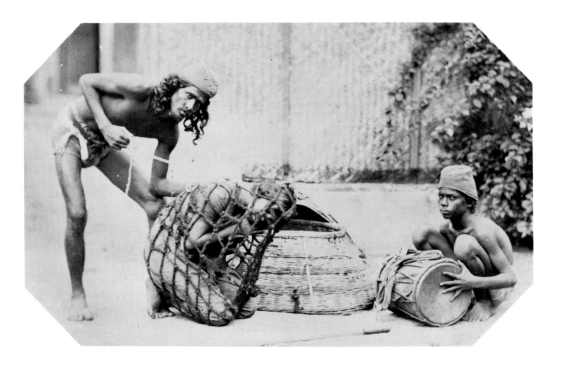

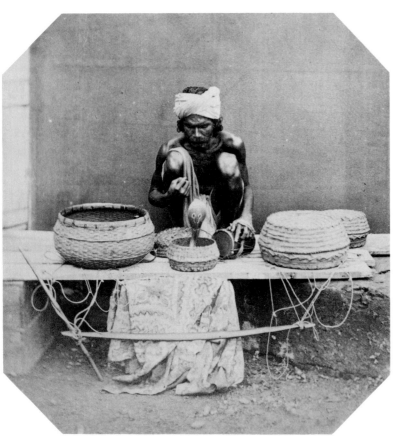

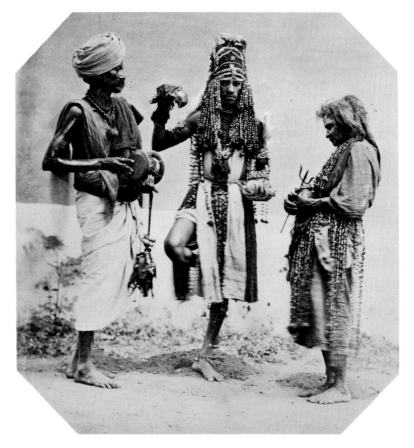

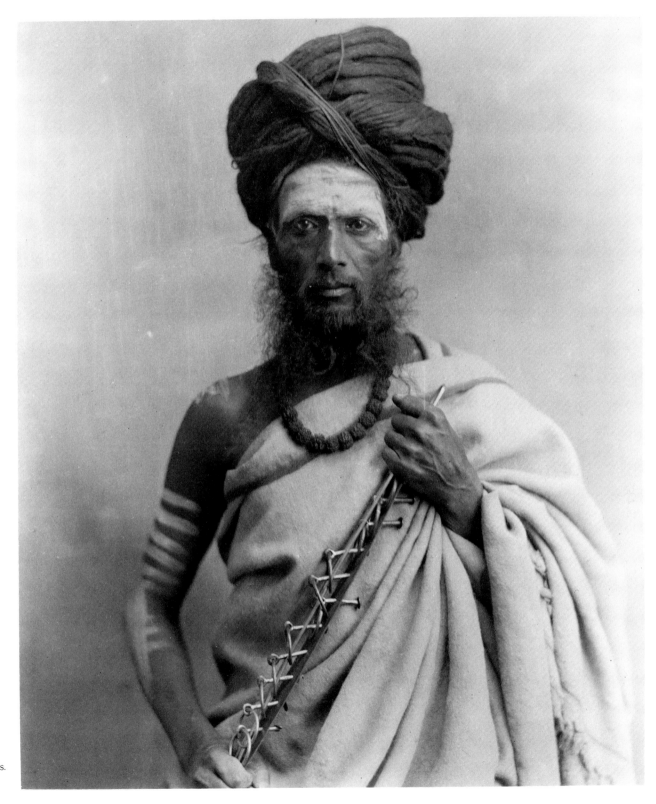

Photographer unknown: *Fakir*, 1890's.

Banatz Bros: *Mendicants*, 1890's.

97

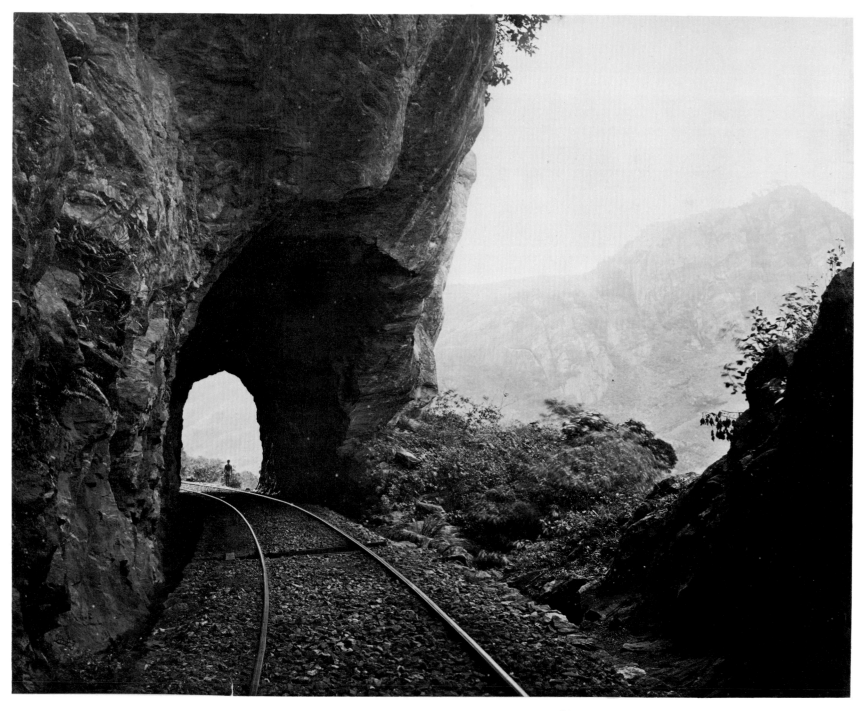

Photograph attributed to Bourne & Shepherd: *View on the Ceylon Railway Incline,* 1860's.

Capt. W. W. Hooper: *The Kill of the Decoy,* 1870.
 This photograph is from an album of Indian scenes by V. S. G. Western and Capt. W. W. Hooper.

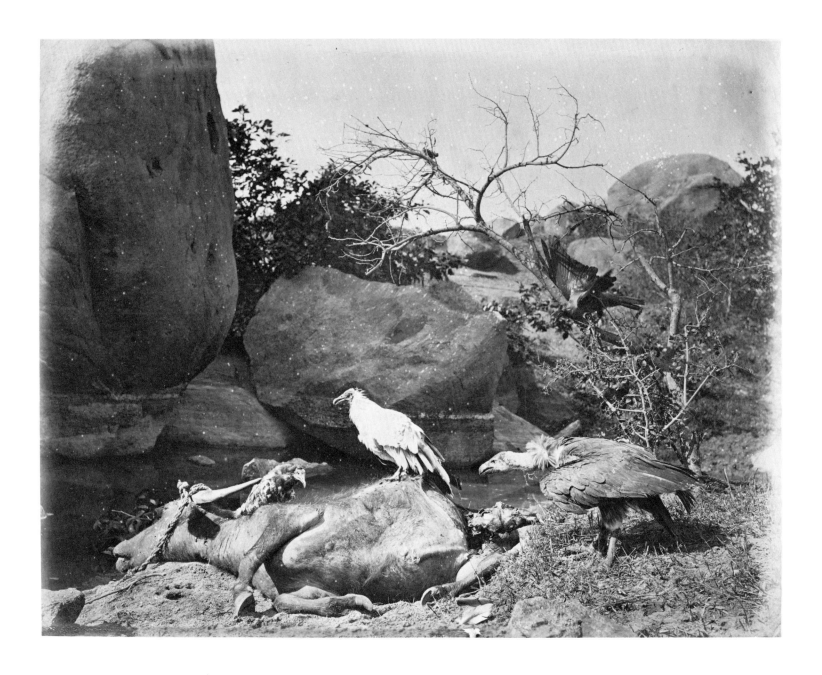

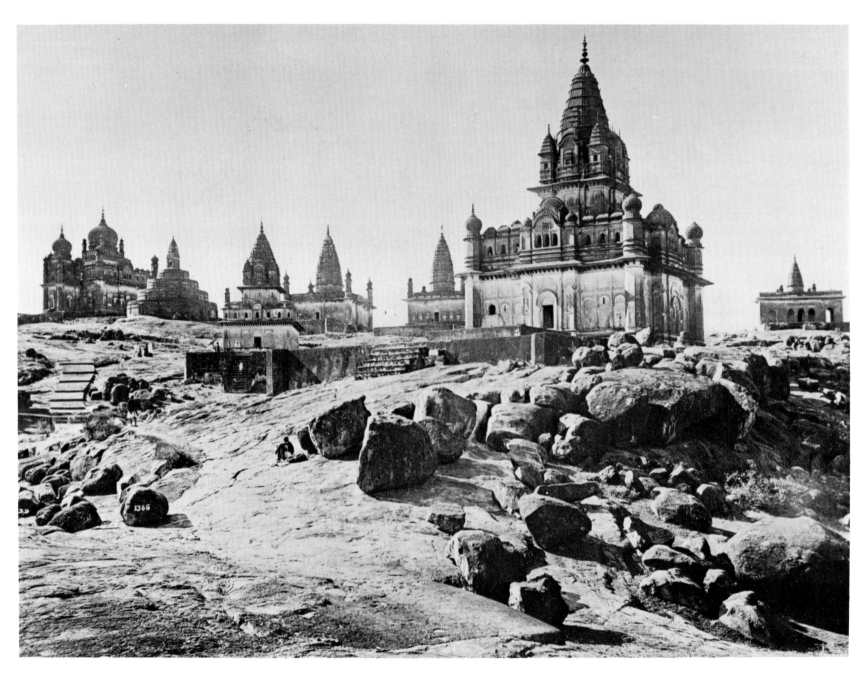

Photographer unknown: *Mausoleums of Brindela*, near Jhansi.

Bourne & Shepherd: *Maharaja Sindia of Gwalior*, January, 1877.

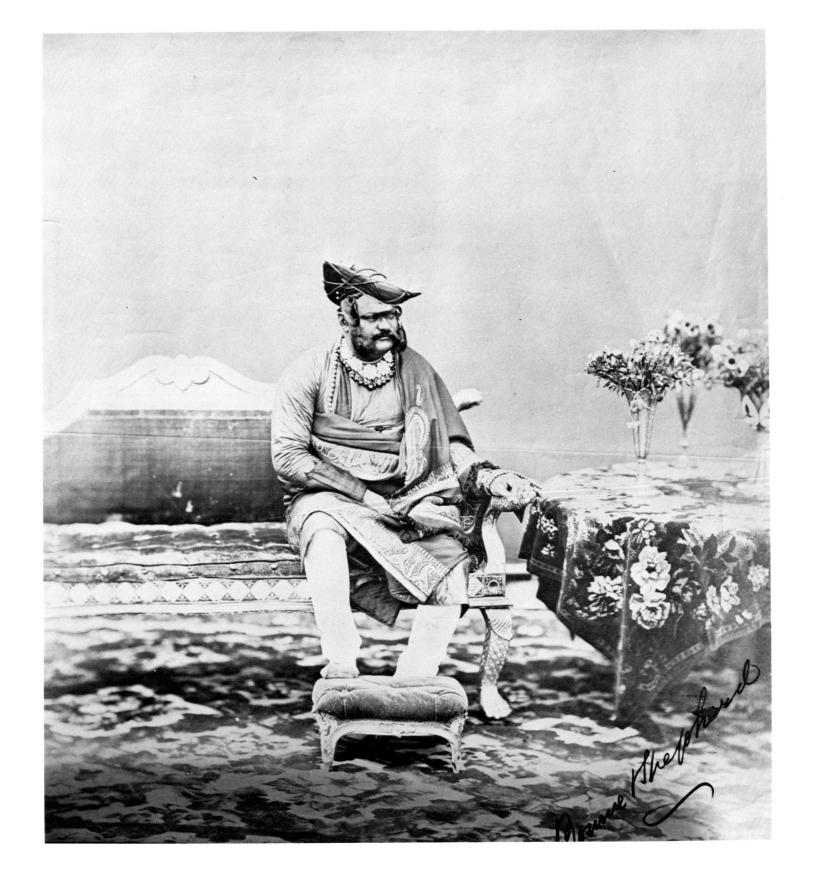

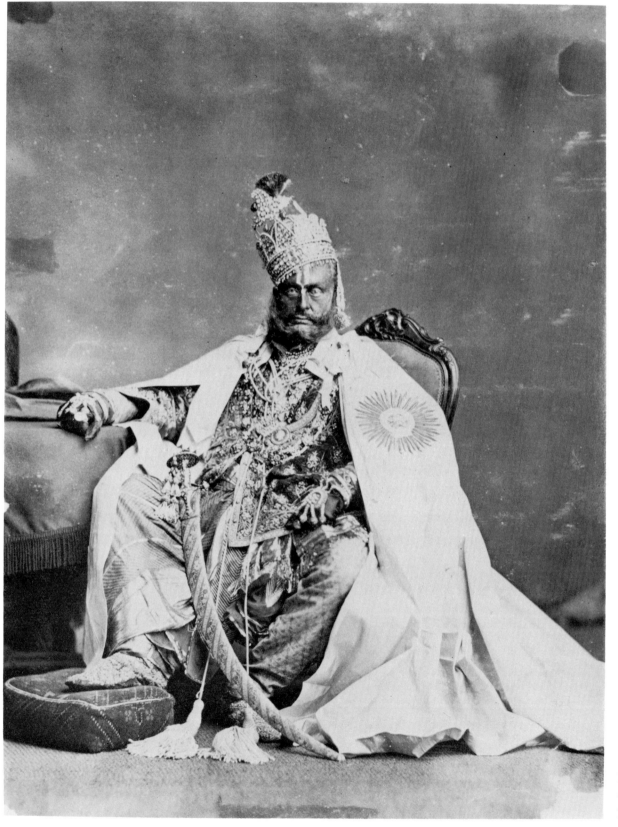

Photographer unknown: *The Maharaja Raghuraj Singh of Rewah.*

Photographer unknown: *Tomb of a Muslim Saint.*

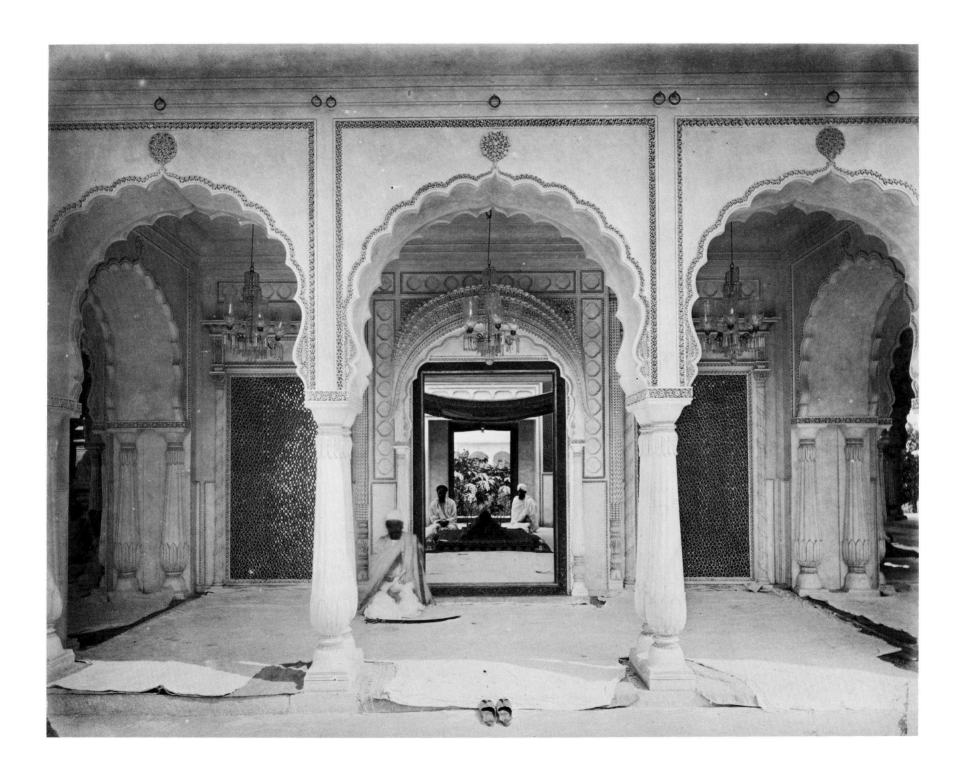

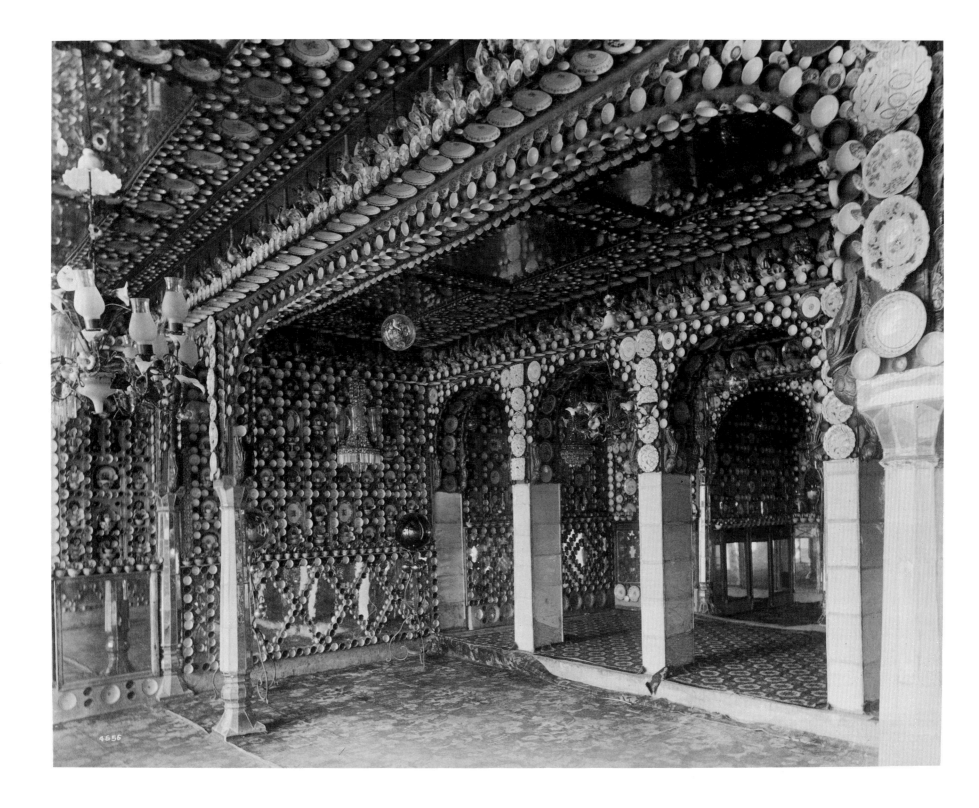

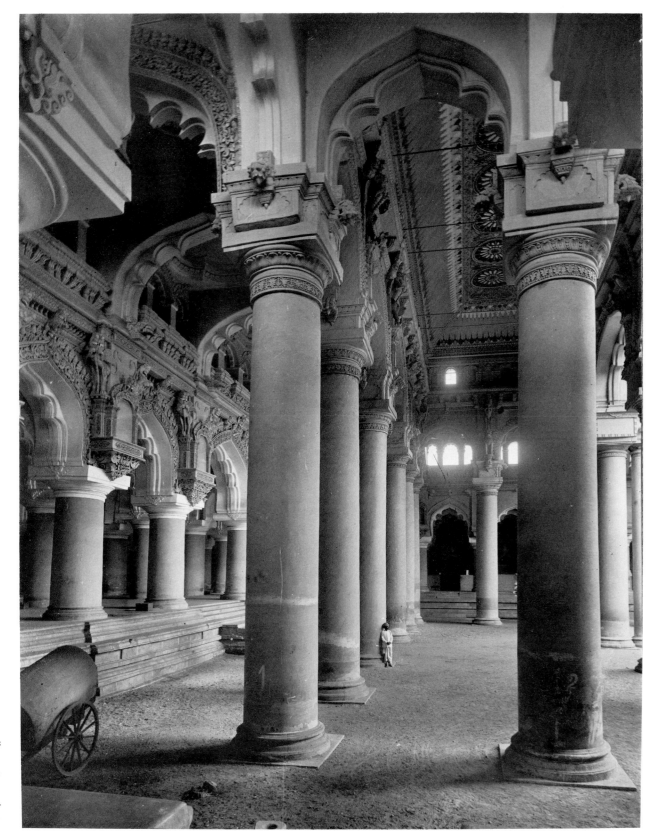

P. A. Johnston, for Johnston & Hoffman: *Interior, Tirumalai Naiks Palace,* Madura, 1885.

The scale of the interior of this palace is indicated by the figure posed against the pillar: the hall is 140 feet long and 70 feet wide; the height of the roof at the center of the dome is 70 feet.

Lala Din Dayal, *Chiniklana,* Hyderabad, 1880's.

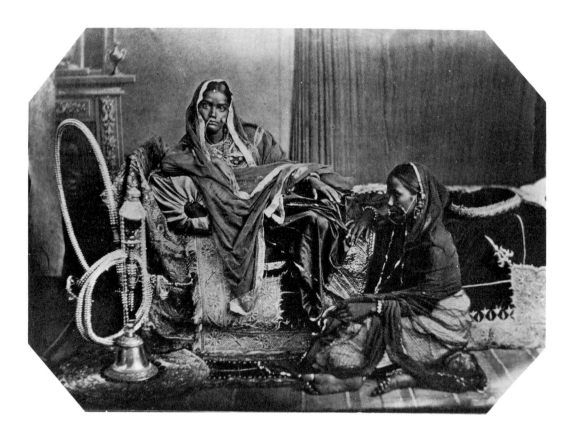

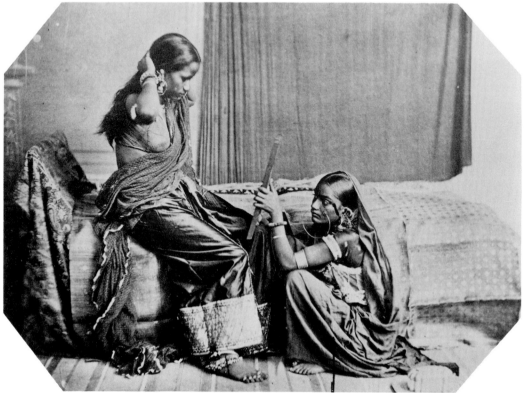

Photographer unknown: *Courtesans with Attendants.*

Photographer unknown: *Batiyah Man and Wife.*

106

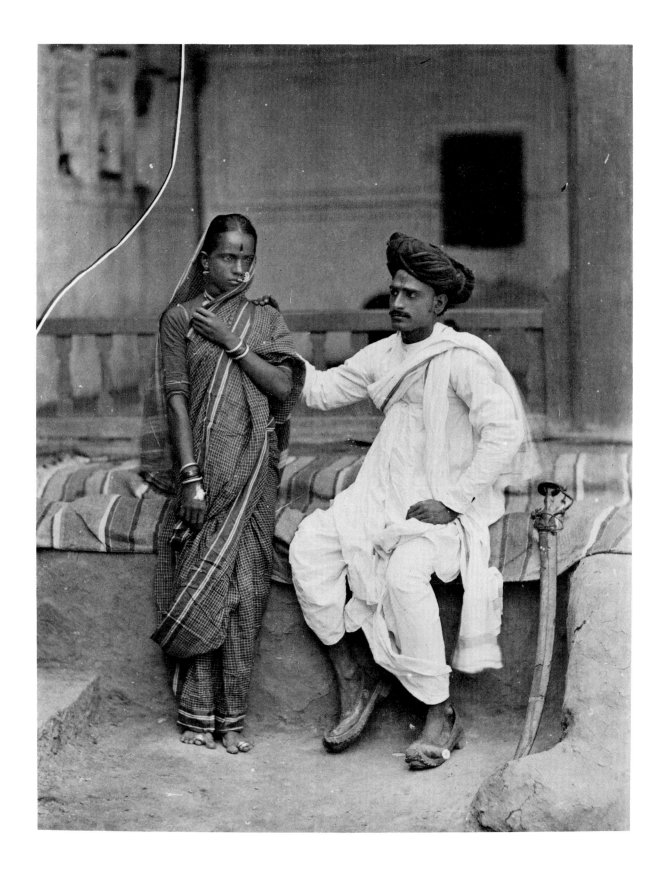

107

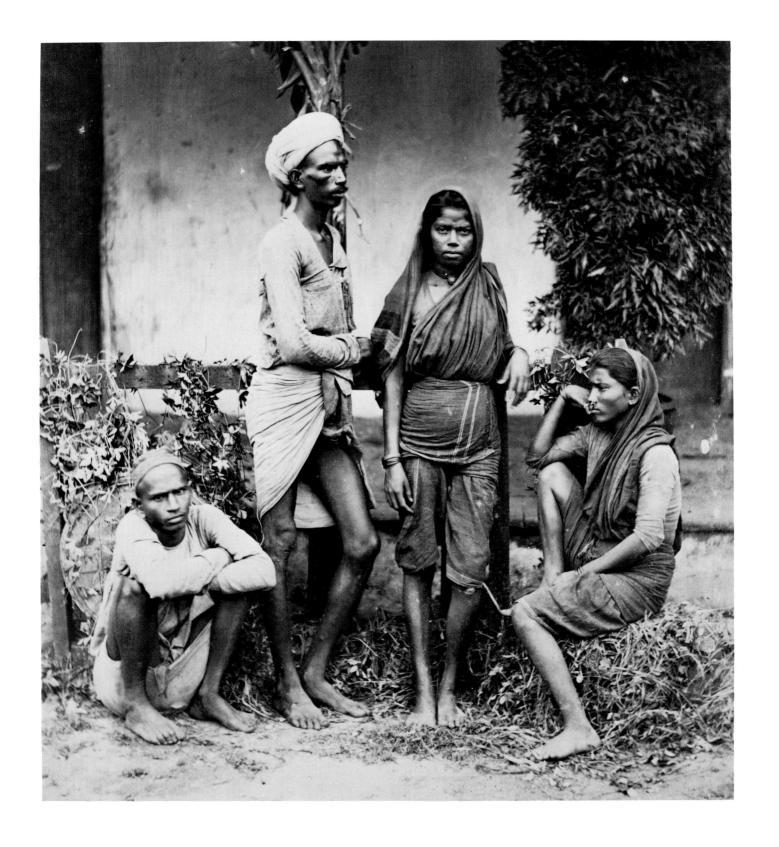

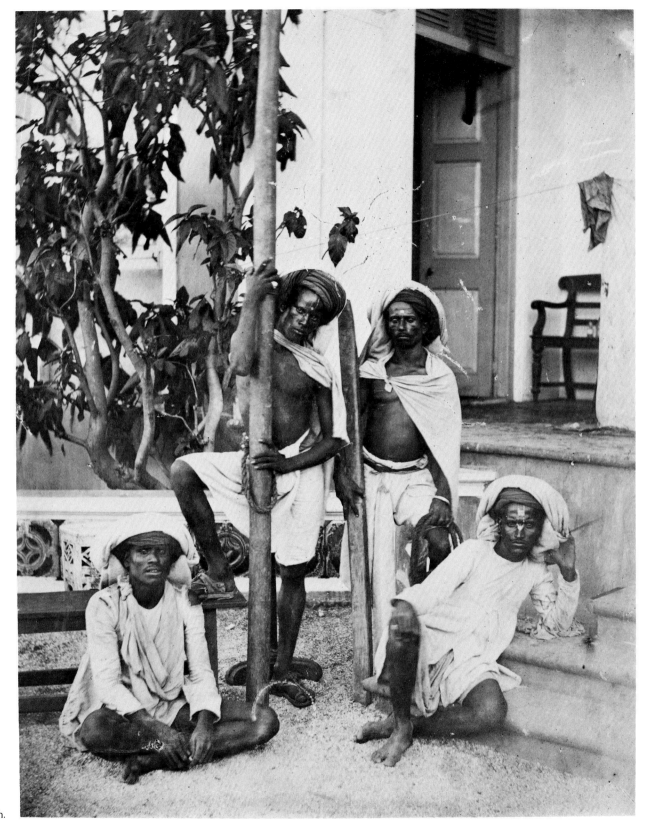

Lt. Churchill: *Native Groups*, Poona, 1860's, published by Frith.

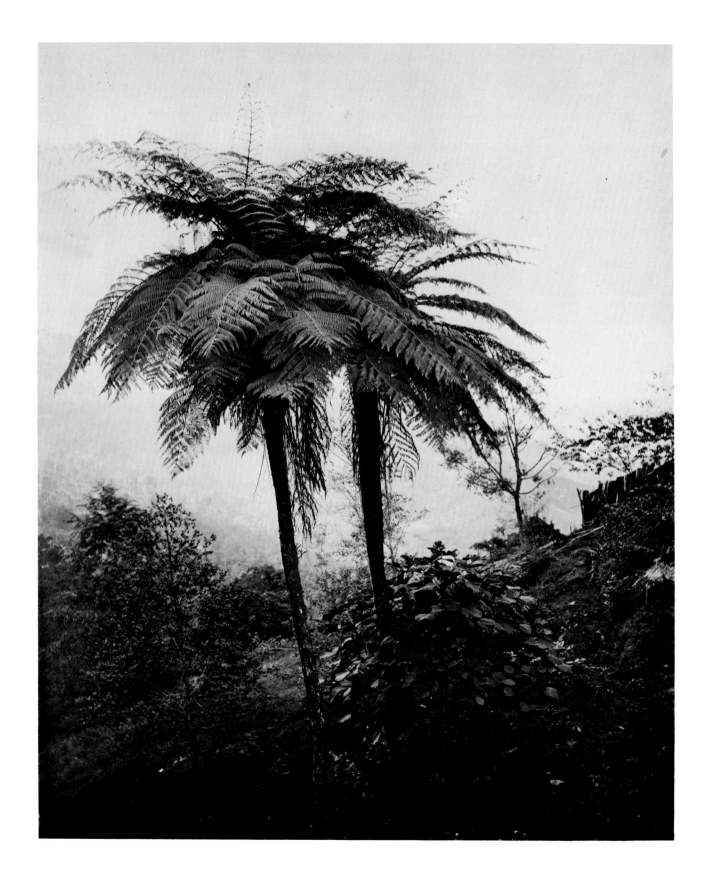

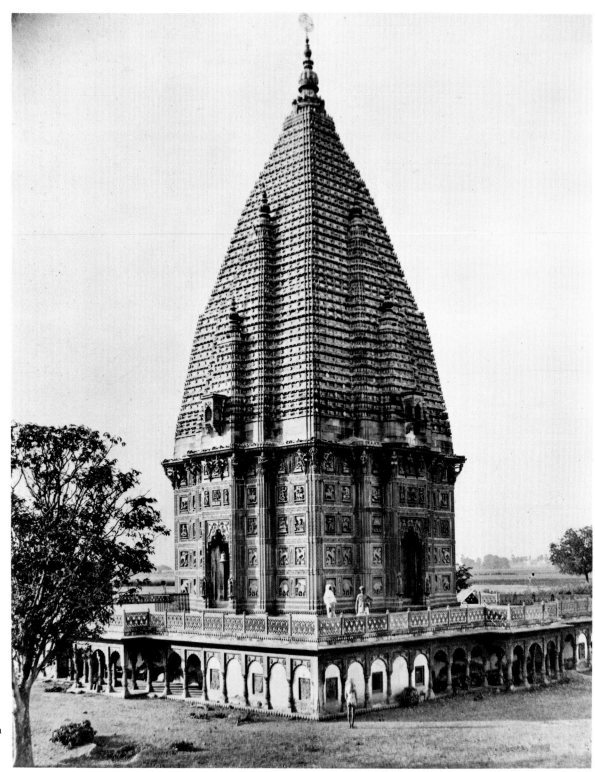

Samuel Bourne: *Sumeree Temple at Ramnaggur, from the Tank,* 1865, Item 1175 in the Bourne & Shepherd catalogue.
 On the platform, left, may be seen Bourne's other camera on its tripod.

Samuel Bourne: *Tree Ferns,* Darjeeling, 1869.

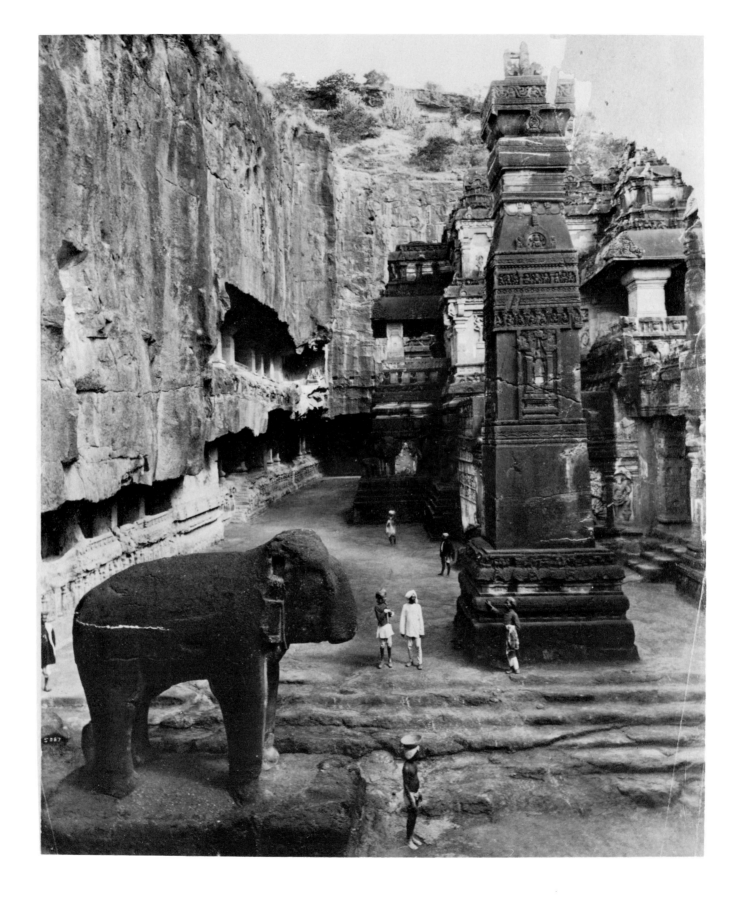

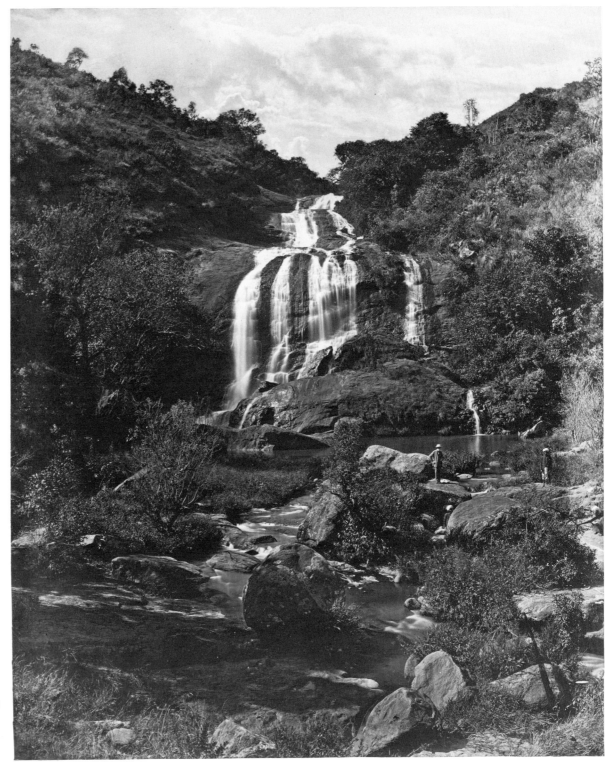

Lala Din Dayal, photographer to H.H. the Nizam: *Ellora, the Kailasa Temple*, 1890's.

Constructed between A.D. 725 and 755 by excavating 200,000 tons of solid rock, the Kailasa Temple is considered the noblest Hindu memorial of ancient India.

Capt. E. D. Lyon: *Kulhulty Falls*, Cotacamund, 1860's.

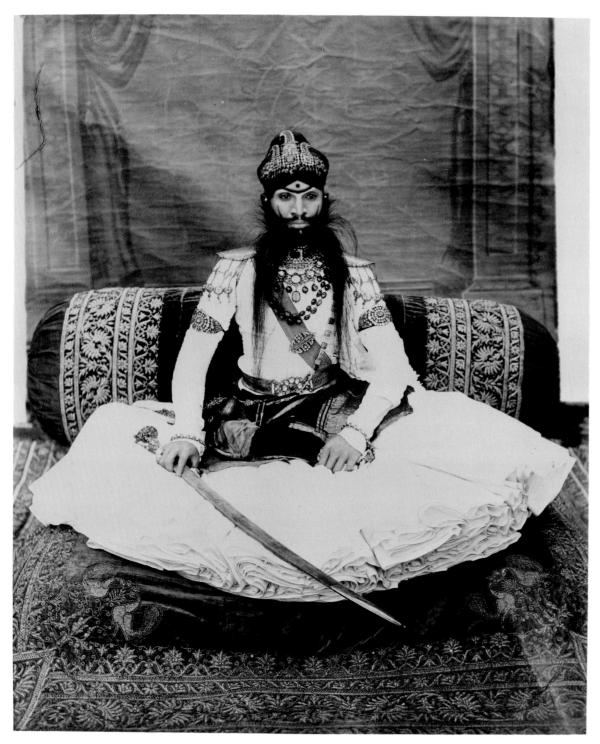

Ganpatrao Abajee Kale: *The Maharao Raja Raghubir Singh Bahadur*, Bundi, 1888.

The Maharao Raja was one of the surviving vestiges of the traditional Rajput royalty, living as his family had in the seventeenth century before the days of the British.

Photograph attributed to Howard: *Hurkara Camels*, Poona, early 1860's.

114

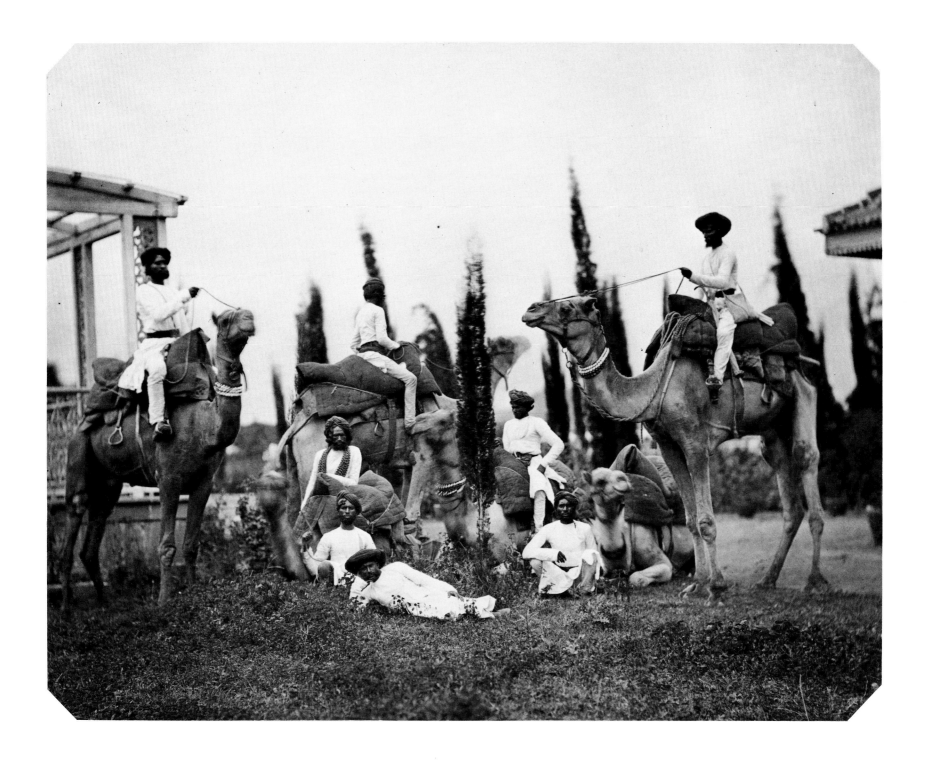

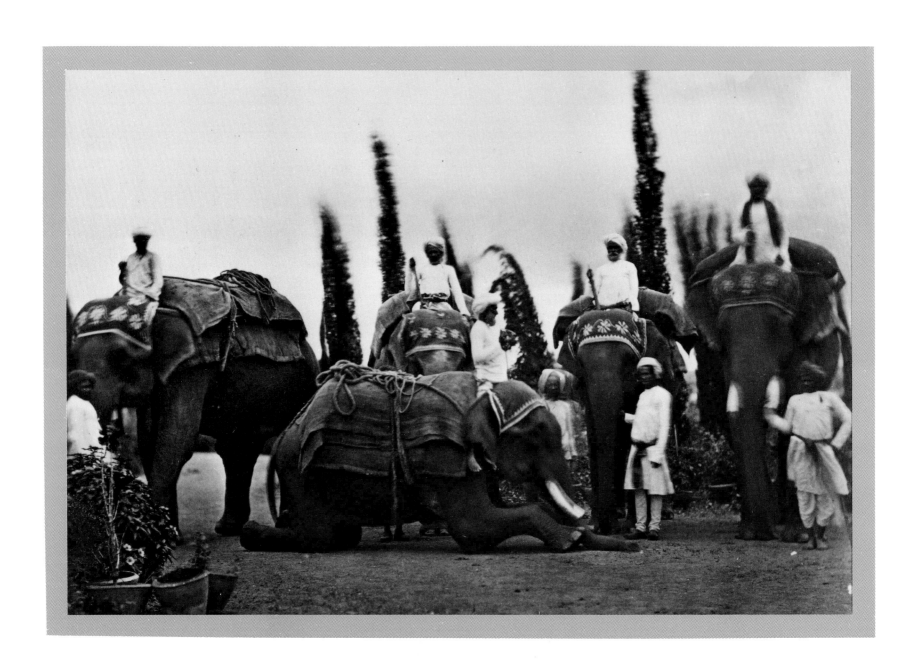

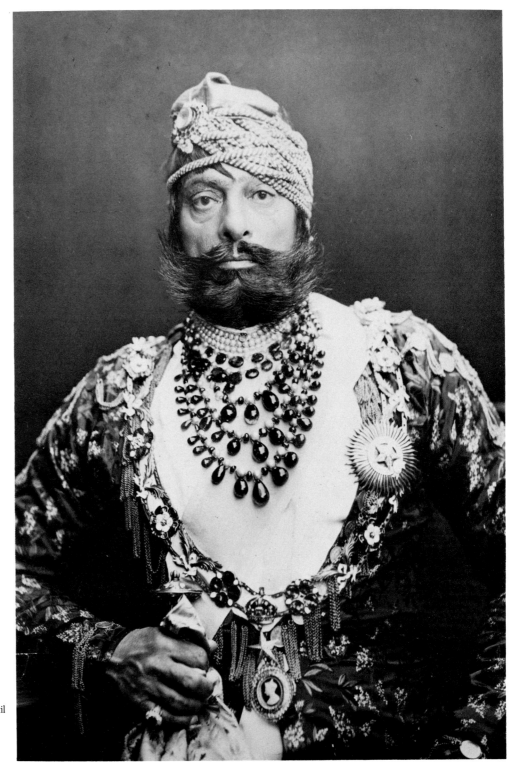

P. A. Johnston, for Johnston & Hoffman: *The Maharaja of Jodhpur, H.H. Sir Jaswant Singh Bahadur*, 1880's.
 The Maharaja ruled a population of 2,524,030 from 1873 until his death in 1893.

Photograph attributed to Howard: *Elephants and Attendants, Poona*, early 1860's.

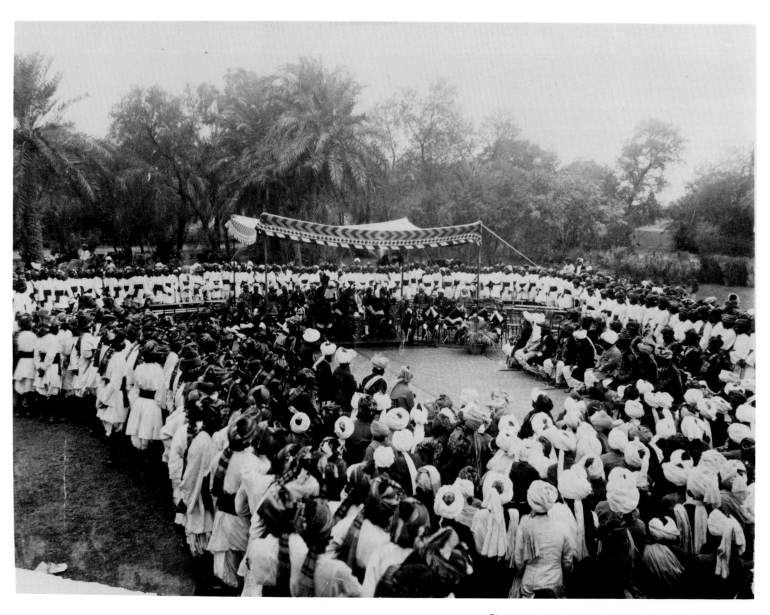

Photographer unknown: *Cureton's Multanis,* Durbar, 1903.

Photograph attributed to Maj. Gill: *Ajanta Caves,* Bombay, 1860's.

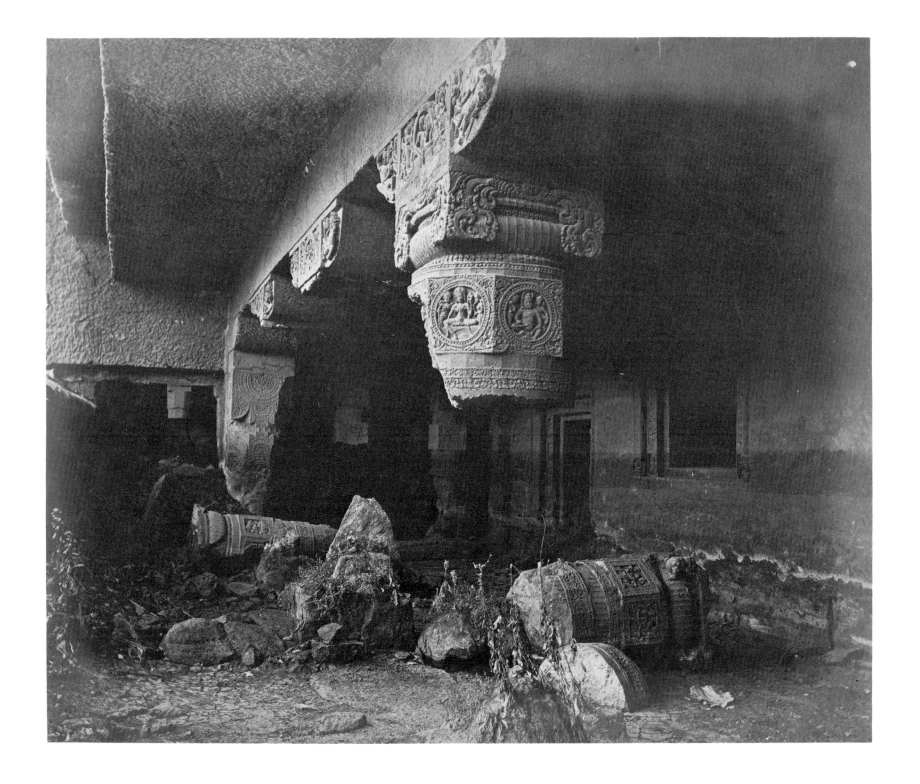

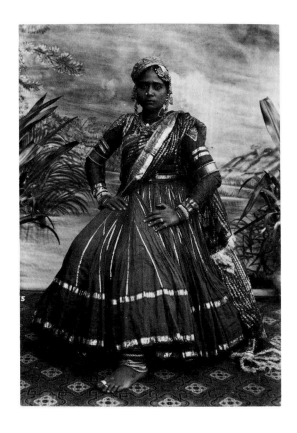

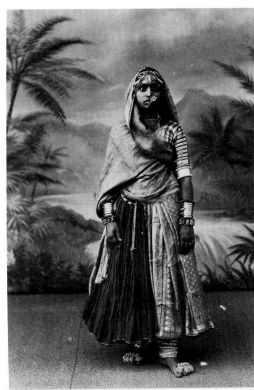

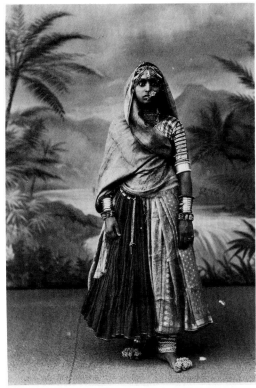

Photographer unknown: *A Hindu Gentleman.*

Johnston & Hoffman: *H.H. Sir Sardar Singh Bahadur, Maharaja of Jodhpur, as a Boy.*

Photographer unknown: *Nautch Girl.*

Photographer unknown: *A Marwaree Woman.*

Photographer unknown: *A Parsee.*

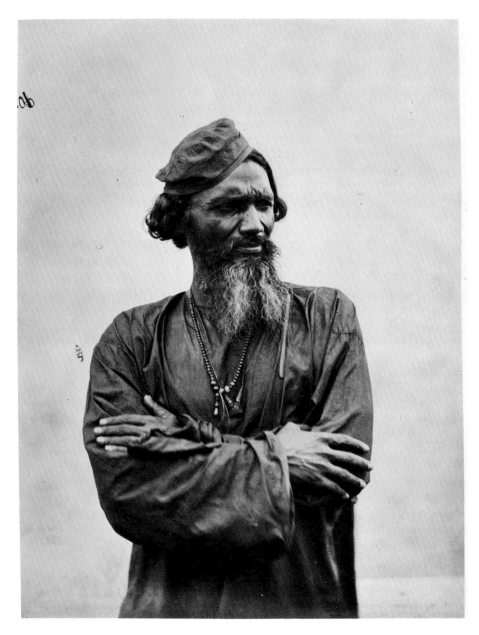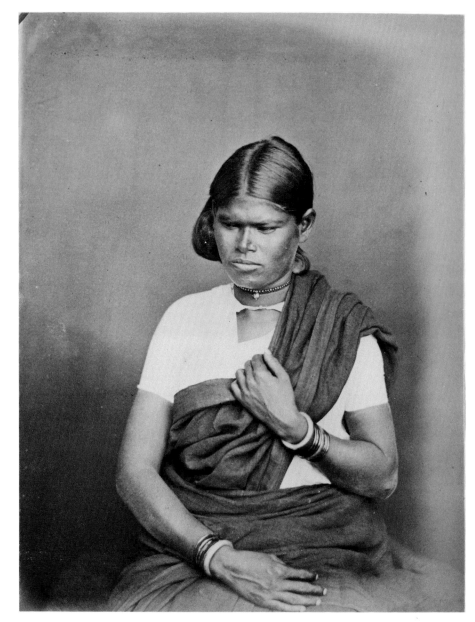

Photographer unknown: *Native Types*.

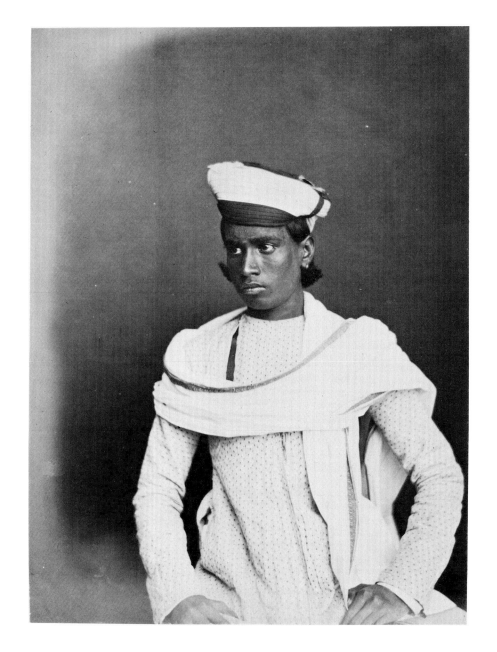
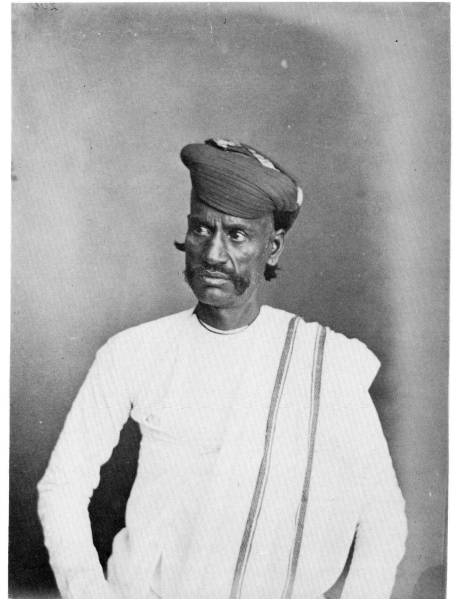

123

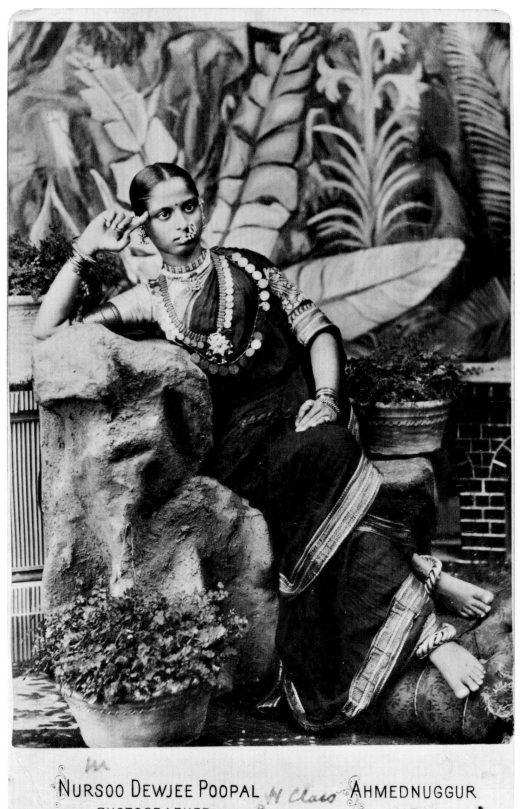

NURSOO DEWJEE POOPAL AHMEDNUGGUR
PHOTOGRAPHER. INDIA.

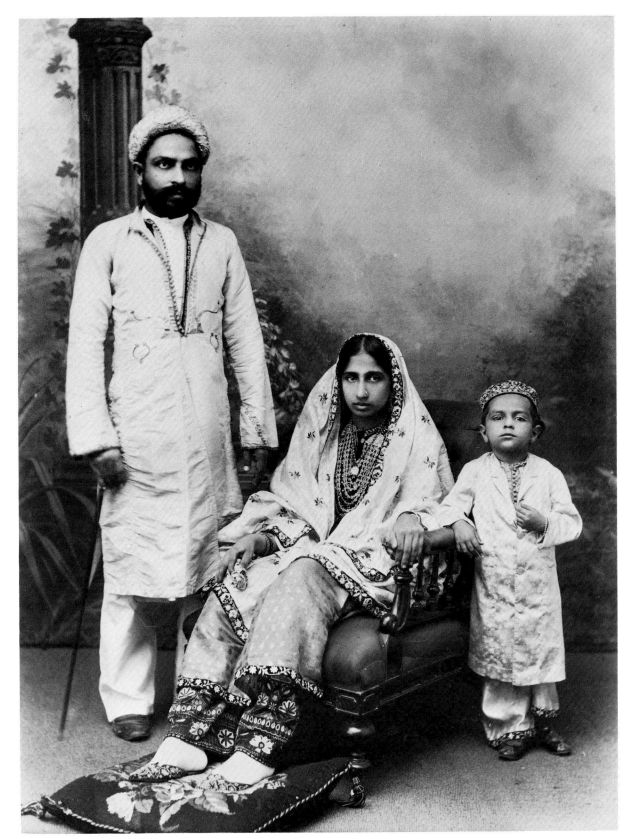

Photographer unknown: *Parsee Family.*

Nursoo Dewjee Poopal: *Studio Portrait,*
Hindu Girl, Ahmednuggur, 1880's.

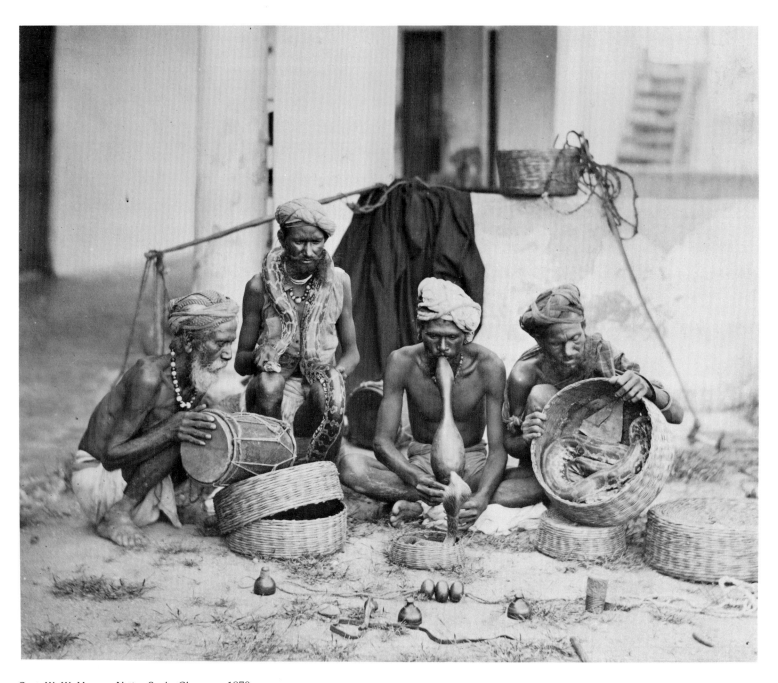

Capt. W. W. Hooper: *Native Snake Charmers*, 1870.

Domestic Village Scene, 1870.

Both photographs are from an album of Indian scenes by
V. S. G. Western and Capt. W. W. Hooper.

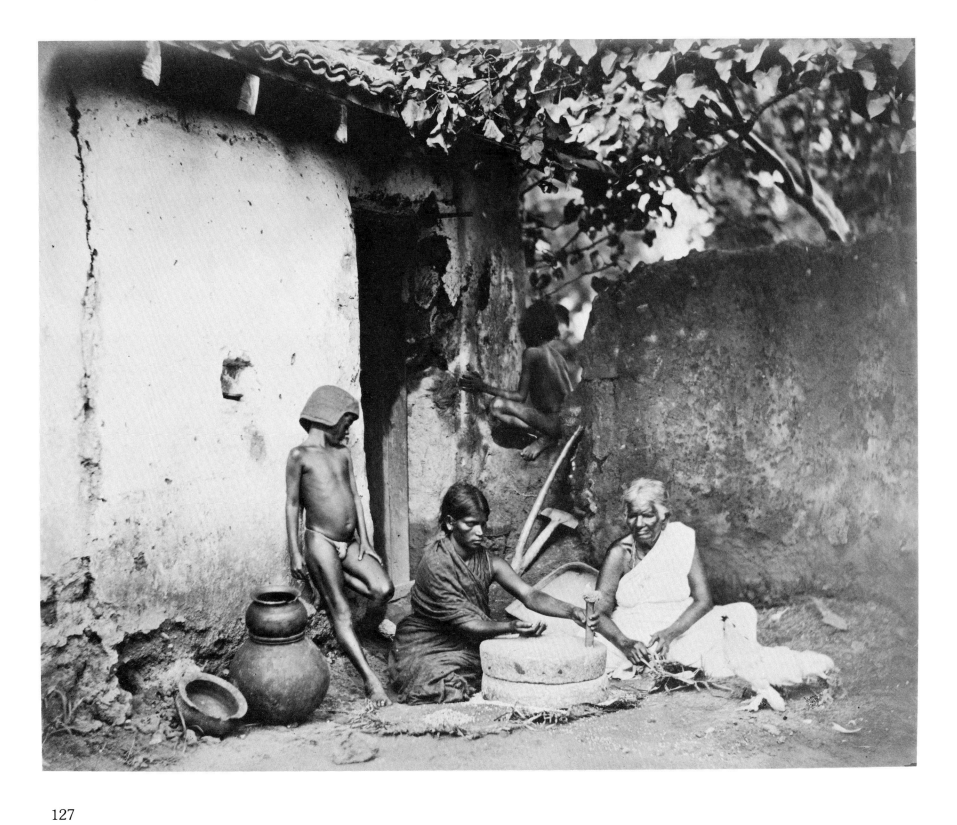

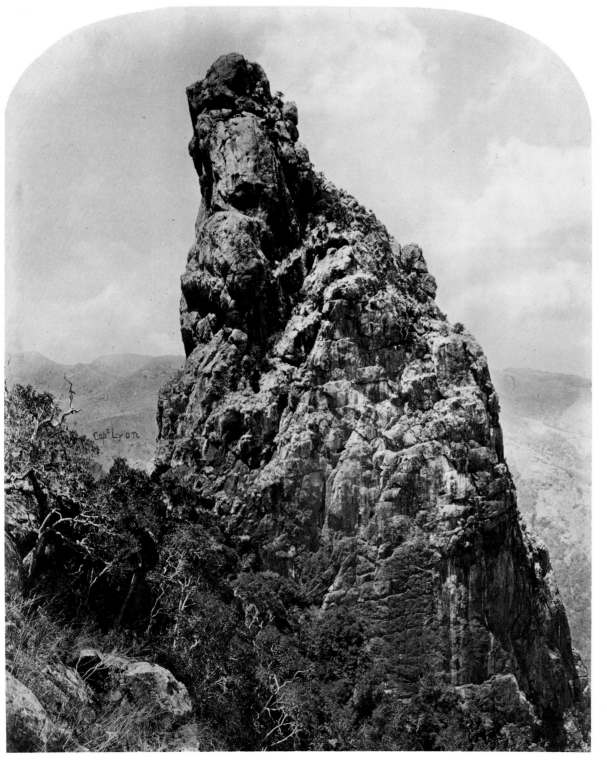

Capt. E. D. Lyon: *Kungaswami Pillar*, 1860's.

Robertson: *Distant View of the Fort of Bassein*, Bombay, early 1850's.

 Robertson was a founding member of the Bombay Photographic Society, 1854.

Photographer unknown: *The Black Rocks*, Mutti Mahal, Jubble-
pore.

Colin Murray: *Moulmein, View on the River near the Rope
Station*, 1870's.

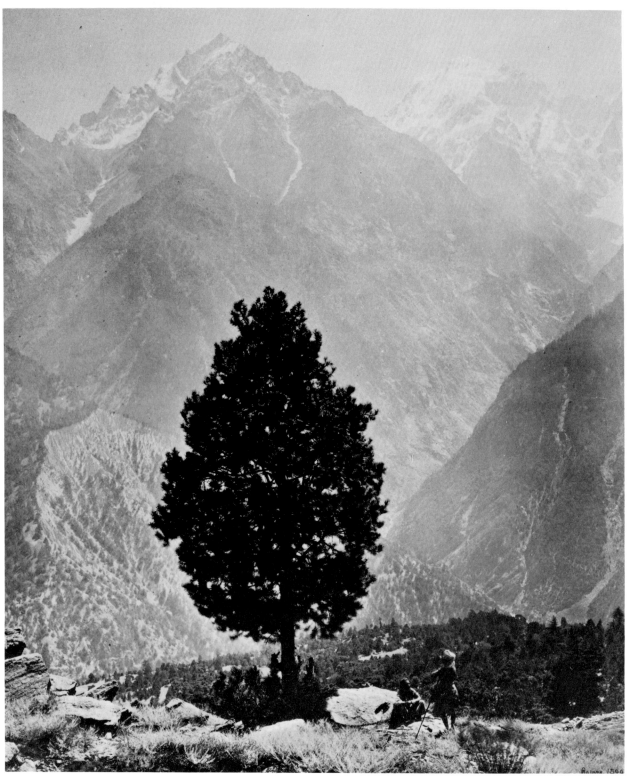

Samuel Bourne: *Specimen of the Edible Pine*, 1866.
 Samuel Bourne took this view near the village of Sungla on his third and final trip into the Himalaya.

Skeen: *Reclining Buddha*, Gal Vehera, Polonnaruwa, Ceylon, 1880's.
 This forty-six-foot-long figure was cut out of living rock.

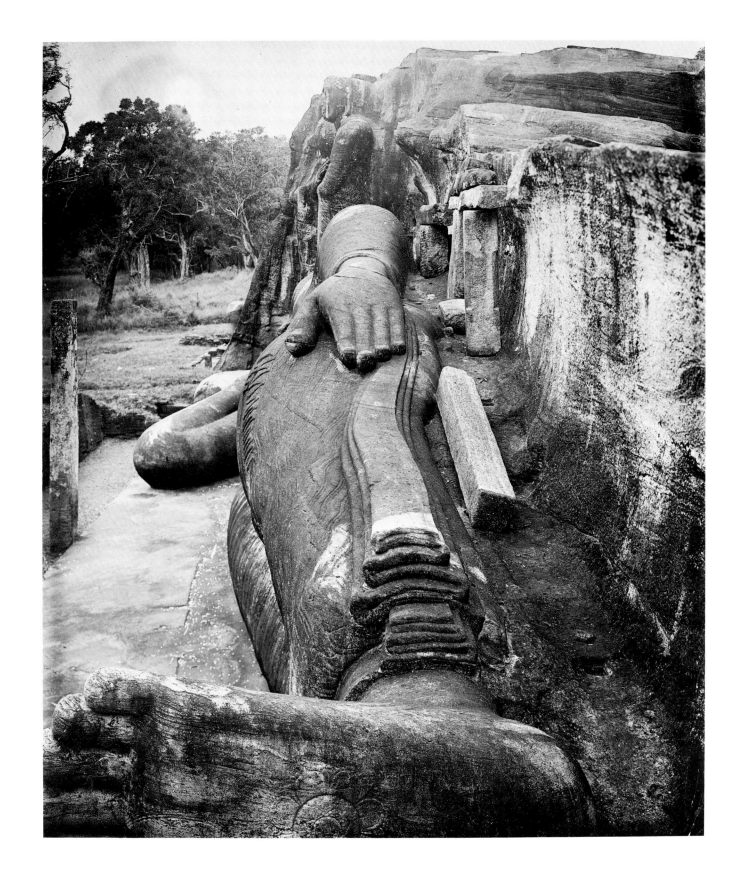

133

The Rulers and the Ruled

The camera recorded India in the nineteenth century, but it also projected upon India an understanding of what the British saw, thought and felt about the land and civilization of which they were masters. The great achievement of the photographers was not that they recorded the "real India," but that they presented with such candor how they, and those for whom they worked, felt about India. Victorian India produced an immense literature — works of great scholarship, travelers' tales, novels, poetry, government reports, propaganda of all kinds — but these photographs convey both the physical reality of India and the interpretation the British gave to their experience.

One tenet of Indian philosophy is that we ordinarily do not see reality, but impose upon it the products of our own perceptions as does the man who sees a piece of rope upon the road and thinks it is a snake. The point of the story is that reality matters less than the man's reaction. So with these photographs: the significant reality they portray is an interpretation of the British presence in India. This presence was in terms of chronology only a brief moment in the history of India or even of England, but it remains one of the fascinating episodes in the complex story of how civilizations and cultures interact.

At different times, the British explained their presence in India as accidental, an empire won in a fit of absence of mind; sometimes, as a saga of moral courage and superior virtue; as a story of greed and lust for power. And not a few believed with passionate sincerity that British dominion in India was the working out of Divine Providence. One can accept any — or none — of these explanations, and see British rule in India as an historical episode that was produced, almost with a sense of inevitability, by the confluence of the great movements of modern history.

Internally, and almost without relationship to the outside world, the tenuous centralized political control that the Mughal dynasty had imposed upon the subcontinent was being replaced by dynamic forces working within Indian politics. It was as one of these forces that the British contended for power in the eighteenth and nineteenth centuries.

This dominance had not been achieved either quickly or easily, and it did not last very long — two centuries at the most. The consolidation of British power in India involved many wars and much intrigue, with the century being neatly bounded on one end by the Battle of Plassey in 1757, which established British influence in Bengal, and on the other by the Great Mutiny of 1857. The second, and final, part of the story lasted not quite a hundred years. The symbolic end came on August 16, 1947, when two new dominions, India and Pakistan, inherited the old Government of India. But, long before that, all but the dullest and most intransigent had known that the story was over, that much the same forces which had brought the British to India in the first place, industrialization, urbanization, nationalism, competition for markets, were now to sweep them away.

The real boundary marks of British power in India, then, are much narrower: 1857 at one end; at the other, 1911, the year the capital of India was shifted, with great pomp, from Calcutta to Delhi. It was meant, of course, to symbolize the permanency of British power and its links with the enduring memories of India's past. But Delhi is more than the site of former empires; it is, above all, the graveyard of kings. The Viceroy was percipient when he forbade the singing of

"Onward, Christian Soldiers." His objection was not to the inappropriateness of the imagery for a Hindu and Muslim country, but to the lines "Crowns and thrones may perish,/Kingdoms rise and wane." Delhi was indeed to be a great capital again, but not for the British. So the full expression of British supremacy in India lasted scarcely sixty years: old men who remembered the desperate days of the Mutiny of 1857 in Delhi saw the King-Emperor enthroned there in 1911. From this brief period come the memories, the images and the myths of British rule in India that are encapsulated in this photographic record.

India was being brought into the Western world system that had been created by the Europeans, and for the next two hundred years its destiny would be linked, not with Central Asia and Persia, as it had been for six hundred years under Turkish dynasties, including the Mughals, but with Western Europe. Of the three great Asian culture areas, China, Japan and India, only India was to come directly under European rule. The significance of this fact is not clear, either for the past development of these civilizations or for the future, but some generalizations can be made with fair confidence. Perhaps the most obvious is that throughout the nineteenth century, and on into the first half of the twentieth century, India was unique among the world's great cultural areas in having rulers who were alien in language, religion and customs.

The result was not just social distance between the rulers and the ruled — which is commonplace in all societies — but a sense of two worlds passing each other in different orbits. For the English, this sense of distance was revealed in an interesting paradox. On one side was the familiar insistence by the old Indian hand on his understanding of the natives, on his knowledge of the way their minds worked, on his ability to get along with them. But this was balanced by the other emphasis that runs through much of nineteenth-century writing about India: the insistence on the mystery of India, the hidden things that no European can fathom — "the spirit of the Horrible," as one writer said, "mingled with the Sublime."

The British intrusion was not, as it is sometimes pictured, an armed invasion from the West. The British had been in India as inconsequential traders since the beginning of the seventeenth century. They began to matter only in the middle of the eighteenth century, when conditions in Bengal, the center of the East India Company's trading activities, made political intervention possible. The weakening of the authority of the Mughal Emperor at Delhi over the outlying provinces of the Empire gave his deputy, the Nawab of Bengal, an opportunity to create what was in effect an independent dynasty in the present Bangladesh and the Indian states of West Bengal, Bihar and Orissa. By 1750, the Nawab had become aware that the East India Com-

Calcutta and Delhi: *Calcutta, "the City of Palaces," was until 1911 the capital of British India. It was originally made up of three small villages on the bank of the River Hugli, where the British East India Company built Fort William in 1696 to protect their trading interests. In the nineteenth century it became the second largest city in the British Empire and a center of immense trade and wealth. It was also the intellectual capital of India. The British were never really fond of Calcutta; Kipling called it "the city of Dreadful Night." The decision in 1911 to move the capital to Delhi was an attempt to give a new base for British rule. Delhi had been the capital of many rulers, including the Mughals, who had moved the capital there from Agra in the middle of the seventeenth century. It figures largely in the history of the British in India in the nineteenth century because it was the focal point of the Mutiny in 1857. The capture of the walled city of Delhi by the rebellious soldiers of the Indian Army, the long siege by the British, the final recapture of the city, and the punishment meted out to the rebels are among the most memorable chapters of the history of the British in India.*

pany, with its headquarters at Calcutta, was beginning to impinge on his authority, especially when his Indian subjects took advantage of trading connections with the English to escape his taxes.

In 1756, the young Nawab, who had just come to power, decided to end the nuisance by dispossessing the English from their holdings at Calcutta, which they had on lease from his predecessors. The result was one of those events, like the Mutiny of 1857, that colored the imagination of the British in India all through the nineteenth century: the Black Hole of Calcutta. After taking Calcutta, the Nawab had shut his English prisoners in a small room; in the heat and humidity of a Bengal night, fifty or so had died. By modern standards, the event would scarcely have deserved notice for more than a day or two in the papers, but for the British of the time it became a talisman for defining Indian treachery and cruelty.

That the English were able not only to reestablish themselves the following year at Calcutta, but to overthrow the Nawab in 1757 at the Battle of Plassey, replacing him with their own candidate, was due to the way the East India Company was able to adjust to the realities of the Indian world. From that point on, sometimes in directions not of their own choosing but generally as the result of careful planning, the British, in the form of the East India Company, became central actors in Bengal politics and within ten years were the effective rulers of the great Mughal provinces. Using Bengal as a base, they eventually extended their control to the entire subcontinent—at times with great rapidity, at other times in the face of fierce opposition.

Between 1757 and 1850, there were few years when wars were not fought and territory not added to the company's possessions in Bengal, Madras and Bombay. By 1805, all of peninsular India—that is, all the territory south from Delhi and stretching from Bengal on the east to Bombay on the west—had been brought under control. After a brief pause for consolidation, the great expansionist thrust continued. In the northwest, Sind, in what is now Pakistan, was conquered in 1843, and by 1850 much of Burma had been added to the Indian Empire.

This period also saw the First Afghan War. In 1839, in an attempt to establish British power in Afghanistan, the Indian Army took Kabul and placed a puppet on the throne. But the British were not able to duplicate their experience in Bengal: they were too far from their base, they knew too little of the country, and they could not find either the collaborators or the political structure that would have made control possible. After an uprising in 1842, they were driven out of Kabul, and of the army of 4,500 soldiers and 12,000 camp followers that retreated toward India only one survived. The British had grown used to military success in India, and the contemporary reaction to the disaster—the greatest ever suffered by the British in India—was summed up by Sir Charles Napier, the general who conquered Sind: "Jesus of Nazareth," he wrote in the margin of a book on the war, "what disgusting stuff is this. With the exception of the women you were all a set of sons of bitches."

Memory of this defeat colored the obsession with Afghanistan that characterized the policy of the Government of India in the second half of the nineteenth century. Revenge, the need to teach "them" a lesson, caution combined with a fear of seeming to be afraid of the Afghans and other tribesmen, all mingled in British attitudes toward the area.

Within the Indian subcontinent, only one important area remained outside British control by the 1840's. This was the Punjab, the great triangular plain bounded on the northwest and northeast by mountains and watered by the Indus River and its tributaries. The conquest of the Punjab in 1849 marked an important stage for British rule in India. Bengal, Madras, Bombay, the great original centers of British power, retained their political and commercial dominance throughout the century, but a shift of interest and concern took place. It is not accidental that most of the photographs of India presented here are from north India; if any existed from the previous century, Bengal and, to a lesser extent, south India would have figured more prominently. It can be argued that for the first hundred years after the takeover in Bengal, the image of India was in fact an image of Bengal. The Bengal physical landscape, religion, and cultural traits were, to a very remarkable degree, synonymous in the Western imagination with India. This focus changes after 1850. Punjab and

the Northwest Frontier replaced Bengal as the primary source for the image of India.

For administrators in the 1850's a new day had dawned in India, and if they had been asked to define the chief indication of Western or, specifically, British superiority, they would likely not have spoken in terms of Western superiority in religion, art or culture. They would almost certainly have claimed that the British excelled in the ability to give good government, to provide the Indian people with what they needed and most conspicuously lacked in their own political structures: efficiency, order, equal justice, peace. It was in this spirit that great changes were begun and others planned: a postal service, telegraphs, railways, new highways, new canals for irrigation, steamship communication with England, a university system.

Then, quite suddenly, an event occurred that challenged many of the presuppositions on which British rule had been built. In May, 1857, many units of the Indian Army rose in revolt against their officers, Delhi fell to the rebellious troops, and then all through the Gangetic plain, the heartland of the Mughal Empire, towns and cities were taken. What had begun as a revolt of army units protesting poor pay and bad service conditions became a more general movement as leaders of the old order that had been displaced by the British — landlords, rajas, local chieftains — joined in the uprisings.

For almost a year there was fierce fighting, not so much in pitched battles as in the cities of Cawnpore and Lucknow, where small British units were besieged by the Indians, and in Delhi, to which the British laid siege, where the old Mughal Emperor had been proclaimed as the head of the uprising. By the end of 1858, British power was restored everywhere, but the memory of the Mutiny, for the next generation at least, colored perceptions and shaped responses. That the uprisings of 1857 were always referred to as "the Mutiny" is, of course, significant in itself. Later generations of Indians, during the nationalist movement in the twentieth century, were to call it "the First War of Independence," which is only the obverse of the story, but the British understanding always carried with it a message of treachery, disloyalty and betrayal. That alien rulers could have expected any other reaction from a conquered people may seem absurd, but at heart the British believed that the Indians had been given, and had gladly accepted, the gifts of good government, justice and order. In the Mutiny they had shown themselves untrustworthy.

The Mutiny was one of the first modern wars, in that the telegraph, popular newspapers, and photography-improved communications in general made the events of immediate concern to people far from the scenes of the battles. War reporters were present at the battles, and their reports, combined with the official accounts, were used for propaganda purposes in ways that were to become commonplace in

The Afghan Wars: *The First Afghan War (1838–42) was the result of British uneasiness over Russian proceedings along the Afghan border. The war began in March, 1838, when Sir John Keane led his "Army of the Indus" through the Bolan Pass to establish Shah Shuja, friendly to the English, as head of Kabul and Kandahar. Two years later, revolt broke out violently at Kabul. On the sixth of January, 1842, after agreeing to evacuate the country, 4,500 soldiers and 12,000 followers marched out of camp. The march became one of mass confusion and massacre, with the result that a sole survivor made it through the Lalaband Pass.* (left)

The Second Afghan War (1878–80) resulted when Shere Ali, the Amir, ignored Lord Lytton's treaty of alliance, refusing to admit a British agent into Afghanistan. Because of the Amir's friendly overtures with the Russians, the British advanced on several fronts to establish their authority. The success of their initial ventures turned to bloody defeat—not once as before, but twice—when the British were finally forced to withdraw from Kandahar.

later wars but which were pioneered to a considerable extent in 1857. Indian brutality and cruelty, juxtaposed with British heroism and endurance, were the staples of these reports, and rumors that Englishwomen had been violated by natives, that they had been made to march naked through the streets of Delhi, aroused fierce racial hatred.

It was this presentation of the Mutiny as a struggle between two contrasting moralities—one exemplifying the virtues of the West, the other the vices of Asia — that colored later British perceptions of Indian character. For the British, the two great symbols of the Mutiny were the Residency at Lucknow, where a small group of the English were besieged for four months, and the Well of Cawnpore, where the bodies of Europeans were thrown when, according to the British version, they had been massacred in cold blood after having been promised safe conduct. Even after India became independent in 1947, inscriptions at the two sites contrasted the treachery of Indians and the bravery of the English.

This understanding of the Mutiny was used to justify the ruthlessness with which the British acted in order to regain power. There was no large-scale massacre of Indian civilians but there was selective violence and random cruelty. The common mode of executing soldiers who had mutinied was to strap them across the mouths of cannon and to blow them to pieces while their comrades looked on. Civilians believed to be guilty were often hanged in public. "Ven-

geance is mine, saith the Lord, I will repay" was a favorite text of officials who saw themselves as the instruments of Providence. A British soldier put it another way when he was asked why he had hanged two harmless old village women: "Them's wot breeds the niggers."

A combination of terrorism and the use of legal processes explains to a considerable extent the success of the British in putting down the uprisings and in restoring their authority. There were those who deplored the violence at a time when the cry in England was for harsh punishment.

Queen Victoria herself wrote of her "feelings of sorrow and indignation at the unchristian spirit shown by the public towards Indians in general and towards sepoys without discrimination." Canning, the Governor-General, was derisively nicknamed "Clemency" for forbidding acts of vengeance, and for insisting that charity toward the defeated was prudent common sense. Self-serving virtue was part of the secret of British rule in India, and, in retrospect, it appears to have been as just and humane a way of conducting an imperial exercise as any that could be devised.

A guiding conviction had been that the Indians did not care who ruled them, as long as they were well ruled. The Mutiny called this comforting assumption into question, but did not destroy it. Instead, the British concluded that the Mutiny proved, not that the Indians hated foreign rule, but that they had made errors in ruling India.

The Indian Mutiny, 1857: *Throughout the spring of 1857 there were indications that the Indian soldiers of the Bengal Army, the largest of the three armies of the East India Company, were dissatisfied and mutinous. The story that soldiers had been issued with bullets greased with pigs' and cows' fat — insults to the religious sensibilities of both Muslims and Hindus — was only one of the many rumors that spread throughout the army. The first important outbreak came when soldiers at Meerut killed their British officers and seized Delhi. At the same time, there were uprisings in other parts of North India, particularly in the cities of Cawnpore and Lucknow, where the leaders were representatives of the old order that had been displaced by the British. The most famous of these was the Nana Sahib, the heir of the Maratha leader, the Peshwa, whom the British had defeated a generation before.*

What was needed, then, was changes in the structure of the administration, the reorganization of the army, and, more generally, a reexamination of the direction of government policy. While Indians did not care who governed them, or even how they were governed, they cared profoundly about their customs, their religious forms, and their society.

We may assume that the Victorians in India were like us, that they wanted to make over the world. On the contrary, at the very heart of British rule was the belief that it depended upon interfering as little as possible with Indian life, permitting old forms to continue and introducing change only where it was necessary to maintain the structure of British power. It is this balancing of innovations necessary to continue British supremacy in India over against the sense that it was dangerous to tamper with Indian society that explains the tensions that characterize Indian social and political life in the last years of the nineteenth century. From the outside, the structure looks fixed and permanent, but the structure masked an uneasy awareness that the Europeans ruled India on sufferance.

During the last quarter of the nineteenth century, in 1876, 1896 and 1899, there were three devastating famines. The great question at the time was government responsibility in alleviating suffering. The issues were moral and economic. Should the government interfere in the law of supply and demand by providing food for those who could not afford to buy it at market prices? Much of the suffering in India was caused not so much by an absence of food as by high prices and unemployment related to the failure of a harvest.

When the government did intervene to provide employment through public works or through direct relief, many argued that too much help was given, and the people were demoralized. The combination of morality and laissez-faire economics is plain in the injunction of the Famine Code of 1880: relief should not be given on such a scale as "to check the growth of thrift and self-reliance." And always the impossibility of bringing about change, partly because of the unpredictability of nature, partly because of the nature of Indian society, was emphasized.

At the beginning of the twentieth century, Lord Curzon declared that it would be "treason to our trust" even to suggest a time would ever come when the British would not be needed in India. But one does not talk that way unless the doubts are there. They were not paraded in public, but they are plain enough in the official minutes and memoranda that in a bureaucratic despotism take the place of political discussion. How should we rule India? How should we ensure that the disloyal, the disaffected, the treacherous, do not once more threaten British power? Sometimes, especially in public, the question was put in the opposite form: What can we do for the people of India, how can we fulfill our trust to them? These were the questions that were being answered through both change and the resistance to change in the late nineteenth century.

One of the great symbols of change was the piece of legislation passed by the British Parliament in 1858 called "An Act for the Better Government of India," by which the old East India Company, which was still the formal ruler of India, was replaced by the British

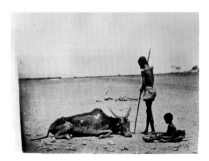

Famine: *More than disease or warfare, the single great specter that haunted India. In 1769–70, during the early British period, Bengal lost an estimated third of its population. In 1782–85, the Delhi region was similarly struck and took some thirty years to recover. In 1837–38, famine came to the Upper Ganges. In 1866, Orissa was said to have lost a quarter of its inhabitants from a famine the Bengal Government failed to identify in time. From the famine of 1876–78 in the south grew the great Famine Code of India, formulated by Lord Lytton, that made it possible to move at the first signs of shortage and declare a state of scarcity and then of famine. As well, there was in the second half of the nineteenth century a growing recognition of the need for irrigation, a program that did not fully get under way until the Nineties.*

Crown. As Queen Victoria put it, the British people realized that "India should belong to me." Ultimate control of India was in London, yet for all practical purposes India was governed from India. The rulers were alien, and the mechanisms through which they ruled — the bureaucracy, the army, the legal system — were largely Western in origin, but they reflected the historical experience of India.

There were, in fact, two "Indias" in the nineteenth century: British India, the territory which was directly ruled by the British, and the territories known as Native States that were indirectly governed through Indian rulers. The designation "native" had no pejorative meaning in the nineteenth century, and since it is the familiar term, it will be used here. Both kinds of territory were linked through the Governor-General, but the distinction between the two was important both in theory and in practice. British India, comprising two-fifths of the total area and three-fifths of the population, included the three great coastal provinces of Bombay, Madras and Bengal, the northern province of Punjab, and the whole of the Ganges Plain from Delhi to Bengal, which was eventually organized into the United Province.

The rest of India was made up of the Native States. There were about 600 of these, varying from Hyderabad, which at the beginning of the twentieth century had a population of eleven million, to those which consisted of a few villages. Some of the rulers, especially in Rajputana, traced their dynastic lineages back for a thousand years; most of them were descendants of military freebooters who had established themselves in the late eighteenth century. As the British conquered the more valuable and strategic areas of India, they were content to leave many of the chiefs in possession of their lands, in return for promises of support and an agreement not to make war on their neighbors. Before the Mutiny, it had been assumed by many British officials that the Native States were anachronisms that should be absorbed into the structure of British India, but this attitude changed after 1858. Most of the princes had remained loyal during the uprising, so there was a desire to reward them while assuring their support for the future. The result was that while the actual autonomy of the native princes was even more circumscribed after 1858 than before, they were given a new role in relation to British

India. "Pampered and petted favorites" was a common phrase for them by some observers; others saw them as "bulwarks of the Indian Empire," their states oases of stability in a time when political ferment and nationalist demands became common in British India.

Beyond this, princely India supplied an element of fantasy to the drabness of British India. Stories of the luxury and wickedness of the palaces were both titillating and repellent. Kipling summed it up neatly:

> Native states were created by Providence in order to supply picturesque scenery, tigers, and tall writing. They are the dark places of the earth, full of unimaginable cruelty, touching the Railway and the Telegraph on one side, and, on the other, the days of Harun-al-Raschid.

The tales of cruelty were probably true enough, as were those of imaginative debauchery, including one maharaja who, as one traveler reported, had "a taste that ranged from small boys to elephants." The British brought to India a well-developed sense of history, and an awareness of place to which princely India appealed, with its continual reminders of the past.

It was British India, however, that counted in the scheme of things; Calcutta and Bombay had none of the romance of Bundi or Jaipur, but the great cities were the focus of the commercial wealth and the political power that were transforming the ancient civilization. The great symbol of power was the Governor-General, who was both the head of the bureaucracy that ruled India and, as Viceroy, the representative of the British Crown, a reminder that the Queen of England was Empress of India, the successor to the Mughal Emperors.

All through the nineteenth century, Calcutta was the capital of India, and the Governors-General lived in a vast mansion that was a copy of an English country house, Kedleston Hall. They were surrounded by splendidly costumed servants and their public appearances were marked by elaborate rituals and ceremonies.

"The Great Ornamental" was the nickname given to the Governor-General by his underlings. The post was not coveted by

the most ambitious or the most talented, for it did not permit much personal initiative. The Governor-General was Chairman of the Bureaucracy, not a President or Prime Minister. A stranger to India, the Governor-General could do little to affect policy unless, like Curzon, he was willing to fight the civil service and the army. Lord Elgin, who became Governor-General in 1862, complained that he had less real power in India, where he was supposed to be a despot, than he had when he was Governor-General of Canada, where he was a constitutional figurehead. The office was a graveyard of political reputation—no one ever succeeded in using it as a stepping stone to high public office after returning to England. Either he lost touch with English politics or, in some curious way, Englishmen showed their judgment of Imperial India by rejecting those who had ruled it.

The real control of British India, nonetheless, was exercised by members of the Indian Civil Service. "Civil Servant" had a special meaning in British India. It did not denote the hordes of clerks and officials who operated, in India as elsewhere, the structures of government, but referred only to those who had been chosen, after an entrance examination given in England, to occupy all the high-level posts in the administration. The key position was the District Officer—or Collector, as he was usually known, recalling his function as a tax-collector. The Indian peasants often referred to him as "Sarkar," using the word for Government, because he was the embodiment of political power, presiding over the courts, the revenue system, and the police. There were only about a thousand of

them, and they were the real rulers of India. Much has been written about their dedication and devotion to duty, the respect they gained from Indians, and their even-handed justice. They were nearly all British—in 1899, only 33 out of 1,021 were Indians—and they, too, spelled out the charade of power which the Indians read. They were fond of thinking of themselves as Plato's ideal rulers, the guardians who, when "in any place of command, in so far as they are indeed rulers, neither consider nor enjoin their own interest but that of the subjects on behalf of whom they exercise their craft."

The reality of Civil Service rule was that the Government of India had only two principal functions: the maintenance of law and order, which included security from external threats, and the collection of taxes, particularly the land tax, which paid for the law and order. That they succeeded was because, as stressed above, from the very beginning the rulers had made alliances with important groups and interests within Indian society. Nor did the Collector, despite his air of omniscience, know all the details of the administration. The day-to-day running of the district was in the hands of Indian officials, and there is no doubt that it was they who often exercised the real power.

The British who came to India, especially the official class, knew that they would spend their working lives there, even if they did not like it. Throughout most of the year, India is not a pleasant land even for its own people, much less for those who come from the soft greenness of England. Month after month of heat, dust and insects fray the most equable nerves. Even those most fascinated by its culture and civilization, but who have lived protected by devices of

The Viceroy: *From the Latin* vice, *"in place of," and* roy, *"king," this was the term applied, after the Indian Mutiny of 1857, to the Governor-General, the head of British rule in India. Answerable directly to the Crown, the Viceroy was in charge of all administration and constituted the direct link between London and the British Government in India. The Governor-Generals who served in India during the period of this book are: Lord Canning, 1856–62; Lord Elgin, 1862–63; John Lawrence, 1864–69, the last Indian civil servant to be appointed to this position; Lord Mayo, 1869–72; Lord Northbrooke, 1872–77; Lord Lytton, 1876–80; Lord Ripon, 1880–84; Lord Dufferin, 1884–88; Lord Lansdowne, 1888–94; Lord Elgin, 1894–99; Lord Curzon, 1899–1905; Lord Minto II, 1905–10; Lord Hardinge II, 1910–16.*

modern technology, find India physically unpleasant. Those who do not share that fascination find it harsh and ultimately repellent. The life of India is so memorable in its color and intensity that it is easy to forget the background of drabness and monotony. Novelists have often tried to impart this aspect of India; David Rubin, a modern novelist, defines it exactly when he speaks of the

> dust, with the fields brown, the leaves a sickly grey in the hot breath of the summer wind, the lonely huddles of sun baked huts half-submerged in a surf of sand where listless buffaloes looked for water.

That is the physical background for Indian life — and the reason why foreigners who have lived in India, and Indians themselves, have an unease about the land and their relation to it.

And yet memory and the artifacts that preserve memory — the novels, the photos, the books of reminiscences — do show the rulers, and even the ruled, at play and taking their ease. The British were, of course, dedicated sportsmen, believing, incidentally, that this was one of the ways that set them apart from Indians. The Indians accepted this criticism at face value, as when a famous Indian historian, pondering the reasons for the decline of the Mughal Empire, concluded that an important factor was that the young Mughal princes, unlike Englishmen, did not play games or take cold showers.

Probably no one goes pig-sticking in India now — not even the most self-consciously Anglicized members of the Indian elite — but sober cultural historians insist that for British officials and army officers pig-sticking was the most esteemed of all sports. Certainly,

contemporary memoirs and photographs are filled with the sport. Hunting wild boars on horseback with a spear was dangerous and exciting, and that must have been the secret of its appeal. Such sports had a social function, for, as one chronicler of the age put it:

> Ugly lusts for power and revenge melted away and even the lust for women assumed — so it was said — reasonable proportions after a day in pursuit of pig.

Pig-sticking was a sport that went well with the kind of hero pictured in popular nineteenth-century novels about India: "uncomfortable and splendid . . . all sunburn and stern renunciation." So did tiger-shooting and polo. The pictures of tiger-shooting recall Mughal miniatures, with the elaborate preparations making the sport a ceremony. Dozens, sometimes hundreds, of beaters would drive the animals toward the hunting boxes where the hunters were waiting. It, too, was a dangerous sport, but more so for the beaters than for the hunters. The redeeming social significance was that tigers, especially the man-eating ones, were terrifying the villages, and one small piece of the colonial myth suggested that only the British had the courage to seek out and destroy the beasts.

Polo was the sport of officers and maharajas, but every member of the Indian Civil Service had to be able to ride a horse, and polo lifted the drab requirement of the civil service test to the level of romance. The first Western players appear to have been British tea planters in Assam. They had learned it in the hill state of Manipur. Since there is evidence that the game originated in Persia in the sixth century B.C., it

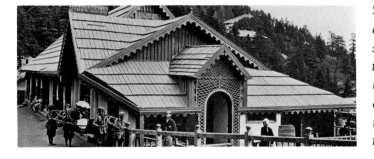

Simla: *The hill station in the Himalaya northeast of Delhi where the British moved the administration during the hot summer months. Simla was immortalized by Kipling in his short stories as a place of constant social activity and romantic intrigue. The center of these stories was the wives of British officials who came to Simla during the summer, while their husbands had to stay on the plains, and the young officers of the Viceroy's entourage and other unattached men. The remoteness of Simla coupled with the enormous difficulty of moving all the apparatus of the government twice a year back and forth to Calcutta affected the attitude of the Government officials to the problems of India.*

provides a good illustration of the way in which alien forms became Indianized.

Cricket and tennis were the other great outdoor recreations, and the ones to which Indians eventually took with greatest avidity. Historians of the interaction of cultures give little attention to such matters, but it is surely of considerable significance that while Indians remained rather indifferent to the great cultural achievements of the West — art, music, religion — they adopted Western sports. One possible explanation is that the Indians saw sports, particularly tennis and cricket, as the special characteristics of the British rulers, embodying the values that they particularly prized: manliness, courage and physical endurance.

Reference to climate, sports and virtue leads inevitably to the two great social institutions dividing the rulers from the ruled: the hill station and the club. For those Indians who in the late nineteenth century were beginning to demand a share in the government of their country, the hill station and the club were the symbols of alienation, of the lines drawn to exclude Indians from full participation in the political and social institutions created in India. The British hill station based on the idea of the rulers escaping from the heat of the Indian plains to the coolness of the mountains was not a British invention—Kashmir was beloved of the Mughals—but when Simla was made the summer capital a whole new meaning was given to the practice. It meant that for six months of the year the capital of India was not Calcutta but Simla, that the Governor-General and his secretariat moved themselves and their files a thousand miles to a climate and an ambience that was as remote as can be imagined from the realities of Indian life. There were many hill stations besides Simla, and most foreigners as a matter of course fled to them during the hot weather. For a few months each year, India disappeared; its place was taken by a world that was in India yet had little physical or spiritual relationship to the life of the great cities or of the countryside.

But perhaps the club, even more than the hill station, produced a sense of isolation from India, a social distance between the rulers and the ruled. The club was a British invention, but it fitted in well with Indian ideas of the separation of classes for eating, drinking and social intimacies. What distressed sensitive people, both British and Indian, was that the club became a mark of deliberate separation of the races—the visible symbol that while men might work together in business or in government, they could not meet together as social equals. The common arguments for the exclusion of Indians from the clubs were that one could not relax unless one were surrounded by one's own kind, or that, since Indian men did not bring their wives to social gatherings, it would be wrong to invite them to places where there were Western women. A familiar statement of this attitude is in E. M. Forster's novel *A Passage to India,* when the newly arrived Miss Quested said at the club that she wanted to meet Indians:

> She became the centre of an amused group of ladies. One said, "Wanting to see Indians! How new that sounds!" Another, "Natives! why, fancy!" A third, more serious, said, "Let me explain. Natives don't respect one any more after meeting one, you see."

All this is easy to mock, but it conceals something of great importance. What the club stood for was "the club," the group that ruled India. Writing of Kipling's world, C. S. Lewis spoke of the sense of "the shared intimacy within a closed circle," the sense of belonging that depends upon the awareness that others are excluded. It was no accident that the old clubs disappeared in provincial India as more and more Indians came into the higher government services in the twentieth century. "The club" had begun to lose its meaning.

The nineteenth-century British were entranced by history, and everywhere they went they searched for documented clues to the past. They used to express surprise that Hindus had no sense of history, but the British obsession with the past in the nineteenth century is, in some ways, even more surprising. The discovery and re-creation of India's past was very largely a British achievement, and one that was largely the work of gifted amateurs. In their spare time, and almost as a hobby, civil servants translated works from Sanskrit and Persian, deciphered inscriptions, and worked out a chronology of India's past. Others wrote grammars and compiled dictionaries.

144

The first Director-General of Archaeology, Alexander Cunningham, was appointed in 1861, after he had badgered the Government into giving him a small staff to catalogue India's monuments. He was not a trained archaeologist nor were most of his immediate successors, but they succeeded in saving and recording the physical remnants of India's past. It is one of the many ironies of the British experience in India that it was the proprietary curiosity of such men that provided Indian nationalists with the material framework for the version of the past that infused Indian nationalism.

Of that phenomenon, the growth of Indian nationalism, Victorian photographers took little note. Their focus was elsewhere: on the frontier, on the army, on sports, on the great monuments from India's past. When they turned to the people of India, they photographed the picturesque, the bizarre, the primitive. They were interested in the romance of India, represented by the princes; in the pomp and circumstance of the Viceroy; in the rich diversity of India's peoples, ranging from the hill tribes of the frontiers to the wealthy, Westernized, but vaguely exotic Parsis.

There are no photographs here of the first meeting of the Indian National Congress, which met in 1885, where the leaders proudly declared that beyond the diversity and divisions of Indian life there was a unity which made India a nation, not just a congeries of people as the British insisted it was. These leaders were quite deliberately, but still very politely, throwing down the gauntlet to the British, declaring that they had a right to speak for India.

The nationalism of India had, in fact, little in common with the nationalism of Europe or, at the other end of the spectrum, of the new nations that have emerged in Africa. Its leaders spoke English, and many of them dressed in Western clothes, but almost all of them came from those classes, especially the Brahmin castes, that had traditionally been the spokesmen and leaders within the fabric of Indian society. Because this was so, they were not then — nor are they now — social revolutionaries. They had no desire to drive the British out or to overturn society, for they were too much part of both the traditional society of India and the new one that the British had created. What they sought was a chance to participate directly in the existing structures of power.

This desire represented, not some new concept of "nationalism" for India, but only a normal ambition for places of prestige and power. That it found expression through the medium of the English language, and very often used the rhetoric of British and European political thought, was an accident of history. The currents that were flowing in India's political life had their sources deep in India's own past and in her own needs. It was for this reason that in 1947 the old Government of India, the artifact of British imperialism, gave way to the new governments of India and Pakistan, with Bangladesh eventually being added as another expression of the forces at work within the political and social structure of the subcontinent. These forces

Rudyard Kipling (1865–1936): *The Laureate of Empire summed up in his poetry, short stories and novels the experience of the British in India. He was contemptuous of the English-educated, urban Indians, the "babus," but he had equal scorn for British politicians and intellectuals who wrote about Indian problems. The heroic figures, whether British or Indian, are strong men, doers rather than thinkers. The sturdy peasants and the tribesmen of the Northwest Frontier are the "real Indians," just as the real Englishmen are those who govern India for its own good. Born in Bombay, Kipling was sent back to England at six with his younger sister and boarded with a horror of a woman who took in the children of Britishers living abroad. There and at a minor school in Devon, he gained his fierce regard for the spirit of the gang, its cheerful superiority and emphasis on fitness. Moreover, he had an ear for dialects and delighted in putting down the sound of the barracks-room. Kim illustrates the complexity and ambiguity of his attitudes as well as his greatness as a writer.*

were hidden by the political unification of the subcontinent in the nineteenth century. The British believed, however, that they had achieved far more than a political success: they were convinced that political unity was a good in itself, a self-validating statement of the benefits that British rule had conferred upon India.

In all the tangled history of the Indian subcontinent, nothing is more complex than this interweaving of the political achievement of the British and the creation of nation-states. The process is almost certainly not yet completed, as was demonstrated in 1975 when the Government of India concluded that such remnants of nineteenth century liberalism as freedom of the press and unlimited access to the courts were working against the chief end of the state—the preservation of law and order.

What has since transpired historically would not have surprised those who ruled the world depicted in these photographs. They knew, as a character in one colonial novel put it, that Indians needed "duty, responsibility, discipline, organization." These were the very qualities, the British were convinced, that they had supplied to India, and that had united India under one rule, replacing the ancient splintered anarchy. It is this understanding of Indian history that has been spoken of as the myth of British India. That it has reappeared in a revised and updated form in present-day India may suggest that, like all successful myths, it is a statement of reality. Or it may simply be that those who claim now, as in the nineteenth century, to be the possessors and guardians of "duty, responsibility, discipline and organization" are caught by that larger myth, India itself.

In Forster's *A Passage to India,* when Mrs. Moore entered the cave, she left behind those who spoke of life in terms of duty. In the cave, she listened for the voice of India and she heard it in the echo: "Everything exists, nothing has value." Here, one can hear both voices, the voice of Victorian India and the voice of India as it will always be.

Ainslie Embree

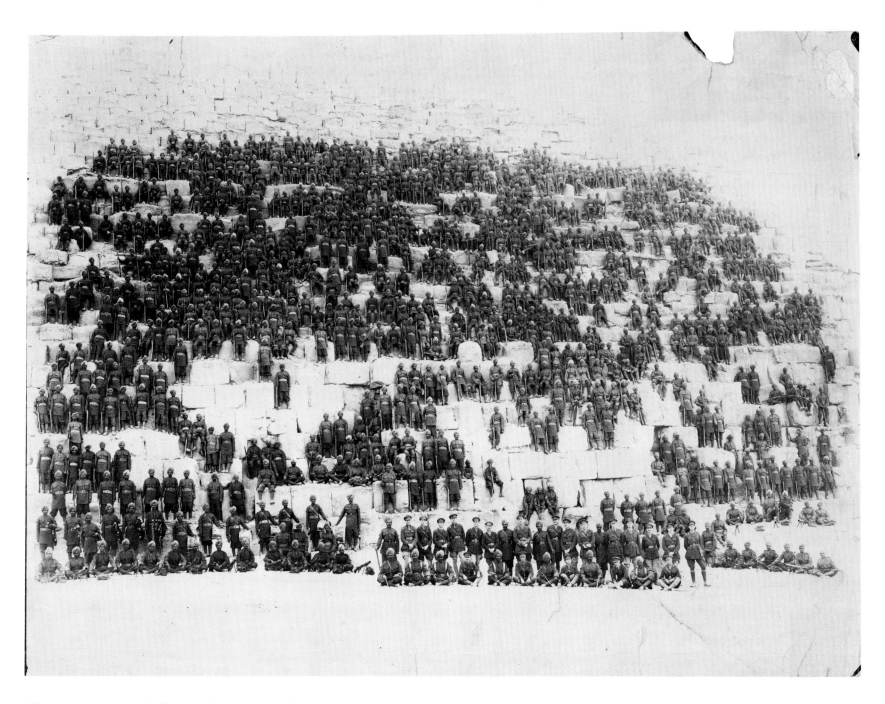

Photographer unknown: *The 38th Dogra Regiment on the Steps of the Great Pyramid*, 1919.

In World War I Indian troops fought for the first time in Europe and the Near East.

Footnotes

1. William Gilpin, *Three Essays on Pictur-esque Beauty or Picturesque Travel,* third edition (London, 1808), p. 2.
2. Thomas Daniell, *Oriental Scenery* (1810).
3. William C. MacKenzie, *Colonel Colin Mackenzie, First Surveyor-General of India* (W. Edinburgh and R. Chambers, 1952), p. 177.
4. Fergusson and Burgess, *The Caves of India* (W. H. Allen Co., London, 1880), pp. xvi, 282, 312.
5. T. Blees, *Photography in Hindoostan* (Bombay Education Society Press, 1877), p. 102.
6. *Ibid.,* p. 105.
7. Lieutenant-General Sir George MacMann, *Vignettes from Indian Wars* (S. Low Marston and Co., London, 1932), p. 136.
8. R. Desmond, "Photography in South Asia during the Nineteenth Century," from the India Office Library and Records Annual Report for 1974 (India Office Library, London, 1974), p. 19.
9. Michael Maclagan, *"Clemency" Canning* (St. Martin's Press, New York, 1962).
10. Lieutenant-General Sir George MacMann, *op. cit.,* p. 137.
11. Henry Mead, *The Sepoy Revolt: Its Causes and Its Consequences* (G. Routledge and Co., London, 1858).
12. Walter Copeland Jerold, *Field Marshal Earl Roberts, V.C.* (W. A. Hammond, London, 1914).
13. *Thackers Post Directory* (Calcutta, 1899), p. 22.
14. Samuel Bourne, *British Journal of Photography* (March 18, 1870), pp. 28–29.

Further Reading

Annan, Noel (Lord Annan). "Kipling's Place in the History of Ideas," *Victorian Studies,* Vol. III, 1959–60. Reprinted in *Kipling's Mind and Art,* ed., Andrew Rutherford, London, 1964.

Atkinson, G. F. *Curry and Rice.* London, n.d.

Ball, Charles. *History of the Indian Mutiny,* 2 vols. London, 1858–59.

Barbier, Carl Paul. *William Gilpin: His Drawings, Teaching, and Theory of the Picturesque.* Oxford, 1963.

Blees, T. *Photography in Hindoostan.* Bombay, 1877.

Boileau, J. T. *Picturesque Views in the N.W. Provinces of India.* Calcutta, n.d.

Brothers, Alfred. *Photography: Its History, Processes, Apparatus and Materials.* London, 1899.

Bruce, J. *Annals of the East India Company.* London, 1810.

———. *Centenary Review.* Royal Asiatic Society of Bengal, Calcutta, 1885.

Burgess, James. *Photographs of Architecture and Scenery in Gujerat and Rajputana.* Calcutta, 1874.

Clarke, Captain Melville. *From Simla through Ladac and Cashmere.* London, 1862.

Croucher, John H. *Plain Directions for Obtaining Photographic Pictures.* Philadelphia, 1855.

Daniell, Thomas and William. *Oriental Scenery,* 6 vols. 1795–1808.

———. *A Picturesque Voyage to India, by Way of China.* London, 1810.

——— *Views of Calcutta.* London, 1786.

Desmond, R. "Photography in South Asia during the Nineteenth Century," from the India Office Library Report for 1974.

Edwards, Michael. *British India, 1772–1947.* London, 1967.

———. *The Last Years of British India.* London, 1969.

Egerton, P. H. *A Journal of a Tour through Spiti to the Frontier of Thibet.* London, 1864.

Elliott, J. C. *The Frontier.* London, 1968.

Embree, A. *Charles Grant and British Rule in India.* New York, 1962.

———. *Exhibition of Mr. William Simpson's Watercolour Drawings of India, Thibet, and Cashmere.* London, 1864.

Fergusson, J. *Illustrations of Various Styles of Indian Architecture.* London, 1869.

———. *One Hundred Stereoscopic Illustrations of Architecture and Natural History in Western India.* London, 1864.

———. *Rock-cut Temples of India.* London, 1864.

Fergusson and Burgess. *The Caves of India.* London, 1880.

Forrest, Sir George William. *History of the Indian Mutiny,* 3 vols. London, 1904–12.

Forster, E. M. *A Passage to India.* London, 1924.

Gernsheim, Helmut. *Masterpieces of Victorian Photography.* London, 1951.

Gilpin, William. *Observations on the Coasts of Hampshire, Sussex and Kent.* London, 1804.

———. *Three Essays on Picturesque Beauty or Picturesque Travel.* London, 1808.

Hanna, Henry Bathurst. *The Second Afghan War, 1878–79–* Westminster, 1899–1910.

Hooper, W. W. *Burmah: A Series of One Hundred Photographs.* London, 1887.

Innes, Arthur Donald. *A Short History of the British in India.* London, 1902.

Johnson and Henderson. *Indian Amateur's Photographic Album.* Bombay, 1856.

Johnson, W. *The Oriental Races and Tribes: Residents and Visitors to Bombay.* Bombay, 1872.

Long, Charles A. *Practical Photography.* London, 1854.

MacKenzie, William C. *Colonel Colin MacKenzie, First Surveyor-General of India.* Edinburgh, 1952.

Maclagan, Michael. *"Clemency" Canning.* New York, 1962.

Mead, Henry. *The Sepoy Revolt: Its Causes and Its Consequences.* London, 1858.

———. "Military Proceedings for April, 1879, No. 2986–2988." India Office Library, London, 1879.

Mosley, L. *The Last Days of the British Raj.* London, 1962.

Murray, John. *Agra and Its Vicinity.* Calcutta, 1858.

Price, Lake. *A Manual of Photographic Manipulation.* London, 1868.

Roberts, Earl, Frederick Sleigh. *Letters Written During the Indian Mutiny.* London, 1924.

Roberts, P. E. *A History of British India.* Oxford, 1932.

Robinson, H. P. *Letters on Landscape Photography.* London, 1885.

——— *The Studio and What To Do in It.* London, 1885.

Root, Marcus A. *The Camera and the Pencil.* New York, 1864.

Russell, William Howard. *My Diary in India in the Year 1858–59.* London, 1860.

Spear, Percival. *India.* Ann Arbor, 1961.

———. *The Nabobs.* Oxford, 1963.

———. *Twilight of the Mughals.* Cambridge, 1951.

Sykes, D. H. *Photographic Album of Bombay Views.* Bombay, 1872.

——— and Dwyer. *Somnath, Girnar, and Junaghad.* Bombay, 1869.

———, Dwyer, and Burgess, J. *The Rock Temples of Elephanta and Gharapuri.* Bombay, 1871.

———, Dwyer, and Burgess, J. *The Temples of Satrunjaya.* Bombay, 1869.

Talboys-Wheeler, J. *The Imperial Assembly at Delhi.* Calcutta, 1877.

Taylor, M. *The Oriental Annual.* London, 1834–40.

——— and Fergusson, J. *Architecture at Beejapoor.* Bombay, 1866.

——— and Fergusson, J. *Architecture in Dharwar and Mysore.* Bombay, 1866.

Thompson, E., and Garratt, G. T. *The Rise and Fulfilment of British Rule in India.* London, 1934.

Tingsten, Herbert. *Victoria and the Victorians.* London, 1965.

Tripe, Linneaus. *Photographs of Elliot Marbles.* Madras, 1858.

———. *Stereographs of Madura.* Madras, 1858.

———. *Photographic Views in Madura.* Madras, 1858.

———. *Photographic Views of Poodoocottah.* Madras, 1858.

Watson, Francis. *A Concise History of India.* New York, 1975.

Watson, J. Forbes, and Kaye, J. W. *People of India.* London, 1868–75.

The Last Empire was prepared and designed by Marvin Israel and Michael Flanagan.